Visual Literacy

VISUAL LITERACY

EDITED BY

JAMES ELKINS

Routledge
Taylor & Francis Group
New York London

Routledge
Taylor & Francis Group
270 Madison Avenue
New York, NY 10016

Routledge
Taylor & Francis Group
2 Park Square
Milton Park, Abingdon
Oxon OX14 4RN

© 2008 by Taylor & Francis Group, LLC
Routledge is an imprint of Taylor & Francis Group, an Informa business

Printed in the United States of America on acid-free paper
10 9 8 7 6 5 4 3 2 1

International Standard Book Number-13: 978-0-415-95811-0 (Softcover) 978-0-415-95810-3 (Hardcover)

Except as permitted under U.S. Copyright Law, no part of this book may be reprinted, reproduced, transmitted, or utilized in any form by any electronic, mechanical, or other means, now known or hereafter invented, including photocopying, microfilming, and recording, or in any information storage or retrieval system, without written permission from the publishers.

Trademark Notice: Product or corporate names may be trademarks or registered trademarks, and are used only for identification and explanation without intent to infringe.

Library of Congress Cataloging-in-Publication Data

Visual literacy / edited by Jim Elkins.
 p. cm.
 Includes bibliographical references and index.
 ISBN 978-0-415-95810-3 (hardback) -- ISBN 978-0-415-95811-0 (pbk.) 1. Visual literacy. 2. Visual communication. 3. Visual perception. I. Elkins, James, 1955-

LB1068.V567 2007
370.15'5--dc22 2007017432

Visit the Taylor & Francis Web site at
http://www.taylorandfrancis.com

and the Routledge Web site at
http://www.routledge.com

Contents

	Preface	vii
	Introduction: The Concept of Visual Literacy, and Its Limitations JAMES ELKINS	1
1	Visual Literacy or Literary Visualcy? W. J. T. MITCHELL	11
	Four Fundamental Concepts of Image Science W. J. T. MITCHELL	14
2	The Remaining 10 Percent: The Role of Sensory Knowledge in the Age of the Self-Organizing Brain BARBARA MARIA STAFFORD	31
3	Nineteenth-Century Visual Incapacities JONATHAN CRARY	59
4	From Visual Literacy to Image Competence JON SIMONS	77
5	The Visual Complex: Mapping Some Interdisciplinary Dimensions of Visual Literacy PETER DALLOW	91
6	Visual Literacy in North American Secondary Schools: Arts-Centered Learning, the Classroom, and Visual Literacy SUSAN SHIFRIN	105

7	Philosophical Bases for Visual Multiculturalism at the College Level WILLIAM WASHABAUGH	129
8	Bridging the Gap between Clinical and Patient-Provided Images HENRIK ENQUIST	145
9	The Image as Cultural Technology MATTHIAS BRUHN AND VERA DÜNKEL	165
10	Visual Literacy in Action: "Law in the Age of Images" RICHARD K. SHERWIN	179
	Afterword CHRISTOPHER CROUCH	195
	Photo Credits	205
	Index	209

Preface

A tremendous force of rhetoric has been brought to bear on the notion that ours is a predominantly visual culture. Theories concerning the visual nature of experience have been proposed in art history, cognitive psychology, psychoanalytic criticism, anthropology, artificial intelligence, women's studies, neurobiology, neuropsychology, linguistics, and various branches of philosophy. At the same time, there is little discussion about how visual practices might inform a university education. First-year classes in universities throughout the world remain text-based, with images as an option often declined.

The central purpose of this book is to ask about the possibility of turning the tenor of university education, at least in part, from text-based knowledge to visuality. The central premise is that theorizing on images, which currently takes place mainly in graduate studies in the humanities and in cognitive science, needs to move downward, toward first-year education, where it can begin to directly intervene in the ordinary education of every college student.

This book began as a conference and exhibition held at University College Cork in Ireland, in April 2005. Originally this was intended as a massive volume: it was to include another part of the conference on visuality in different nations, and a text-intensive exhibition of image making in thirty departments around the university. In the event, those two will be published separately. The material on visuality in Western and non-Western countries will appear as *Visual Cultures*, and the exhibition of visual practices outside the arts will be a book called *Visual Practices across the*

University.[1] Together they comprise a single pedagogic and philosophic project, to try to get a provisional idea of the sum total of theories, practices, "competencies," and literacies of the visual.

I owe a great deal of thanks to the people at University College Cork, who helped with all aspects of the conference and exhibition, and above all to Gerard Wrixon and Áine Hyland—then the president and a vice president of the university—who supported every initiative I thought of, no matter how ill-formed. And I owe special thanks to the ordinary (nonplenary) speakers at the conference, each of whom agreed to write multiple drafts of his or her paper, in advance of the conference, to ensure they formed a coherent group. (Some speakers revised their papers as many as five times before the conference; many of them also wrote revisions afterward.) With a field as dishevelled as visual studies, it is important to search for moments of coincidence and agreement.

<div style="text-align: right;">**J. E., April 2007**</div>

Endnote

1. The former is unpublished; the latter will appear as James Elkins, ed., *Visual Practices across the University* (Paderhorn, Germany: Wilhelm Fink Verlag, 2007). The reasons for publishing with Wilhelm Fink, and for dividing the project, are explored in that book.

Introduction
The Concept of Visual Literacy, and Its Limitations

JAMES ELKINS

I chose the expression *visual literacy*, initially in the book *Visual Studies: A Skeptical Introduction*, because its two words compress the common and unavoidable contradiction involved in saying that we "read" images. *Visual literacy* does not avoid that contradiction, or try to improve on it, but starts with the most succinct form of the contradiction itself. Tropes of reading are unavoidable in talk about images, as W. J. T. Mitchell argues in this volume, and *visual literacy* has the virtue of not trying to solve that structural problem. That is the first reason for the title of this book. A second reason has to do with pedagogy. A search of newspaper and magazine databases revealed that *visual literacy* has been in uncommon but intermittent use for over a hundred and fifty years; it has been used to denote low-level, secondary school appreciation, of the sort that enables a student to identify Michelangelo's *David*. I like that somewhat dusty feel, because it is a reminder that these issues of visuality impinge on undergraduate curricula. Visual literacy, or literacies—the plural will be at issue throughout—are as important for college-level education as (ordinary) literacy, and far less often discussed.

A third and last reason for choosing *visual literacy* is that it is convenient in the absence of anything better. It might be possible to speak of *visual competence*, or *visual competencies*, but that sounds awkward, utilitarian, and prescriptive. *Visual practices* is common but vague. *Visual languages* is so freighted with inappropriate precedents, from Umberto Eco to Nelson

Goodman, that it is practically useless. *Visual skills* is too narrow, because much of what matters here is politics, ideology, and history, as well as skills. Inevitably, and properly, contributors to this volume debate the choice of *visual literacy*. Perhaps it is best just to acknowledge the inbuilt awkwardness that language and usage impose on the subject at hand.

The conference that is revised and expanded in these pages was not the first to put stress on the expression *visual literacy*. Before the spring of 2005 there had been at least four conferences with *visual literacy* in their titles, and at least one undergraduate program with that title. "Visual Literacy: The Power of the Picture" was the name of a session at a conference in January 2004, with John Baldessari, Hani Rashid, and Curtis Wong. A white paper, drawn up to reflect the conversation, defines visual literacy as "understanding how people perceive objects, interpret what they see, and what they learn from them." That is at least part of a reasonable definition of the field of visuality, although at that conference the discussion centered

> que specimen erat. Id. N. D. 3, 32.
>
> 161. Videre, cernere, visere, contueri, intueri, spectare, conspicere, adspicere, contemplari, considerare. Videre, von einer Wurzel mit ἰδεῖν, sehen, heißt mit dem Gesichtssinn wahrnehmen, cernere, verwandt mit κρίνω, perf. vidi, sup. visum, mit dem Gesichtssinne unterscheiden, aus seiner Umgebung Etwas herauserkennen. Beide werden auch vom geistigen Sehen gebraucht, sodaß videre ist a) geistig wahrnehmen, synonym mit cognoscere, b) erleben, c) darauf oder darauf sein Augenmerk richten, darauf sehen, daß mit folgendem Relativsatze, ut, ne. Dagegen cernere = deutlich wahrnehmen, erkennen. Videri = scheinen, wie bekannt, aber cerni (in re, re) sich offenbaren. Visere von visum, in genauern Augenschein nehmen wollen, besichtigen, besuchen aus Neugierde, Wißbegierde, Schaulust u. s. w. Spectare, wiederholt ansehen und 2) dem Verlaufe von Etwas, was aus verschiedenen Einzelheiten besteht, zusehen. Davon tropisch a) spectare aliquid = im Auge haben, b) spectare mit ad aliquid, eo, ut, und andern adverbia loci, = worauf abzielen. Contueri, Etwas nach allen seinen Theilen überblicken, also so von spectare unterschieden, daß der contuens die Theile des Ganzen
>
> ¹) Ueber die Uebersetzung von „3. B." s. ut, velut, quidem, und vor Allen Seyffert Schol. Lat. 1, S. 180 ff. und II. Capit. v. Exemplum.

The lexica for visuality, vision, and related terms are immensely complicated. A full study of the concept of visuality would have to look into the concept of image, as in Laurent Lavaud's excellent little book *l'Image*, as well as vision. Here is the beginning of the entry for *videre* and related words, in Friedrich Schmalfeld's *Lateinische Synonymik* (1869).

on digital media and museology.[1] There is an International Visual Literacy Association, whose touchstones include Colin Turbayne's *Myth of Metaphor* and Rudolf Arnheim's *Art and Visual Perception*.[2] The association publishes annual conference proceedings and journals, with an emphasis on design and communication. An online conference on visual literacy, hosted by the New Media Consortium (NMC), concluded a week before the conference at University College Cork.[3]

Dozens of other initiatives come closer to the subject of this book even though they do not use the expression *visual literacy*. There is a design-oriented literature on visual practices, for example, recently centered on Bruce Mau and associated with historian-designers such as Johanna Drucker. Alan Fletcher's massive *Art of Looking Sideways*, an almanac of miscellaneous texts on seeing, is another example; Fletcher is a designer with Phaidon Press.[4] That literature, I find, is not on topic when it comes to visual studies because it draws on the history of design, typography, and leisure more than on wider cultural practices. Further afield, there are books with titles such as *Practices of Looking, Ways of Seeing, Ways of Looking, Seeing Is Believing, How to See* (which is actually an eccentric medical text by Aldous Huxley), *How to Use Your Eyes*, and many others. They do not comprise a field, and some share nothing more than a few common words about vision.

I hope that *visual literacy*, paradoxical and old-fashioned as it is, can be a useful expression for a very pressing problem. The issue at stake in this book is whether or not a university education can be based on images as well as texts. Given the enormous literature on the visual nature of our world—I need only name Mitchell, Nicholas Mirzoeff, Martin Jay, Jean Baudrillard, and Lisa Cartwright to conjure the field—it is amazing that college-level curricula throughout the world continue to be mainly text-based, with intermittent excursions into visual art and culture. The possibility of reconceiving first-year college education so that it works on a visual model is, I think, the most important and potentially revolutionary problem in current curricular theory. It has not even been posed by the field of visual studies, which is still focused on graduate and postgraduate learning. Nor has it been effectively asked by the many freshman courses with titles like *Art Appreciation, Visual Cultures*, and *Introduction to the Visual World*, because they mainly keep to the arts and humanities instead of offering a kind of literacy that might serve for the entire university community, across all disciplines. Nor has the question been addressed by freshman cognitive science courses, which remain—in complementary fashion—within the sciences, and make only peripheral mention of the arts.

What is needed is a university-wide conversation on what might comprise an adequate *visual* introduction to the most pressing themes of

contemporary culture. From the 1980s onward, literary studies was engaged in the "canon wars," debates about what each first-year college student should know in order to be effectively literate. Since then, the literature on literacy has sunk a little into conservatism (as in the work of E. D. Hirsch).[5] At the time, the issues were live ones: if a student should be aware of Toni Morrison or Frantz Fanon, which authors should be removed from the curriculum to make room for them? Could Plato be pushed aside to make room for Woolf, or Harvey for Kuhn? That kind of ground-floor debate had the virtue of opening the question of what texts, ideas, events, and names should comprise a minimal common language for all undergraduate students. Art, art history, film studies, and other visual fields never really engaged in the "canon wars," partly because art history could always make room in its massive textbooks for more artists without needing to expel the old canon.[6]

Since the 1980s the rhetoric of images has become far more pervasive, so that it is now commonplace in the media to hear that we live in a visual culture, and get our information through images. It is time, I think, to take those claims seriously. They need to be taken out of graduate philosophy and history classrooms, and brought down the hall to the large lecture theaters where first-year students are taught the things the university thinks are necessary for a general education. It is time to consider the

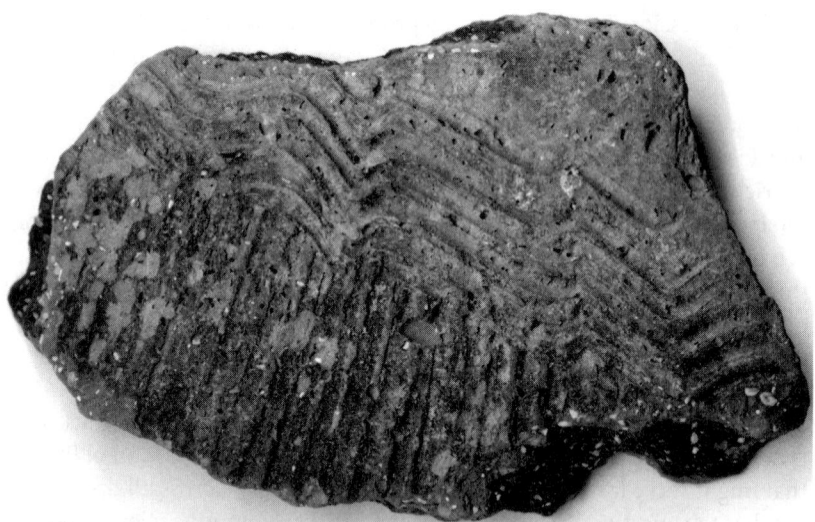

Many visual literacies are the objects of intense specialization; they typically escape visual studies, but figure prominently in the accumulated knowledge of many fields. How many people, for example, could recognize this as a Southeast European, early Bronze Age potsherd? Or even as a Bronze age object? It is from Durankulak, northern Bulgaria.

possibility that literacy can be achieved through images as well as texts and numbers.

The essays in this book can be read selectively, in sets, depending on your primary interest. The contributions fall naturally into four large groups:

1. *Conceptualization.* Several essays—notably Mitchell's, Peter Dallow's, William Washabaugh's, and Jon Simons's—push the conceptualization of visual literacy. Mitchell's first essay is a nicely done deconstruction of the expression itself. (His second addresses a different audience; *Bildwissenschaft* is a recently resurrected word, with resonance for an earlier generation of German art historians; Mitchell is here responding in part to Horst Bredekamp's interest in a kind of *Bildwissenschaft* as a way forward with visual studies—a way that involves my second category, below.) I am glad that Mitchell's first essay and Simons's both appear in this book, because together they are an excellent account of the limits of the concept of visual literacy: Mitchell's concerns the expression's self-defeating paradox, and Simons's addresses the central problem of the place of politics in images. The two are, in a way, bookends. At the level of abstract analysis, they provide a fair summary of the problems attendant on thinking about the words *visual* and *literate* together. Beyond primary conceptualization, there is a widening field of secondary theoretical sources. Mitchell's and Simons's essays are complemented, in that sense, by Dallow's and Washabaugh's wider range of references—to writers such as Gunther Kress, Theo van Leeuwen, Paul Messaris, Jean-Luc Nancy, William Ray, Bill Nichols, Roberts Braden and John Hortin, Kalpana Seshadri-Crooks, and many others. The open-ended conceptualization of the four papers provides a good picture of the current state of thinking on the subject.

2. *Images outside the arts.* Two essays, Barbara Stafford's and the essay coauthored by Matthias Bruhn and Vera Dünkel, are concerned with scientific and nonart images and ideas. There is a kind of visual studies, practiced mainly in German-speaking countries and in Scandinavia, in which semiotics, technology, engineering, graphs, and science play a far greater role than they do in Western Europe, the United Kingdom, Australia, and the United States. Bruhn and Dünkel work at the Humboldt-Universität in Berlin (where Bredekamp also works), and I invited them to join this volume after the conference in Cork had concluded, because I felt that the book did not adequately reflect senses of *visual literacy* outside of Anglo-American academia. Barbara Stafford's work has long been an independent, innovative project, and her

essay here is part of her current interest in parallels between the most recent neurobiology and contemporary art. It is an example of what can be done with scientific research, and in that sense it complements Bruhn and Dünkel's work, which is part of a project for the study of scientific *images*.

The extension of visual studies into engineering, medicine, science, and other areas beyond the arts is my own particular interest, and it will be developed in another book that began from the same conference, *Visual Practices across the University*. (See the note in the preface.) Even though *Visual Practices across the University* was designed as an integral part of the conference, the present book is a better reflection of the state of the field: the great majority of people who work in and around visuality, visual studies, and visual literacy do not care for the specifics of scientific images, or for visual practices beyond the humanities or outside of popular culture. It is statistically appropriate, then, that this book has only two instances of science. (I am excluding Henrik Enquist's essay for the moment.)

A word, in passing, about the images with discursive captions that are scattered throughout this book. For several reasons, the majority of essays in this book are only sparsely illustrated. Partly that is because some of the authors understandably wanted to avoid long entanglements wth the increasingly intractable copyright laws governing images. Several of the authors in this book have also published lavishly illustrated books. But part of the reason for the lack of illustrations is endemic to visual studies, and that raises an interesting and delicate issue. An important strain in visual studies is preeminently conceptual or philosophic, and a number of books on the subject have few, or no, illustrations. That theme is not yet part of the discussion in the field, but I was happy to take advantage of a suggestion made by an editor at Routledge, who said I might send in some extra illustrations to help balance the book. (To give the book the appearance of visuality that readers might expect.) My choices—the pictures with discursive captions, which are not directly related to their places in the book—reflect my own interests in an intensively visual form of visual studies, one that strays well outside art. Those two interests are not representative of the field as a whole, or of any consensus of these authors, so the added images are partly a form of editorializing. (They ended up being my own contribution, more in pictures than words.) Without them, the uneven distribution of images in the book would have been an accurate representation of current writing in both

visual studies and art history: some authors rely on individual pictures and close analyses of them, and others do not.

3. *Politics.* As a general rule, one that has many exceptions, the central concerns of visual studies in English- and French-speaking countries are politics, social construction, and identity: how images shape perception and the self, and how they reflect and project collective and national ideologies. Images as politics, and politics as images, are the direct subject of Simons's paper and the principal concern of several others, including Dallow and Washabaugh. An education in visuality, Washabaugh says, is intended "to enable students to understand, and intervene in, the constructions of race and gender that are mediated by their visual experiences." The underlying assumption might be something like this: our sense of self, both individually and collectively, is made and remade in and through the visual, and therefore it is fundamentally important to learn to understand images as social constructions rather than reflections of reality, instances of aesthetic pleasure, or marketing tools. Visual studies and media studies, in this view, can help to educate people to think and act responsibly in contemporary late capitalist culture.

At present, visual studies explores these issues, but does not take them as intrinsic limitations to any wider study. Yet if visual studies is to contribute to a university-wide conversation on visual literacy, it is necessary to question the web of familiar theories that currently entangles the field, and keeps it wrapped in the humanities.[7] Several essays in this book do that by moving into other fields. Stafford's essay is in this category, and so is Jonathan Crary's. His contribution may not seem perfectly on topic, because it is concerned with several episodes in nineteenth-century visuality, but it is exemplary of work that can move outside the twentieth-century sources that continue to concern visual studies. (Note his resistance to one of the questions from the audience, which tried to pry him away from his subject.)

Two other essays, however, are included here principally to show how much visual studies can offer to the university outside the fine arts. Richard Sherwin's contribution is a signal example of work on visuality between visual studies, art history, film studies, and law. The coincidence of law and criticism has been a concern in humanist scholarship since Stanley Fish's work in the 1980s; but it is only recently that lawyers have become aware of the need to be visually literate in order to win cases. Henrik Enquist's work, done in a hospital in Sweden, is aimed at giving patients the ability

to communicate more fully and effectively with their doctors. That is a common theme in patient care, but Enquist works entirely visually. When a doctor presents a patient with a partly incomprehensible picture of the inside of her body—an image fraught with pain and unhappiness—the patient is asked to respond, not with words, but with images of her own. There are some wonderful pictures here, especially the ones that resulted when Enquist gave patients disposable cameras and asked them to take photographs of the things that made them most happy. They are photos of things that, in other circumstances, might seem fairly bleak or ordinary: refrigerators, televisions, kitchens. But they are the beginnings of a visual dialogue with the intimidating machinery of professional medicine, and by extension with the equally intimidating machinery of visual studies.

4. *Pedagogy.* And finally, several essays are included in this book because they address pedagogic issues in a helpful, practical way. If you are a teacher or administrator, or you are planning an undergraduate program of visual studies, the essays by William Washabaugh and Susan Shifrin are designed to be useful resources. Washabaugh's essay surveys the philosophic bases of the visual studies approach to images (as in topic 1, above), and his essay ends with a list of North American visual studies initiatives, including URLs. Susan Shifrin's essay similarly ends with a survey of North American initiatives in secondary school visual education. Ideally, this kind of work should be made systematic, and expanded to include countries outside the United States. The only way to really understand how visuality can be taught is by comparing programs around the world, and Washabaugh's and Shifrin's essays in this book make a detailed and reliable start. The small amount of research I have done along those lines (in *Visual Studies*) was enough to reveal three, and possibly four, species of visual culture studies in different parts of the world. Each has its histories, which differ from the North American model. (The third book that will come out of the Cork conference, *Visual Cultures*, is a look at the *history* of ideas about visuality and literacy in different countries.)

So, this is a book on the slightly dubious expression *visual literacy*, intended to move visual studies out of its specialization in postgraduate education, and to nourish debate on the place of the visual in the university as a whole. My hope is that in a few years, universities will take up the challenge of providing a visual "core curriculum" for all students. Images are central to our lives, and it is time they became central in our universities.

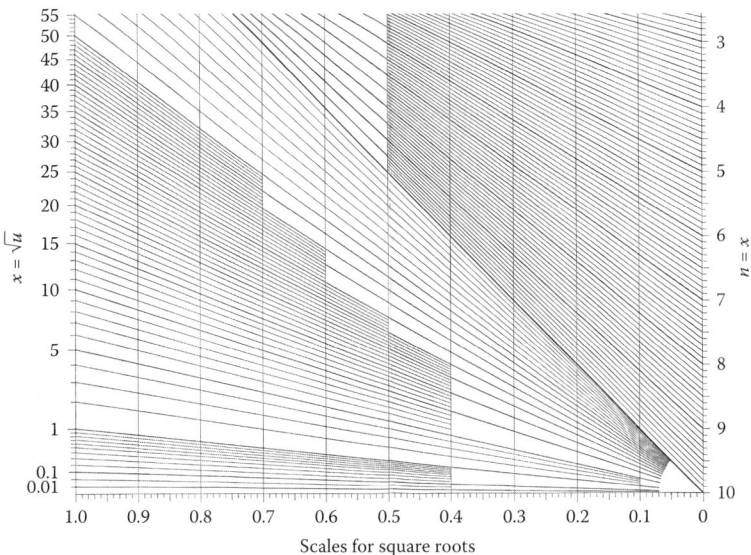

N.B. The primary scale, $x = \sqrt{u}$, has a modulus $m = 1$ in. To get a scale of any modulus, fold along the corresponding parallel to the primary scale; e. g., for $x = 0.63 \sqrt{u}$, fold along the parallel through 0.63. For method of construction, see Art. 3.

For engineers in the nineteenth and twentieth centuries—up to the advent of the pocket calculator—graphical calculation was a necessary skill. Graphs were devised for all sorts of calculations, from hydraulics to concrete manufacture. Recently the history of graphs and quantified images has found its way into visual studies via the histories of science and visual communications, but it is still a minority interest despite the ubiquity of such images. This is part of a graph for calculating square roots, from Joseph Lipka's *Graphical and Mechanical Computation* (1918).

Endnotes

1. I thank Julie Chase, conference coordinator at the Berkshire Conference, for sharing the session's white paper.
2. International Visual Literacy Association, www.ivla.org.
3. New Media Consortium, "NMC Series of Online Conferences," www.nmc.org/events/2005visual_literacy_conf/index.shtml.
4. Alan Fletcher, *The Art of Looking Sideways* (London: Phaidon, 2001). See, for example, Johanna Drucker, *Figuring the Word: Essays on Books, Writing, and Visual Poetics* (New York: Granary Books, 1998); and Bruce Mau, *Massive Change: Institute without Boundaries, 2003* (London: Phaidon, 2004).
5. Among many others, E. D. Hirsch, *A First Dictionary of Cultural Literacy: What Our Children Need to Know* (Boston: Houghton Mifflin, 1989).
6. This is explored at length in my *Stories of Art* (New York: Routledge, 2004).
7. The argument is developed in my *Visual Studies: A Skeptical Introduction* (New York: Routledge, 2003), 105–6, where I suggest (partly rhetorically, but partly seriously) sources such as Giambattista Vico or Jacob Burckhardt might be put in place of some of the more common points of reference.

CHAPTER 1
Visual Literacy or Literary Visualcy?

W. J. T. MITCHELL

Visual literacy has been around for some time as a fundamental notion in the study of art history, iconology, and visual culture. It is a strong and seemingly unavoidable metaphor, one that compares the acquisition of skills, competence, and expertise (quite distinct levels of mastery) to the mastery of language and literature. Seeing, it suggests, is something like reading. But how exactly? And how is seeing different from reading? What are the limits of this metaphor? Even more interesting, what would happen if we reversed the positions of tenor and vehicle in the metaphor, and treated reading as the "tenor"—the thing to be explained—and vision as the vehicle that might help explain it? What would happen, in other words, if we thought of our task as one of research and teaching in reading, based in models drawn from seeing and the visual system?

First, the limits of the metaphor. If seeing is like reading, it is so only at the most rudimentary and literal levels. Reading strikes us immediately as a much more difficult acquired skill. Normally, before one can even begin to learn to read a language, one must already have learned how to speak it. If the writing system is phonetic, one will have to have learned the alphabet that coordinates the spoken with the written word: in this sense, we might note, the skill of reading is already a visual skill, since it involves the recognition of the distinct letters of the alphabet, and the linking of them with appropriate sounds. If the writing system is not phonetic, but ideographic or pictographic, then the demands on the visual system are

sedulity [si'dju:liti] *n.* 勤勉,勤奋
sedulous ['sedjuləs] *a.* ①勤勉的；孜孜不倦的 ② 小心周到的: with ~ care 小心翼翼地 / ~ flattery 百般的奉承 / play the ~ ape (在文学创作方面)依样画葫芦 ‖**~ly** *ad.* / **~ness** *n.*
see[1] [si:] (saw [sɔ:], seen [si:n]) ❶ *vt.* ①看见,看到: He looked round but *saw* nobody. 他转过头去看了一下,但没有看见什么人。/ Can (或 Do) you ~ that light in the distance? 你看见那远处的灯光吗? / ~ someone move (或 moving) about 看见有人走动 / ~ a guided missile launched 看见发射导弹的情景 / He was *seen* to leave (或 was *seen* leaving) the room. 有人看见他离开房间的。/ ~ the whole 看到全体 / I was surprised to ~ him so much changed. 我很惊讶地看到他大大的变样了。/ I *saw* at a glance that 我一眼就看到…[注意: ~ 主要指"看见", look (at) 主要指"看着", watch 主要指"注视"]
②察看,查看: Watch and ~ how others do it. 好好看着人家是怎么干这事的。/ *seen* fire 【军】目视射击 / Please ~ who's at the door. 请去看看谁在门口。/ Go and ~ if the tractor needs oil. 去看一下拖拉机是否要加油。/ Let me ~ your pass. 出示你的出入证(或通行证)。
③遇见;会见,约见;访问(尤指看医生、找律师等);接待: I *saw* her at the exhibition the other day. 前几天我在展览会上碰见她。/ I'm glad to ~ you. 我很高兴同你见面。/ *See* you again (或 later). 再见! 回头见! / *See* you. [美俚]再见! / I'm ~ing him this evening. 今天晚上我将会见他。/ be too ill to ~ anyone 病重得不能会见任何人 / When will you come and ~ us? 你什么时候来看望我们? / You'd better ~ a doctor. 你还是去看看医生吧。/ We ~ no visitors during study hours. (我们在)学习时间不会客。

More on the endless lexicon of visuality and vision. It is not just the dozens of root terms and their etymologies that determine the valences of visuality in different languages: it is also the thousands of compounds, expressions, and slang terms derived from them. Multicultural studies of visuality face this daunting task: to approximate translation by taking account of the matrix of uses that surround the fundamental terms. This is just the beginning of the entry for *see*, in *A New Chinese-English Dictionary* (1981).

even more profound. Chinese has over two thousand characters that must be memorized before one can begin to read, much less write.

Seeing, by contrast, seems like an easily and naturally acquired skill, at least at some basic level. I'm not talking about the highly developed competencies of, say, an Aboriginal hunter-gatherer in her environment, or the paleontologist scanning an excavation, or the connoisseur in front of a painting, or even the fairly rudimentary ability to see that a drawing is a perspectival projection in three dimensions, but the acquisition of a basic threshold of competence in the visual-spatial world: the abilities to distinguish objects from the space in which they are located, to track a moving object, and to distinguish foreground and background, figure and ground. These are skills that we share with most primates, and that are the fundamentals of what Bishop Berkeley called "visual language." He called this the "universal language of nature," to contrast it with the *spoken* and *written* "natural languages," which are, as we say, cultural constructions based in arbitrary, symbolic conventions. But he did insist on calling it a language because he recognized, correctly, that even though it is "universal" and "natural," it is not innate, not hard-wired into an organism, but must be learned. To use a computer analogy, the visual system is like a software application. It must be installed properly, and at the right time in the development of the mature "mechanism." If one is blind from birth, for instance, and then is given eyesight at age twenty or thirty, it is very unlikely that one will be able to use that eyesight to see anything. It will be too late to learn the "language of vision," perhaps in something like the same way (but much more radically) that it is difficult to acquire a new verbal language late in life. The installation procedure for the visual system, Berkeley notes, is similar to that of language acquisition in that it is what linguists would call *doubly articulated*: that is, it is not enough to have light impressions fall on the retina and stimulate the visual cortex. One must learn to use and understand the visual impressions by coordinating them with tactile impressions. Thus, normal seeing is, in a very real sense, a form of extended, highly flexible *touch*. There is no "pure" visuality, or, as Gombrich pointed out long ago, "[T]he innocent eye is blind." And *innocent* here means, quite precisely, *un*touched.

There would be much more to say on these matters, and I hope that so far everything I've said is quite uncontroversial, and in fact generally taken for granted. What I have described to this point is what Barbara Stafford has suggested we call "visual competence," a kind of baseline skill (like the ability to read) that is a necessary, but far from sufficient, condition for the more advanced and specialized skills we might want to call *visual literacy*—that is, connoisseurship: rich, highly cultivated, and

trained experiences and techniques of visual observation. What I want to propose now is the reversal of field in the concept of visual literacy that I suggested at the outset. To what extent, in other words, does *verbal* literacy involve, and perhaps depend on, some sort of visual competence or even visual literacy? Does one need to be able to see to understand a language? Obviously not. One has to possess visual competence in order to *read* a text (unless it is written in Braille), but hearing is perfectly adequate as a threshold for normal competence in a natural language.

Four Fundamental Concepts of Image Science[*]

When I published *Iconology* twenty years ago, I had no idea that it would be the first volume in what has turned out to be a trilogy (*Picture Theory* and *What Do Pictures Want?* in 1994 and 2005 would turn out to be the sequels). In the mid-1980s, notions such as "visual culture" and a "new art history" were nothing more than rumors. The concept of "word and image," much less an International Association for the Study of Word and Image (IAWIS), was hardly dreamed of. And the idea of "iconology" itself seemed at that time like an obsolete subdiscipline of art history, associated with the founding fathers of the early twentieth century, Aby Warburg, Alois Riegl, and Erwin Panofsky.

Now, of course, the terrain looks quite different. There are academic departments of visual studies and visual culture, and journals devoted to these subjects. The new art history (as inspired by semiotics, at any rate) is yesterday's news. The interdisciplinary study of verbal and visual media has become a central feature of modern humanistic study. And new forms of critical iconology, of *Bildwissenschaft* or "image science," have emerged across the fields of the humanities, social sciences, and even natural sciences.

Iconology played some part in these developments. Exactly what its influence has been would be difficult for me to assess. All I can do at this point is to look back at the ideas that it launched in relation to their further development in my own work. In the last twenty years of working through problems in visual culture, visual literacy, image science, and iconology, four basic ideas have continually asserted themselves. Some of these were already latent in *Iconology*, but were only named in later writings. I hope this preface will help readers obtain an overview of the consistent themes and problems that grew out of *Iconology*, and that have now become what I think of as "the four fundamental concepts of image science." I call them the *pictorial turn*, the *image-picture distinction*, the *metapicture*, and the *biopicture*.[1] Here, in very schematic form, are the basic outlines of these concepts.

[*] This second, independent, essay was delivered by the author, shortly after the first, at the 2005 conference in Ireland.

1. *The pictorial turn*: This phrase (first developed in *Picture Theory*) is sometimes compared with Gottfried Boehm's later notion of an "iconic turn," and with the emergence of visual studies and visual culture as academic disciplines; it is often misunderstood as merely a label for the rise of so-called visual media such as television, video, and cinema. There are several problems with this formulation of the matter. First, the very notion of purely visual media is radically incoherent, and the first lesson in any course in visual culture should be to dispel it. Media are always mixtures of sensory and semiotic elements, and all the so-called visual media are *mixed* or hybrid formations, combining sound and sight, text and image. Even vision itself is not purely optical, requiring for its operations a coordination of optical and tactile impressions. Second, the idea of a "turn" toward the pictorial is not confined to modernity, or to contemporary visual culture. It is a *trope* or figure of thought that reappears numerous times in the history of culture, usually at moments when some new technology of reproduction, or some set of images associated with new social, political, or aesthetic movements, has arrived on the scene. Thus, the invention of artificial perspective, the arrival of easel painting, and the invention of photography were all greeted as "pictorial turns," and were seen as either wonderful or threatening, often both at the same time. But one could also detect a version of the pictorial turn in the ancient world, when the Israelites "turn aside" from the law that Moses is bringing from Mt. Sinai and erect a golden calf as their idol. Third, the turn to idolatry is the most anxiety-provoking version of the pictorial turn, and is often grounded in the fear that masses of people are being led astray by a false image, whether it is an ideological concept or the figure of a charismatic leader. Fourth, as this example suggests, pictorial turns are often linked with anxiety about the "new dominance" of the image, as a threat to everything from the word of God to verbal literacy. Pictorial turns usually invoke some version of the distinction between words and images, the word associated with law, literacy, and the rule of elites, and the image associated with popular superstition, illiteracy, and licentiousness. The pictorial turn, then, is usually *from* words *to* images, and it is not unique to our time. This is not to say, however, that pictorial turns are all alike: each involves a specific picture that emerges in a particular historical situation.

Fifth, and finally, there is the meaning of the pictorial turn that is unique to our time, and is associated with developments in disciplinary knowledge and perhaps even philosophy itself, as a successor to what Richard Rorty called "the linguistic turn." Rorty argues that the evolution of Western philosophy has moved from a concern with things or objects, to ideas and concepts, and finally (in the twentieth century) to language. My suggestion has been that the image (not only visual images but verbal metaphors

as well) has emerged as a topic of special urgency in our time, not just in politics and mass culture (where it is a familiar issue) but also in the most general reflections on human psychology and social behavior, as well as in the structure of knowledge itself. The turn that Fredric Jameson describes from "philosophy" to something called "theory" in the human sciences is based, I think, in a recognition that philosophy is mediated not only by language but also by the entire range of representational practices, including images. For this reason, theories of imagery and of visual culture have taken on a much more general set of problems in recent decades, moving out from the specific concerns of art history to an "expanded field" that includes psychology and neuroscience, epistemology, ethics, aesthetics, and theories of media and politics, toward what can only be described as a new "metaphysics of the image." This development, like Rorty's linguistic turn, generates a whole new reading of philosophy itself, one that could be traced to such developments as Jacques Derrida's critique of logocentrism in favor of a *graphic* and *spatial* model of writing, or Gilles Deleuze's claim that philosophy has always been obsessed with the problem of the image, and thus has always been a form of iconology. Philosophy in the twentieth century has not just made a linguistic turn; "a picture held us captive," as Ludwig Wittgenstein put it, and philosophy has responded with a variety of ways of breaking out: semiotics, structuralism, deconstruction, systems theory, speech act theory, ordinary language philosophy, and now image science, or critical iconology.

 2. *The image-picture distinction*: If the pictorial turn is a word → image relation, the image-picture relation is a turn back toward objecthood. What is the difference between a picture and an image? I like to start from the vernacular, listening to the English language, in a distinction that is untranslatable into German: "you can hang a picture, but you can't hang an image." The picture is a material object, a thing you can burn or break. An image is what appears in a picture, and what survives its destruction—in memory, in narrative, and in copies and traces in other media. The golden calf may be smashed and melted down, but it lives on as an image in stories and innumerable depictions. The picture, then, is the image as it appears in a material support or a specific place. This includes the mental picture, which (as Hans Belting has noted) appears in a body, in memory or imagination. The image never appears except in some medium or other, but it is also what transcends media, what can be transferred from one medium to another. The golden calf appears first as sculpture, but it reappears as an object of description in a verbal narrative, and as an image in painting. It is what can be copied from the painting in another medium, in a photograph or a slide projection or a digital file.

The image, then, is a highly abstract and rather minimal entity that can be evoked with a single word. It is enough to name an image to bring it to mind—that is, to bring it into consciousness in a perceiving or remembering body. Panofsky's notion of the "motif" is relevant here, as the element in a picture that elicits cognition and especially *recognition*; the awareness that "this is that"; the perception of the nameable, identifiable object that appears as a virtual presence; and the paradoxical "absent presence" that is fundamental to all representational entities.

One need not be a Platonist about the concept of images, postulating a transcendental realm of archetypes where forms and ideas dwell, waiting to be incarnated in the material objects and shadows of sensory perception. Aristotle provides an equally solid starting point, in which the images would be something like the classes of pictures, the generic identifiers that link a number of specific entities together by family resemblance.

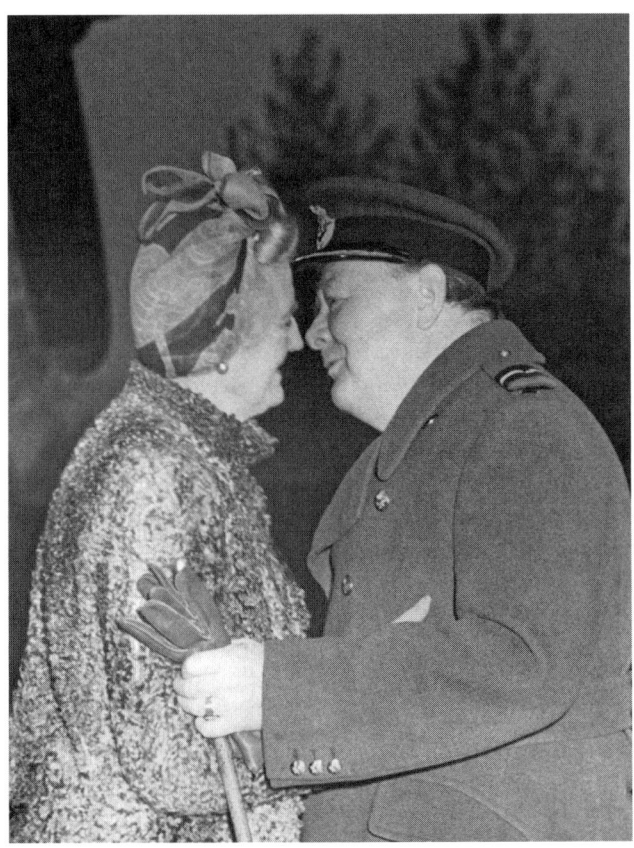

Winston and Clementine Churchill.

As Nelson Goodman would put it, there are many pictures of Winston Churchill, pictures that contain Churchill's image. We could call them *Churchill pictures*—a phrase that suggests membership in a class or series, in which case we might say that images are what allow us to identify the genre of a picture, sometimes very specifically (the Churchill picture) or quite generally (the portrait). There are also caricatures, pictures of (for instance) Winston Churchill as a bulldog. In this case, two images appear simultaneously and are fused in a single figure or form, a classic instance of visual metaphor. But all depiction is grounded in metaphor, in "seeing as." To see an inkblot as a landscape is to make an equation or transfer between two visual perceptions, just as surely as the proposition that "no man is an island" implies a comparison or analogy between the human body and a geographical figure.

An image, then, may be thought of as an immaterial entity, a ghostly, fantasmatic appearance that comes to light or comes to life (which may be the same thing) in a material support. But we need not postulate any metaphysical realm of immaterial entities. The casting of a shadow is the projection of an image, just as is the imprint of a leaf on a page, or the reflection of a tree in water, or the impression of a fossil in stone. The image is thus the perception of a relationship of likeness or resemblance or analogous form—what C. S. Peirce defined as the "iconic sign," a sign whose intrinsic sensuous qualities remind us of some other object. Abstract and ornamental forms are thus a kind of "degree zero" of the image, and are identifiable by very schematic descriptions such as arabesques or geometrical figures.

The relation between image and picture may be illustrated by the double meaning of the word *clone*, which refers both to the individual specimen of a living organism that is the duplicate of its parent or donor organism, and to the entire series of specimens to which it belongs. An image of the world's most famous clone, Dolly the sheep, can be duplicated as a graphic image in photographs, each of which will be a picture. But the image that is duplicated in all these pictures and that links them as a series is quite strictly analogous to the biological image that unites all the ancestors and descendants of the singular clone in a collective series that is also known as "the clone." When we say that a child is the "spitting image" of his parent, or that one twin is the image of her sibling, we are employing a similar logic in recognition of the family resemblance that constitutes the image as a relation rather than an entity or substance.

3. *Metapictures*: Sometimes we encounter a picture in which the image of another picture appears, a kind of "nesting" of one image inside another, as when Velázquez paints himself in the act of painting in *Las Meniñas*, or Saul Steinberg draws the figure of a man drawing in the New World.

In Nicolas Poussin's *Adoration of the Golden Calf*, we see the image of a desert landscape with the Israelites dancing around it, the high priest Aaron gesturing toward it, and Moses coming down from Mt. Sinai, about to break the tablets of the law in anger at this lapse into idolatry. This is a metapicture in which an image in one medium (painting) enframes an image in another (sculpture). It is also a metapicture of a "pictorial turn" from words to images, from the *written* law of the Ten Commandments (and especially the law against the making of graven images) toward the authority of an idol.

Metapictures are not especially rare things. They appear whenever an image appears inside another image, whenever a picture presents a scene of depiction or the appearance of an image, as when a painting appears on a wall in a movie, or a television set shows up as one of the props in a television show. The medium itself need not be doubled (e.g., paintings that represent paintings, or photographs that represent photographs): one medium may be nested inside another, as when the golden calf appears inside an oil painting, or a shadow is cast in a drawing.

There is also a sense in which any picture may become a metapicture, whenever it is employed as a device to reflect on the nature of pictures. The simplest line drawing, when reframed as an example in a discourse on images, becomes a metapicture. The humble multistable image of the Duck-Rabbit is perhaps the most famous metapicture in modern philosophy, appearing in Wittgenstein's *Philosophical Investigations* as an exemplar of "seeing as" and the doubleness of depiction as such. Plato's Allegory of the Cave is a highly elaborated philosophical metapicture, providing a model of the nature of knowledge as a complex assemblage of shadows, artifacts, illumination, and perceiving bodies. In *Iconology*, I referred to these kinds of verbal, discursive metaphors as "hypericons," or "theoretical pictures" that often emerge in philosophical texts as illustrative analogies (cf. the comparison of the mind to a wax tablet or a camera obscura) that give images a central role in models of the mind, perception, and memory. The "metapicture," then, might be thought of as a visually, imaginatively, or materially realized form of the hypericon.

As the Allegory of the Cave suggests, a metapicture may function as a foundational metaphor or analogy for an entire discourse. The metaphor of the "body politic," for instance, involves seeing or imaging the social collective as a single gigantic body, as in the figure on the frontispiece of Hobbes's *Leviathan*.[2] The familiar metaphor of the "head of state" quietly extends this analogy. This is a metaphor that reverses itself in modern biomedical discourse, in which the body is seen, not as a machine or organism, but as a social totality or "cellular state" riddled with parasites, invaders, and alien organisms; divisions of labor between executive, judicial, and

20 • W. J. T. Mitchell

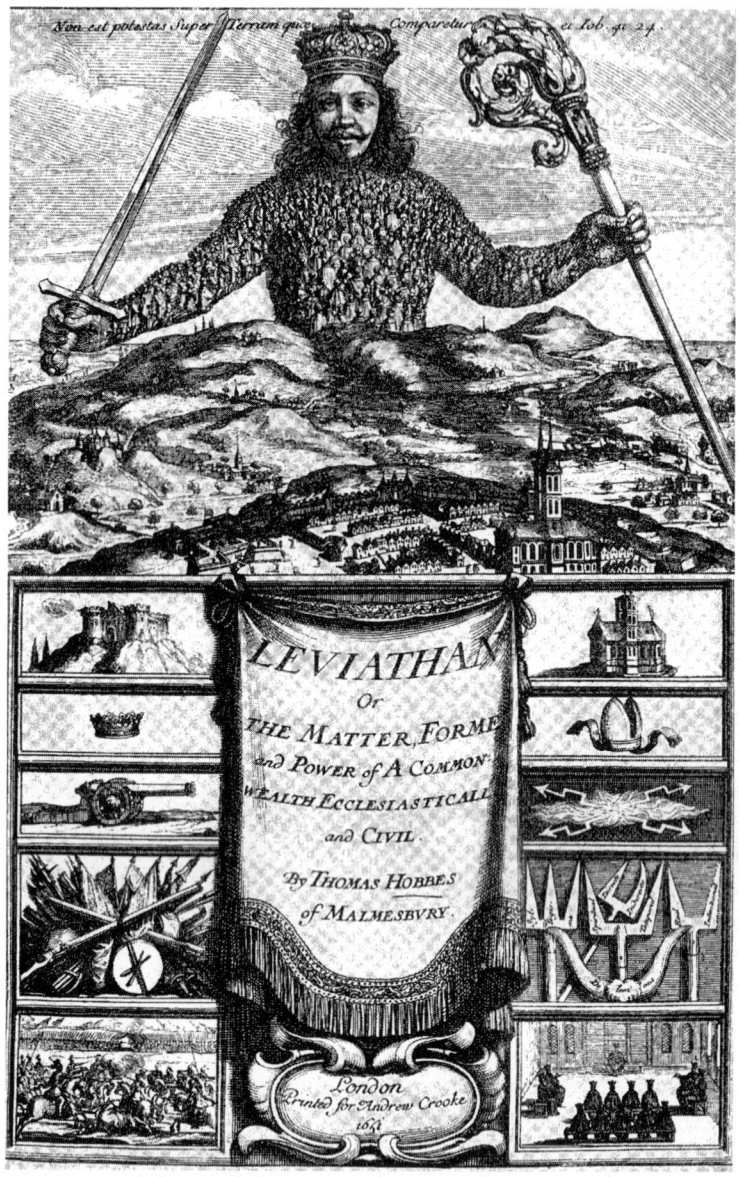

Thomas Hobbes, *Leviathan*. Frontispie Questions

deliberative functions; along with an immune system that defends the body against outsiders and a nervous system that communicates among its parts or "members." Is the metaphor of the "member" a mapping of the social body onto the organic body, or vice versa? What kind of body

is imaged in the figure of the corporation? These sorts of reversible and foundational metaphors are what George Lakoff and Mark Johnson call "metaphors we live by." They are not merely ornaments to discourse, but structuring analogies that inform entire epistemes.

4. *Biopictures:* A new version of the pictorial turn has taken place in our time, exemplified most vividly by the biological process of cloning, which has become a potent metaphor as well as a biological reality with profound ethical and political implications. Cloning is, of course, an entirely natural process in plants and simple animals, where it designates the process of asexual reproduction of genetically identical cells. The original meaning of *clone* (in Greek) was a "slip or twig," and it referred to the botanical process of grafting and transplanting. With the discovery of microorganisms and cell reproduction, the concept of cloning moved over to the animal kingdom as well. But in recent years, a revolution has occurred in biology with the (partial) decoding of the human genome and the cloning of the first mammal. The possibility of human reproductive cloning is now on the technical horizon, and this possibility has reawakened many of the traditional taboos on image making in its most potent and disturbing form, the creation of artificial life. The idea of duplicating life forms, and of creating living organisms "in our own image," has literalized a possibility that was foreshadowed in myth and legend, from the science fiction cyborg, to the robot, to the Frankenstein narrative, to the Golem, to the biblical creation story itself, in which Adam is formed "in the image and likeness of God" from red clay, and receives the breath of life.

Of course, there are numerous other ideas in *Iconology* that have been further elaborated over the twenty years since its publication. The idea of treating "word and image" as a distinct theoretical problem that requires not only a semiotic, formal analysis, but also a historical and ideological contextualizing, has been highly productive in a number of fields. The whole cluster of anxieties surrounding the image (iconophobia, iconoclasm, idolatry, fetishism, and the prohibition on graven images in Judaism, Christianity, and Islam) has become a central concern of image study in an age characterized by a "return of religion" that was scarcely glimpsed in the 1980s. And the critique of "ideology critique" itself as a "rhetoric of iconoclasm" has, I hope, chastened the ambitions of a demystifying criticism that invariably appeals to its own ideological infallibility. I have, by contrast, wished to ally myself with the more modest aims of "secular divination" and deconstruction that I associate with the examples of Edward Said and Jacques Derrida, the two critical theorists who have been to me the most inspiring contemporaries in what I still think of as the Golden Age of Theory.

Questions

Jon Simons: In thinking about visual literacy, you've gone over ideas you've written about before about visual images and the ideological stakes that are implicit in debates about them. In the past two days we have been talking about understanding the visual in larger contexts, in other environments, and in relation to other senses. In terms of the recurring trope of the pictorial turn, or the contest of words and images, I wonder if you are familiar with the work of Jacques Rancière, and in particular his notion of the "distribution of the sensible": the way that different uses of senses, and different aesthetic activities—say, reading or painting—are distributed politically among different social groups according to different aesthetic regimes or distributions.* I wonder if Rancière's approach might be a broader way of contextualizing the pictorial turn and its political implications.

Tom Mitchell: I don't know the specific text you're referring to; I know Rancière's work, but not the concept of the distribution of the sensible, which sounds to me very promising. If I understand the thrust of your question, and of Rancière's concept, it corresponds rather exactly to what I am arguing: you need to look at the social valence and distribution of semiotic modalities—not just words and images, but the whole panoply of *figures* of the distribution of the sensible. I would include, among such figures of sensory distribution, Foucault's notion of the seeable and the sayable as strata in discourse and representation; Lacan's idea of the scopic and the vocative (the drive to see and to show, which includes the drive to touch, as distinct from the drive to hear and speak—what Saussure called "the phonation circuit"); and of course Peirce's distinction between the iconic and the symbolic, bridged by the indexical (the symbolic being the legisign, the sphere of law-governed signs). I was very interested in Richard Sherwin's account of how a pictorial turn is obviously occurring in courtrooms, and disseminating itself throughout the world. It is no accident that the law is what is written, and what is said. The courtroom in our time, and not just in our time, has been a place of spectacle, and we are encountering new forms of spectacle today.

* Jacques Rancière, *The Politics of Aesthetics*, trans. Gabriel Rockhill (London: Continuum, 2004).

So for me, the word and image problem gets most interesting when it ceases to be abstract, when it ceases to be merely semiotic or technical. The danger of such formulations is that they lead to reified distinctions. You end up saying, "Well, we know that words can be precise and logical, and pictures are emotional." But everyone knows that is bullshit! You have to keep testing the word and image problem against situations, and noticing reversals of the field and unpredictable upsurges from these semiotic relations.

Bill Washabaugh: Earlier, you referred to Pope Gregory's dictum; your purpose seems to have been to question the pope's willingness to let words trump images. (Recently, Peter Burke also cited Pope Gregory's dictum, but for the opposite purpose, namely, to raise more doubts about the value of images.)* In any case, might there not be a problem in referring to Pope Gregory's dictum because of conflicting conceptions of *word*? The problem that I see is that *we* might be inclined to interpret Pope Gregory's notion of *word* in a modern Lockean sense, according to which each "word" has a specific denotation, and functions like an authoritative form of knowledge.† But the concept of "the word" that was conventional from Gregory's time to the Renaissance was an Augustinian notion, according to which "words" operate, along with objects and events, to form analogies that, at best, provide spare hints about the inscrutable Logos spoken by God.‡ As an illustration of this analogical understanding of "words," let me offer a fourteenth-century illumination showing John the Evangelist literally eating the Book (it's the frontispiece for Gellrich's book).§ This illumination draws together signs through which the faithful might track connections between "Word made flesh" (John 1:14), "Unless you eat my flesh and drink my blood …" (John 6:53), and "This is my body," words of consecration spoken over bread that is then

* Peter Burke, *Eyewitnessing: The Uses of Images as Historical Evidence* (Ithaca, N.Y.: Cornell University Press, 2001), 47–48.
† Richard and Bauman and Charles L. Briggs, *Voices of Modernity: Language Ideologies and the Politics of Inequality* (New York: Cambridge University Press, 2003), 31.
‡ Marcia Colish, *The Mirror of Language* (New Haven, Conn.: Yale University Press, 1968); Jesse Gellrich, *The Idea of the Book in the Middle Ages* (Ithaca, N.Y.: Cornell University Press, 1985); and Eugene Vance, *Marvelous Signals: Poetics and Sign Theory in the Middle Ages* (Lincoln: University of Nebraska, 1986).
§ Gellrich, *The Idea of the Book*, frontispiece.

eaten during the Eucharist. "Words," for the illuminator, were not seen as building blocks through which speakers might themselves assemble whole meanings, but as threads in already woven tapestries that speakers draw on warily, being only dimly cognizant of the rich connections such words embody. With Locke, the tide turned against such analogical thinking, and "language was powerfully reimagined as a question of individual words spoken by individual speakers."*

TM: Yes, I would be very concerned about that. I would want to try to figure out as specifically as possible what is at stake there, how the word-image dichotomy is being mobilized, and for what purpose. You're right, the word means something different in the period 500 to 1500. For Gregory, the word was above all that of *scripture*, and the important thing was to maintain control over the interpretation of images, to make sure the responses and readings of the laity remained doctrinally sound, and to head off misreadings that might lead into idolatry or unorthodox fables and superstitions. There are some aspects of Gregory's notion of the word-image relation that carry over into modern semiotics. For example, Peirce's distinction between the symbol and the icon as the difference between the *legisign*, the sign that obeys a law or rule, and the *qualisign*, the sign that is simply an instantiation of its own qualities, a "firstness" that is very close to raw perception. The icon is thus an extraordinarily open and indeterminate sign, and in some ways Peirce never felt he had gotten hold of it, and perhaps he didn't want to get hold of it, but to leave it open as the productive, generative sign-function that is (in Nelson Goodman's terms) replete, dense, and saturated with excess meaning. This may be why the image generally plays the role of the transgressive sign, the one that has a surplus of meaning, that resists encoding, that is dangerous to the rule of law. I would further associate this transgressive character of the image with the foundational character of the second commandment (the prohibition on graven images) as the principal legal injunction that distinguishes the three religions of the book (Judaism, Christianity, Islam).

* Bauman and Briggs, *Voices of Modernity*, 38.

But, as you rightly point out, it isn't that words and images exist in separate compartments, or that they only interact as antagonists. One of the key things about language is that images come bubbling up inside of it. We recognize this in our ordinary metalanguage, when we talk about a "language of images" in referring to metaphors, concrete words, analogies, or words that become so resonant that they take on an emotional valence that exceeds any denotation they might have. So it isn't that words and images are opposed, and Peirce made this point as well: the icon surfaces in language itself. This is why we may want to eat a book, or at the very least kiss it—a kind of symbolic gesture of eating and incorporating that is common practice with Christian icons.

Ding Ning: I know you are perhaps the first scholar to describe the concept of the "pictorial turn." Today, you talked about visual literacy, and its importance. I just wonder if people in the distant future may look at us and say, "Ah, that stupid generation, looking at rubbish—movies, television series, digital images." Might it be possible that in future there may be a *textual turn*: people may go back to reading books, so to speak—they might realize the importance of verbal literacy?

TM: That's a great question, and I think you can already see why. I'm sure that the future will look back on us and regard us as hopelessly naïve and very poorly informed. But I also would not be surprised if people will look back on ours as a kind of golden era of discovery, and new awareness of images, media, and visual culture. Just imagine them saying, "What happened? There was a great era from 1990 to 2010 when suddenly people started looking beyond just the visual arts, and they opened up the entire field of visual culture and visual literacy, and revolutionized pedagogy and the teaching of art."

I've had both these feelings. I do an exercise in my Visual Culture classes called "showing seeing." It's based on the old show-and-tell exercise from American elementary education. The students have to come in and show what seeing, what the visual process is in some concrete way. I ask them to role-play as anthropologists who are reporting on seeing, display, depiction, spectacle, and other visual practices as if they were strange, exotic activities that needed to be explained from the ground up. The point is to defamiliarize vision, which is difficult to do

because it strikes us as transparent, self-evident, and natural, when in fact it is filled with peculiar ritual behaviors (from the etiquette of staring and eye contact, to exhibitionism, voyeurism, and other forms of visual play that involve blind spots and games of "Now you see it, now you don't"). When you see these exercises (which quickly become a kind of performance art in their own right), it strikes you that something new is happening with vision, a new kind of self-consciousness, criticality, and sophistication about what it is to see the world and especially to see other people and be seen by them. The future, I imagine, will have mixed feelings about these early pedagogical gestures: they will see them as incredibly naïve and innocent, but at the same time I think they will understand that something new was coming into the world, and we, our generation—yours and mine—were there to bring it about.

Dominic Marner: I am a medieval historian, and I was taken by the discussion of the medieval view of things, and the eating of books. Two footnotes: first, the place of sight is very important in the Middle Ages and the early medieval period; this has been written about extensively. One example is that in the early Christian church, just prior to the moment when the host is being elevated and the words "This is the body of Christ" are spoken, the catechumens are moved out of the way so that they cannot see the event. They can hear it, but not see it, because sight is the important aspect. The second footnote: in the Book of Kells, you have one of the best examples of words that are actually images. There's a compelling argument to be made that the words in such manuscripts are meant to be seen and not read—that is part of their importance.

TM: Thank you for both those comments. In many ways, I think it makes sense to think of our time in relation to medieval attitudes to vision. Television has made the miraculous ritual, the communion, the elevation of the host, and the Eucharist available to millions of people in real time. Derrida has written very well about tele-technology and its conjunction with religion.* We have just seen the most spectacular funeral, of Pope John Paul II. We have also seen the most spectacular proliferation of the image of a woman in a vegetative state—a woman who

* See Jacques Derrida and Bernard Stiegler, *Echographies of Television* (Cambridge: Polity Press, 2002).

has not been allowed to die for fifteen years, her face painted, staged so that she looks as if she is responsive.*

The way I would distinguish the two periods, in this respect, would be to say that now we have a technology that produces what I want to call *bio-pictures*—pictures that have some kind of property of liveliness that is not just their verisimilitude, their lifelikeness, but also their metastatic quality, the way they circulate. In the medieval ritual, only the faithful gathered in the particular place could see the miraculous event in real time. Now, when you think of the way Pope John Paul II mastered television, miraculous events are transmitted worldwide. This is another aspect of the pictorial turn, and it is another reason why religion has made such a stunning comeback: it can take the miraculous moment, and transmit it through a technical medium that seems not to compromise its sacredness at all, but rather to amplify it. If you watched the mourners in Rome at John Paul II's funeral, there was undiminished piety.

Lilly Koltun: Could you comment on a different way in which word and image seem to be converging, and what that might mean for society becoming visually literate? Google is in the process of scanning millions of books in the libraries at Michigan University, Harvard, Stanford, the New York Public Library, and the Bodleian in Oxford, and turning them into images, which would then be available on the Internet. (And the French have begun a parallel project, and invited Québec to join them.) There has been an enormous growth in the urge to document: that's why we have amateur videos, for example of 9/11—things we can use to call government to account. Or, to take a third example, there is an enormous growth in the desire for genealogies—using technologies that also involve words and images. What do you think this might mean for the people whom Microsoft is anticipating as wanting or needing the new technology?

TM: I think again of the example of the Book of Kells, where the word is made into an image, and in so doing it gains an aura, a sacred presence, that it would not have if it were, say, in New York Times 12-point type. In regard to the scanning and archiving you're talking about, you'd have to ask about the quality of images. I saw the very expensive facsimile you

* See, for example, "Terry Schiavo," http://en.wikipedia.org/wiki/Terri_Schiavo.

have of the Book of Kells; and I am reminded of the *Très riches heures of du Duc de Berry*, which is now only shown to heads of state.*

JE: Herb Kessler has a great story about seeing the original: he describes footprints in the snow that have never been reproduced.

TM: Reproductions divide in at least two directions. One is the archiving of unique originals, and attempting somehow with higher and higher resolution reproduction to retain aura, or at least to give some semblance of it. The other is simply archiving information—texts for reading—and in that case, texts will be searchable. (I doubt anyone will produce a search program for the Book of Kells in its facsimile version!) As a general matter, then, I think "convergences" of word and image are not unique to our time. I see the dialectic between word and image as an unsurpassable fissure or fold in the fabric of representation, but one which is always "widening" or being "overcome" in the practical use of signs and symbols at any time. So words and images have always "converged" in the phenomenology of *writing* as a visible, graphic notational scheme that unites eye and ear, symbolic and iconic and indexical elements. The question is, what kind of convergence, under what conditions, for what purposes? Simply to declare that our time is one in which words and images are converging is only the opening move: I would also want to ask, *how* are they converging? From what previous position of separation? And, equally important, how are they *diverging*? Why, for instance, is something called "the visual" so often regarded as inimical to verbal literacy in our time?

Sinéad Furlong: Do you think there is a way in which we can move away from canonical readings, and introduce into the classroom a different concept of art history? Do you think we can move forward in that way, or do you think that the nature of teaching (examinations, modules, and so forth) will prevent that kind of progress?

TM: Visual studies has meant, among other things, and to paraphrase Rosalind Krauss, a view of art history in an expanded field. As such, it does not betray any of the earlier versions

* For a digital facsimile of the *Très riches heures* in Chantilly, see "Les Très Riches Heures du Duc de Berry," www.christusrex.org/www2/berry/. The Book of Kells facsimile is *Evangeliorum quattuor Codex Cenannensis...* (New York: Urs Graf, 1950–1951). See Michael Camille, "The Très Riches Heures: An Illuminated Manuscript in the Age of Mechanical Reproduction," *Critical Inquiry* 17, no. 1 (Autumn 1990): 72–107.

of art history. Alois Riegl and Aby Warburg had it in mind, in a sense, and so did Panofsky. In saying this, I don't mean at all to diminish the importance of the enclave or preserve of the aesthetic, of visual art. But it seems to me art history works best when it isn't just art history: when it spends a lot of its time thinking about where the boundary might be drawn that constitutes what we consider fine art. In part, the history of art actually is this activity of asking, where is the artistic image? What is the image in the expanded field beyond the artistic? How do images circulate across the borders between art, commerce, science, politics, and various "intimate public spheres" of privacy and subjectivity? In that sense, visual culture can deliver what was promised, but not quite delivered, by art history. In many ways, the scanning and searching technologies you describe are essential to the revolution we are experiencing in the study of visual images, but I think we also have to acknowledge that there was a long process of preparing for this revolution that reaches back into the nineteenth century and before, including the invention of reproductive engraving, of high-speed lithography, and of still photography that made it possible for Aby Warburg to conceive of an "atlas of images." Now we have not only these kinds of archives growing exponentially, but storage and retrieval technologies for the entire range of print and audiovisual media. My students at the University of Chicago are currently working on a project called the "Media HyperAtlas," which is an attempt not just to map the varieties of images, but to produce a taxonomy of the types of media in which images appear.*

* To see some of their activities, go to the Chicago School of Media Theory, www.chicagoschoolmediatheory.net/home.htm.

CHAPTER 2

The Remaining 10 Percent
The Role of Sensory Knowledge in the Age of the Self-Organizing Brain

BARBARA MARIA STAFFORD

> All longing converges on this mystery: revelation, unraveling secret spaces, the suggestion that the world's valence lies just behind a scrambled facade, where only the limits of ingenuity stand between him and sunken gardens. Cryptography alone slips beneath the cheat of surface.
>
> —Richard Powers, *The Goldbug Variations*[1]

> What thing or person inside us dreams what we dream, and then he wondered, are dreams perhaps the soul's memories of the body, and this seemed a reasonable explanation.
>
> —Jose Saramago, *The Gospel According to Jesus Christ*[2]

In this essay, I want to propose a counterexample to the usual art and science dialectic, one that is not resolved by the absorption of the second term by the first. Instead, the aim of this inquiry resembles the combinatorial alternative evoked in Nobel Prize–winning chemist Roald Hoffmann's poem: "like / the dislocation under a / tunneling microscope, order /well-disposed to each side," the action lies at the interface.[3]

Let me be clear: the task is not about making art do science, or vice versa.[4] Rather, interaction happens at the defining "edge." My hope is that

isolated research in both domains on what, from a new media perspective, might be called the "hypertext"[5] remixing, or, from a neurological perspective, the automatic resorting, of our sensory experience in the construction of a private self will lead to a new understanding of human interiority. This research is now uneasily caught between self-absorbed "maelstrom" and parallel "coexistence," not yet lifted into a Peircean "thirdness" of dense intermedial experience.

Specifically, I am interested in demonstrating how the developing sciences of the mind are exerting pressure on and, indeed, turning upside down some of the traditional assumptions by which art historians and other "imagists" have explained such fundamental activities as consciousness, inference, and emotion. Conversely, I argue that certain "general" morphological structures of aesthetic experience, namely, the fact that much higher thinking can be done without language,[6] are evident in the way that perception, physiology, and thought are inextricably mixed. Further, I analyze how seeing, feeling, and imagining are increasingly becoming associated with purely internal events of the mind. Much of this new interiority takes for granted the largely automatic ways by which we rearrange and categorize stimuli coming from the external world.[7]

Visual literacy is a temporal construct, rising or falling with the cultural and scientific assumptions and values of a given period. Currently, in the humanities, however, it rests on implicit views of perceptual processes and of the perceiving mind that are far from up-to-date and that, surprisingly, remain anachronistically Lockean. Witness the failure to take up the challenge posed by "mental representation" in lieu of an outmoded "representation." We now know that it is totally erroneous to believe that an image of the world is passively "impressed" on the retina and transferred to be "received" by a "seeing" cortex, there to be decoded and analyzed.[8] Vision, as many artists past and present have intuited and shown in their works, is a dynamic process in which the brain, largely automatically, filters, discards, and selects information, and compares it to an individual's stored record.

Our thoughts, so the argument runs, tend not to be focused outward because the brain-mind is mostly an autopoietic self-organizing system.[9] Even higher-level consciousness is borne aloft on an ocean of "automatic life regulators"[10] (the recent estimate is 90 percent)—much like digestion or the secretion of bile. To be sure, the activity of the cognitive system has to be understood as shaped by the coevolving environment. But the brain as a set of self-sustaining and self-reflexive functions performs largely unconsciously and autonomously, even when it adapts to changing surroundings.

On the other hand, we are being told by many neurobiologists and cognitive scientists that, like our organism, we live in a brain-saturated world. But what does this mean? Today, then, there is an odd tension between understanding the brain as an automatic machine questing "for essentials,"[11] in Semir Zeki's words, and understanding it as a phenomenologically distributed system that learns multiple ways of inhabiting the world *in relation* to our bodies, other people, diverse organisms, and the ecology—an experiential or developmental hypothesis reminiscent of Maurice Merleau-Ponty.[12]

My focus, in this essay, primarily concerns the first side of the equation: the ruling metaphor of automatic knowledge in neurology and, with it, the asynchronous paradigm of perception as chiefly autopoetic. I am not disputing this fact. I am asking, what are the macroconsequences of putting attention almost wholly in the service of microcircuits, cerebral localization, processing-perceptual systems, and other inbuilt constancies?

Both positions are hardly new. Already in the eighteenth century, matter appeared sufficient to generate the mind. Julien La Mettrie argued for the existence of a bodily "machine" and the sensitive soul as its driving empirical force.[13] On the other hand, the cult of an animating sensibility, as well as Spinozistic pantheism, leveled contrary modes of experience by physically interfusing them.

Today, however, a more extreme materialism has triumphed in some quarters claiming that all mental life springs from neuronal processes in the brain, most of them automatic. Daniel Dennett, for one, posits the self as spun from a webwork of internal operations.[14] Others, like Andy Clark, argue against such solipsism and for an active externalism. Thought itself is made materially possible by organic resources in the outside world while the environment tangibly crisscrosses with our intelligence.[15] Yet even in Clark's dispersed neurophenomenology, the implicit argument is that the world and all things in it are connected and sustained by processes of their own making.

Three intertwined notions emerging from the revolutionary findings of the modern neurobiologic sciences have, I believe, fundamental implications for visual-sensory education. Significantly, these constructs represent reversals of powerful earlier epistemological models. They are, first, that cognition does *not* function like seeing—a venerable analogy spanning from Plato to John Locke. It is ironic that while ongoing experiments in adaptive optics now make it possible to see microscopic features in the living eye—witness the fantastic imaging of the retina and its individual cones seen with the aid of an ophthalmoscope—vision is simultaneously being downplayed as the "first sense" for knowing the world. This paradox variously infuses the approaches now dominant in the science of

mind: the computationalist-symbolic, the connectionist-dynamic, and the embodied-enactive. The latter hypothesis is of particular interest (for example in the work of Bernard Baers, David Lewis-Williams, Thomas Metzinger, and Francisco Varela) to my argument, and I will return to it throughout.

The second issue undergirds the first. One of the chief ways in which neurobiologists and cognitive scientists are bridging the disciplinary gulf between the sciences and humanities is by demonstrating that human perception transcends the strictly given. While this is no news to humanists, such a finding nonetheless brings greater precision to the study of all those symbolical systems (from semiotic physiognomics to Romantic grammars of expression)[16] attempting to divine, and then correlate, a basic formal idiom with the infinite blur of morphological situations. As an instance of dynamic apprehension, this inferencing activity is further "dilated" by the concrete sights of our surroundings.[17] But the extensional impulse to select what the brain detects is done in accordance with its own self-organizing structure. Consciousness as co-apperception is thus fluidly part of the ordinary physical world *and*, at the same time, highly reliant on the laws of its own neurobiological substrate.[18]

Moreover, as we know from brain lateralization studies, it is not just our global functional states that are skewed in the inbound direction. Humans have brains that are asymmetric, just as our hands, hearts, livers, kidneys, and amino acids are asymmetric.[19] Language-related processes have long been lateralized in the left hemisphere, and the more holistic spatial and perceptual functions have been assigned to the right hemisphere. Yet this neat division of labor has been shown (especially through research on brain lesions) to be something of a cognitive illusion. Both left and right hemispheres work together to create a single individual. Actually, one side often automatically fills in for damaged functions belonging to its mirror opposite with the help of the corpus callosum—the large bundle of fibers by which they communicate and cooperate. The mind, therefore, is not a blank slate. Even before we begin to reason, it is weighted with a diverse repertoire of somatic images carrying with them a load of affective valences that color any occasioning impinging object.

A driving question, then, is, how do we instruct the remaining nonautopoietic 10 percent of the self actively fashioned by, and open to, sensory input coming from the environment? Since so many basic systems are encoded invisibly and unconsciously in the body, and face permanently inward, what makes us direct our attention outward at all, patiently opening our eyes to the manifold appearances unfurling before them? This compression of the role of vision, third, concomitantly dilates perception. Perceptual acts are not directed to some new object, but to the same delimited "thingly

environment" congruent with our framing cognitive architecture. Changing perspectives and sudden shifts in aspect—apprehended dynamically through kinesthetic and tactile sensations—disclose the more persistent workings of the brain. By departing from the habitual or the expected, they reveal what regular stimuli our brain-mind is in a state of receptive readiness for and generally oriented toward.

Kinesis is central to the aesthetic experience. It is also a central factor in vision. The primacy of movement to seeing, which has received new validation in studies of the bioelectrical activity of cortical neurons,[20] demonstrates that all perception is necessarily associated with a motor function. Very different studies on neuroplasticity—with their amazing findings that deadlocked adult human brains are capable of functional reorganization—show the importance not only of sensory-input increase to the circuit-reactivating process, but of repeated movements as well.[21]

In light of the phenomenological ability of motor experience optically, performatively, and even viscerally to dissolve the gap between subject and object, should we be thinking perhaps of *situational studies* rather than of visual or media studies (dominated by the continuity-editing conventions of film as opposed to video layering or televisual juxtapositive technologies)?[22] This binding dynamic—going beyond cinematographic flow—would take into account the fact that the motor-sensory organs are both altered and extended during their spatio-temporal convergence into a constantly adjusting hybrid self. This practice is evident in recent immersive and phenomenologically inflected installations by Olafur Eliasson and Andy Godsworthy as well as in television's dense intertextual field.

In calling for a "situational" architecture, David Leatherbarrow and Mohsen Mostafavi urged an acceptance of "all materials that are available within the limits of a given social, economic, and cultural condition."[23] Expanding their interest in "skin," or "the claims of appearance," I want to include cognitive construction with its struggle to integrate and reconcile materials of different origins. The focus of investigation then falls on the associative processes, the ways in which phenomenal attributes activate connections in the viewer. Inquiry centers on the creative "push" producing the combinatorial "interface" or synthetic "edge" of a common territory, rather than on the specific instrument or display technology.

What Part Auto-Organization? What Part Autocontrol?

Self-assembly—the spontaneous organization of matter into coherent arrangements—is a compositional principle governing diverse materials. Nature is filled with patterns arising from automatic grouping. These range from the opalescent lining of an abalone shell, to the underlying

"granular" dynamics of physical systems, to the internal compartments of a crystal or living cell, to the waves of pinwheeling electrical activity occurring in ventricular fibrillations of the heart.[24] The modern theory of attractors (fractal attractors, strange attractors) embodies this notion of auto-organization as the tendency of any dynamical physical system to begin randomly but to become oriented more and more precisely to a certain pattern. Ilya Prigogine forecast the possibility of order emerging out of chaotic "dissipative structures."[25] Today, nature's atoms, molecules, and colloidal particles are being dramatically expanded. Reengineered, nanodesigned, or genetically altered organic structures not only offer novel features but also impart a precise level of control over their selective interactions.[26]

Synthetic biology's creation of building blocks that include programmable instructions for self-assembly, interestingly, comes at a time when the computational neurosciences view the brain as largely an autopoietic system running on predetermined instructions. Thus, challenges to the Whorfian hypothesis that language determines thought[27] support the neurobiological findings that when humans mimic behavior or acquire a language, they learn to express it in concepts already present in their prelinguistic systems. In other words, the necessary representational apparatus for these cognitive operations *preexists* our exposure to gestures and speech.

Although conflicting theories abound, this is only one example of how the sheer surge in findings coming from the neurosciences obliges us to reconsider the artificiality of the divide between biology and culture. Witness the enormous growth in interdisciplinary studies wedding new insights into the biological basis of thought to previously remote areas in the social sciences and humanities.[28] One could argue that the late twentieth-century "Decade of the Brain" project is caught up in a never-ending spiral. But its initial aspiration to study higher cortical functions in humans has now expanded globally.

Moving beyond the 1990s research focus on computer tomography (CT), positron-emission tomography (PET), and functional magnetic resonance imaging (fMRI) *localizing* brain-imaging technologies, the neurosciences of the twenty-first century also pursue something more elusive: the decentralized brain-in-the-body as well as its deanthropomorphized codependence on the shifting external environment and its miscellany of animals and plants, from bacteria to primates. There is even a metadiscipline of "synnoetics" described as "the cooperative interaction, or symbiosis, of people, mechanisms, plant or animal organisms, and automata into a system that results in a mental power (power of knowing, consciousness) greater than that of its individual components."[29]

Indeed, I wonder if symbiosis in biology (i.e., the mutual interaction involving an autonomic physical association between "differently named organisms")[30] might not have much to teach researchers examining tightly knit communities ranging from dynamically interacting neuronal populations to densely concentrated urban centers?[31] At the same time, the premium placed on investigating immediate interactivity—within a distributed system and at all levels of material and mental life—raises profound questions about the role of the will (*autocontrol* as opposed to *auto-organization*), historical distance,[32] as well as the importance of what lies beyond direct vision.

Perhaps most relevant to the issue of visual literacy, however, is the fact that consciousness apparently produces its own content, that is, the world. To be sure, the idea of a mental template is an ancient one. But contemporary neural Platonism is demonstrating that even our objects of perception, paradoxically, are not located in some external event. Our experience at any given moment of consciousness is produced by our autonomic nervous system interacting with the world. And the form of the resulting representation is more a construction of neural networks than it is a deliberate reflection or projection of that world.[33]

To note this widening of outlook in cognitive research is not to deny—as the brilliant parsing experiments of Semir Zeki and V. S. Ramachandran demonstrate—that the dissection of the receptive field continues unabated. Significantly, the preponderance of neurological investigations focusing on artistic evidence for how the brain works is used to demonstrate *auto-organization*, not autocontrol (willed actions). These two neuroscientists are particularly pertinent because they have made a range of works of art central to their studies of the modularity of vision. Like some phenomenologically inflected studies in cognitive science—trying to account for the fact that things have fleeting appearances—their findings underscore the near simultaneity of stimulus and response. The term *receptive field* derives from sensory physiology and refers to a specific part of the body which, when stimulated, produces an almost instantaneous reaction in a specific brain cell.

Zeki explores how the simple constants in our heterogeneous field of vision are picked up by many visual areas outside area V1 (important for form and orientation) of the visual cortex. These adjacent areas (V2, V3, V3a, V4 [important for color], and V5 [important for motion]) are specialized to process and perceive different attributes of the visual scene.[34] He is thus constructing a bottom-up modular model of vision by looking at discreteness—how brain cells are excited by very selective object properties—citing paintings ranging from Paul Cézanne to Albert Gleizes to René Magritte. These automatic processes constrain humans to pick out

and attend to the constancies present in their field of vision, screening out the noisy background. Additionally, his inquiry into constants leads to the top-down question of universals, or the "laws" of the brain—the anonymous and autonomous perceptual grouping and binding of features always going on below the surface and over which we have no control.

Ramachandran, in turn, is anatomizing the multiple ways in which the limbic system reinforces certain perceptual and cognitive constants of reality. Like Zeki, his focus is Janus-faced, intent on discovering correlations between human pattern recognition (using the exaggeratedly salient forms of caricature and the orientation-selective concealed shapes of anamorphoses) and the limbic system. Such ambiguous forms—belonging to two or more different categories or susceptible to several interpretations, depending on the viewer's perspective—have long been the staples of art.[35]

What is significant from both the artistic and the scientific standpoints is how such equivocal imagery elicits perceptual, cognitive, and even bodily *motion* (e.g., turn of the head, rotation of position, and shift in orientation) in the observer. When activated, the limbic system's nontopographic color and motion maps bind wavelengths coming from geographically separated features in our field of vision. This temporary conjunction of distant points elicits a pleasurable kinesthetic sensation: the "aha" of recognition.[36] Here, then, are the biological activities that underlie both the imaginative leaps of analogy as well as the similarity-searching aesthetics of mimesis.[37] The associative jump to connect resembling, not identical, formal features is enabled because of the deep neurophysiological correspondence between the phenomenal and noumenal systems. And this mental tendency is shared, affecting a private person as well as a community.

The ongoing search for universal absolutes of form, either corresponding to a basic neurological function of our visual system or emerging at a basic stimulus level (the "peak shift" effect), does not just retool twentieth-century "biogenetic structuralism."[38] Unwittingly, it also updates, while radically materializing, late eighteenth-century neurognostic theories and compressive compositional practices. Chief among them was the longing to reimagine the remote origins of art by abstracting simple or "primitive" building blocks (verticals, horizontals, diagonals) from the increasingly complex varieties of aesthetic production proliferating in the modern world. Hewing out compositional units—squares, circles, rectangles, and other basic geometrical figures—from the crowded and distracting flux of actuality tacitly acknowledged that cognition operates largely at the unconscious level. This strategic mode of inferencing further recognized that affect-laden "real symbols" simultaneously embody physical and mental events.

We should think of these early efforts at defining how humans simplify a problem domain as a type of niche construction whereby a cultural species produces environmental change and the environment, in turn, directs cognitive evolution. With the Romantics, then, we are witnessing the deliberate construction of a natural history of aesthetics.

Consequently, the perceived expressiveness of a cultural artifact belongs to the epistemic search for the underlying reason that is operating in reality. It is an attempt to explain the rise of order from nonorder. In a codependent two-way action, specific occurrences in the external world have been causally linked to the human organism over vast stretches of time and space. Human development occurs in relation to the autonomic system, the motor system, the state organizational system, the attention and interaction system, and the self-regulatory balancing system. But, as noted, all of these internal systems are in continuous interaction with the changing environment, and have been so throughout its evolution. What happens in the present is thus the complex result of the reactivation of the modification that the *analogous* historical event caused long ago on the physiological, sensory, emotional, and cognitive levels.

These Romantic quests to discover an unconditional "grammar of expression" were grounded in the now familiar hypothesis that expression is embedded within the basic compositional organization of nature as well as the basic structure of the mind. Then and now, constant optical properties like form, direction, and hue—clearly discernible in elementary geometric shapes, diagrammatic verticals and horizontals, and color primaries—were thought to comprise a body-based semiotic system connecting sensory with cognitive events. That we are routinely able to detect these primitives of experience beneath more complex appearances accounts for the frequent sensation of a generic familiarity glinting below the noisy montage of daily images. No wonder these primes were thought to compose the quintessential characters of visual art from oracle bones to hieroglyphics. That is, these rudimentary characters stood out, sharply salient in art's archaic phases, both historically and cognitively speaking.[39]

An additional important point to emphasize for humanists—following John Searle's lead—is that individual or first-person perspective is not reductively identical to an objective description of the underlying neuronal processes. Feelings are a prime example of organic intensity that exceeds mere physiochemical processes. Antonio Damasio has argued that while these perceptions of arousal occurring in the brain's body map refer to parts of the body and states of the body, they are also integrally cognitive, or *ideas*, about the body. Consequently, he distinguishes feelings from the truly primal emotions, those evolved subcortical action networks encoded within an ancient nervous system.[40]

Reminiscent of Romantic theories, Damasio argues that external objects have a positive or negative value for us because they are inextricably bound to particular body states and the feelings of pleasure or pain we experience as expressive of those body states. What distinguishes Romantic investigations into the operations of perception and recollection from those of today, however, is that they did not stop with an analysis of the immediate phenomenal response. I have argued elsewhere that the Romantic generation was the first to formulate a cognitive image history wedding ethics, aesthetics, and metaphysics with cosmic history. The epistemological question of how we come to be aware of our awareness was contextualized within an unfurling evolution of human thought.

While recent microstudies of seeing and knowing, such as those by Zeki and Ramachandran, are illuminating, their narrow-bore focus on automatic and autonomic systems invites challenges. How do we account for functions that either are not easily compartmentalized or are evasively inaccessible? On one hand, a more holistic view of visual processing is emerging, connecting emotional centers such as the amygdala to motor areas in the brain.[41] Like earlier Romantic artists (William Blake, Henry Fuseli, and Humbert de Superville), this new research investigates fear, joy, or emotional neutrality, not just as centered on the face, but also as suffusing the gesture and action representation of the entire body as mind incarnate. This expansive view helps us understand the enduring importance of ritual or performance, and invites a reconsideration of the neurocognitive foundations of human symbolic activity.

Studying mental representations—those fast-moving electrical storms that internally represent the shifting outer milieu—also reveals a profound connection between motion and emotion. As many art styles intuitively exhibit—from Dutch seventeenth-century trompe l'oeil illusionism (depending for its effect on the snap switch or mental jump of recognition), to the Italian Futurists (exploring the dynamics of co-collaborating subjects and objects as a distinguishing experience of twentieth-century urban life), to the immersive installations of California Light and Color artists like James Turrell or Robert Irwin (embedding the perceiver in transitory phenomena such as veils, sky spaces, and misty *Ganzfelder* where porous self meets dissolving world),[42] thinking arises from motor movement. And motion (as directionality and repetition) is essential to the very concept of an auto-organizing self.[43]

In the era of virtual reality (VR) caves, "cocooning," the domestic workplace, homeschooling, political isolationism, and the inner sanctum of the Web, it is hardly surprising that autopoiesis would become the ruling model for mental operations. For better or worse, information technology, or the paradigm of efficient, largely imperceptible, but, above all, automated

information transfer, is invisibly threaded through the metaphors of brain self-organization. This simultaneously hyperpersonal impersonality of thought is captured in research into neuron-to-neuron communication and oscillatory switching demonstrating how the brain is able to organize itself functionally and architectonically during development.

While a brain-wide distributed network orchestrates the perception and memory of facts and events, this system-wide functional feature also creates configurational associations between the experiencing subject and external stimuli. This codependence derives, in part, from evidence that sensory cues get selectively represented in multiple cortical areas according to their varying impact on preexisting brain functions. Since neurons must be capable of rapid, predictive reorganization of focus depending on myriad cues incoming from the environment, we are—usually without realizing it—creatures composed of many independent consciousnesses.

The vexing question of cognitive binding specifically asks, just how do these vibrating, network-wide voltage ripples get coordinated into a coherent whole? The fact of their mysterious collaboration in the internalization of the phenomenal world—reaching together beyond the body's surface—while embedded inside a closed internal functional space remains the central riddle.[44] This "symbolic shareability"[45] of material thought in motion is again predicated on auto-organization: the monist idea that something is capable of producing a certain type of behavior by itself because its components belong to a single state of the material world.

Such autonomy, stemming from two different traditions—cybernetics and thermodynamics—proposes that material entities are autoconstitutive, generating themselves as continuous processes.[46] The problem with these origins in circuits and other nonliving systems as opposed to living organisms and evolving processes, however, is that they can lead to reductionism, that is, the ill-fated attempt to seek explanations only at the simplest levels of organization.[47] These twin roots are troublingly evident, for example, in the supposedly synthetic approach of neuroeconomics—intent on creating "consilience" between economics, psychology, and neuroscience.[48]

This global attempt to describe all human choice and decision making as a combination of logical consistency, the pinpointing of specific brain components contributing to cooperation (anterior paracingulate cortex) or risk aversion (ventromedial prefrontal cortex), and elementary neural circuitry as accounting for the simplest measurable elements of behavior smacks of an impersonal, global automatism deriving simultaneously from information theory as well as a mechanistically conceived utility. It is also apparent in the science-fiction scenario of "direct-to-mind" learning, or "direct education," which circumvents the confines of four walls and

a classroom. Using Wi-Fi or Wi-Max, high-tech devices supposedly will access information from an advanced World Wide Web "as information flows directly from wireless networks into students' consciousness."[49]

A Field Guide to Situational Studies

My larger point throughout this essay has been that the growing evidence for sensory-input independence, supported by the importance of automatic processes in cognitive activity, places special pressure on what I have been calling the remaining empirical 10 percent. One could argue that Giambattista Vico, in his *Principles of a New Science* (1734),[50] already proposed that the human mind gives shape to the world and that the world, in turn, is in the shape of the human mind. Yet his mythopoetic system—focused on the historical origins of public communication and rearticulated by the Romantics—offers a telling contrast to today's solipsistic neural structuralism obsessed by everything from autism to sensory deprivation.

This obsession with the mostly world-independent "language of thought"[51] characterizes a spate of hybrid fields: cognitive anthropology, cognitive linguistics, cognitive memory studies, neuroaesthetics, neuroeconomics, and neuroethology. As Vico realized early on, this universal mentalese also fabricates an imaginative space of enlightenment in which to conceive of alternative realities. From deep within this cognizing, material cavern—at least since the Upper Paleolithic era (c. 45,000–10,000 B.C.E.)—humans have projected shadowy, mobile shapes on the evocative environment that, in turn, assumes the shape of the human mind.[52]

If the brain-mind has once again become a shadowy cavern, we may well ask, *what do we actually see?* Surely not, as Plato would have it, flickering copies of outside appearances projected on the unifying screen of the mind. If it is indeed a structuring global workspace generating schemata that organize the world into corresponding categories,[53] *how much do we depend upon vision in our symbolization of the world?* If, in its continuous incorporation of external objects, our body's nervous system is "neurosymbolic," just as the ongoing electrochemical activity "wiring" together different self-maps is neurophenomenal,[54] is "visual literacy" a concept adequate to this emerging view of the cosmos in the brain?

While art and cultural historians have been excavating the social side of image history, the role of vision in the construction of experience has been whittled away. Although the object of perception can begin either at the sense receptors or in the imaginal cortex, we now know that the brain routinely goes beyond what is visible in sensory information to construct

a complexly emotional and recollection-laden mental representation.[55] In addition, it is not at all unusual to have visual experiences when we are not actually "seeing" anything.

David Lewis-Williams, in his probing study of the geometric zigzags, grids, dots, and superimposed lines found globally in the patterned caves of the Upper Paleolithic era, provocatively argues that art making depends to a great extent on mental imagery, especially the *inward*-directed kind, rather than higher order intelligence. Entoptic phenomena, originating between the retina and the visual cortex, are wired into the human nervous system. Hence, all people have the potential to experience them with eyes open or shut.[56] As we have seen, affect, episodic-like (event) or semantic-like (fact) memory,[57] intuition, intentionality, dreaming, hypnagogic states, and the conscious and unconscious coherence of the evolving self[58] have all been put under the microscope.

Evolutionary biologists, such as Nicholas Humphrey, propose that the bodily behavior of today developed from sensory responses in the past. Over long stretches of geological time, our sensations became recursive, looping back upon themselves to become, in the process, self-creating and self-sustaining. Such sensory activity still calls attention to the present moment in extending itself toward the actual sites of stimulation to evaluate them. But it also remains closer to home, locked inside the arborescent grotto of the secluded nervous system.[59]

Neurobiologists, in turn, argue that the brain, like the heart, functions as a self-referencing closed system. Rodolfo Llinas, for one, proposes that the "mindness" state—or class of all functional brain states in which sensorimotor images (including consciousness) are generated and which may or may not represent external reality—derives from a brain that is normally not disconnected from sensory input. He emphasizes, however, that it does not depend upon continuous input from the external world to generate perceptions "but only to modulate them contextually."[60] In either case, experience does not directly instruct, but selects from among a preexisting set of alternatives.

Ironically, despite the explosion of sensory media, teachers of the visual are faced with a shrinking arena of influence. In this essay I have tried to sketch both an opportunity and a challenge. If the spectrum of consciousness (and, with it, mental representation) is largely an automatic product of the nervous system, then studies of how we have developed a set of socially shared mental images becomes even more vital. If so much scientific (and, indeed, humanistic) research has gone, and continues to go, into the exploration of how we organize our inner universe, what are the inducements for moving outward to shape public

forms of communication in which visual images comprise the prime component?

In fact, if the human brain models the world for each individual, why confront experience at all to test one's perceptions? Although Jean-Pierre Changeux has proposed using the workspace model, whereby the widespread accessibility of information within neural networks permits the evaluation of hypotheses in relation to other information,[61] he leaves unanswered the question of why go outside in search of context or truth in the first place? As in Keatsian negative capability, why not just linger among too many possibilities or too many unconstrained alternatives?

I think of my analysis so far as a field guide to the specifically neurologically constituted condition of anonymous autonomy. But I look forward to writing a field guide to the situational, that is, to the emergent cross-disciplinary study of the relation between auto-organization and autocontrol in the constantly adjusting performance of synthesis linking the complexities of real-world (humanistic) experience with neurophysiological data (typically dependent on electrical recordings made from single neurons). A situational inquiry would confirm that thinking is both visceral—seemingly unreflective—and by design or pondered. Recognizing this amalgam of unconscious common sense and conscious deliberation allows us to glimpse the cognitive templates against which new information is instinctively compared. Such swift pattern recognition is predicated on the intuitive condensation and crystallization of a vast reservoir of accumulated past analytic processes.[62] By taking into account that our minds are constantly flitting from thought to thought with amazing speed and flexibility, we acknowledge that cognitive acts normally require more than one type of processing[63] and, consequently, evince different types of ordering.

From this performative perspective, the question becomes, what are the connections between auto-organization and cognitive control, where the latter entails understanding how the human brain regulates the flow of information to achieve intended goals?[64] And, more importantly, what can the varieties of art production tell us about the intricate ways in which the frontal region of the brain dynamically and actively switches between multiple functions—automatically scanning and then suddenly willing to pay attention—rather than just statically performing preset tasks or obeying a linear logic?

Conversely, the observations of neurobiology have fundamentally altered the meaning of perception, memory, emotion, and image, so that we humanists can no longer continue with outdated notions about the grounds of our contact with the natural world. This means, among other things, that we

have to reconceptualize the archaic and divisive nature-nurture debate.[65] In this essay, I made the case that a different, more remote and automated, picture of the inner cosmos is emerging than that to which we are perhaps accustomed. But despite much current research focus (the extreming of auto-organization verging on determinism), autopoiesis is not everything.

The role of the environment, the dazzling plasticity of the nervous system, and the importance of learning all point to the need to reassess the role of experience in brain development from birth to maturity. Gerald Edelman, for example, discusses neuronal networks by analogy to Darwinian selection. While growing neurons continuously establish transient connections with one another in a random fashion, these connections rapidly unravel unless some outside influx causes them to be utilized, amplified, and thus stabilized. Or, in the words of Jean-Pierre Changeux, "The Darwinism of the synapses takes over from the Darwinism of the genes."[66]

Along those lines, I believe we must fold visual studies into a more general phenomenology of the senses focused on understanding how rapid neural reconfiguration informs the enormous variety and highly flexible behavioral dynamics of our ordinary lives. Being alive to these "situational" adjustments would take into account how preattentive seeing, like the varieties of memory, the secondary consciousness, and other automatic physiological processes or bodily functions—taken together—becomes amplified by selective attention and conscious conceptualization.

Creativity may well lie in escaping, not giving in to, our autopoietic machinery and focusing carefully on the world. This proactive proposition defies a hyper-Romantic theory of consciousness, recently challenged by John Searle,[67] that we can never perceive the real world but only our mental representations and that even these re-representations are driven by inaccessible mechanisms.[68] I want to argue, instead, that art is a principal example of such willed perception imaginatively and publicly working on the world.[69] This outward-directed attentiveness to the thereness of an object, not just to our private experience of it, captures aspects of high-level cognition such as intention, design, and selection, bringing them back into the circle of awareness.

But these conscious operations are made even more difficult by the proliferation of autopoietic devices and zombie media. These nonconscious technologies of the reflex (blinking, humming, oscillating, and vibrating) are intrinsically compatible with our brain's endlessly self-configuring and inward-zooming remote control. In fact, as Malcolm Gladwell suggests, humans are adept at screening out what does not matter and at reaching "snap" judgments.[70] While we certainly need to be able to synthesize, internalize, and evaluate a signature pattern (say, a bird call) in order to

46 • Barbara Maria Stafford

respond quickly to the identification problem at hand, portable immersive technologies, troublingly, have taken it upon themselves to screen out what supposedly does not matter.

We see this obliteration of conscious thought—where the decision of what should be suppressed is automatically done for us—in solipsistic cell phones, environment-screening Bose headsets, mobile microsized PDAs or removable MP3 players, and VR gaming systems.[71] But we also witness the reduction of personal powers of assessment in those new primes of our social and political life: advertising's creation of corporate logos and global brands. Beverly Fishman's sleek, multipaneled neural landscapes are graphic embodiments of the largely automatic forces currently shaping our biological and cognitive self. In a new generic allegory of the human condition, pharmaceutical monograms—the encircled V of Valium or the swollen H of Haldol—enticingly flash above the pulsating horizon promising universal narcotized relief.[72] Seeing, not seeing as, enables knowledge to grow. Educating the remaining 10 percent, then, is about showing students the deep effects of volition and effort (i.e., autocontrol, not just auto-organization). By changing the way they think about their thoughts, they can change their brains as well as the world.

Beverly Fishman, *Dividose: P.V.K.* (Lemon Yellow/Black/Silver). 2003. Vinyl and powder-coated metal.

Beverly Fishman, *Lem: Stretch H.* 2003. Vinyl and powder-coated metal.

Questions

Richard Sherwin: Thank you; that was an overwhelming, magnificent presentation—but it also left me a little queasy. It gave new meaning, perhaps, to the notion of the "struggle to be free." I was wondering: does one have to be Blake, for example, to overcome the 90 percent of our autopoietic subsystems? Mass media in particular, which is my interest, seems to conspire—

Barbara Stafford: Especially the gaming industry, I would say: they are brilliant, and they have picked specific neural functions to play to.

RS: Do I have any justification, beyond your enthusiasm and inspirational effect, to think that the 10 percent is *adequate* for us to realize, especially in the current cultural climate, meaningful freedom?

BS: I believe in education: but I don't think that we can educate anymore. What needs to be done is to *make it obvious*, make it manifest. Those of us on the humanities side—in visual studies, in cultural studies—are locked into an old place, using old concepts. (It's taken me five years to get to this point in my argument; I'm going to be at the *Wissenschaftskolleg zu Berlin* next year, *Gott sei dank!*, where I can write my book.) It is a question of *value*: you can do something with the 10 percent, if you know the mechanisms, if you know the autopoietic *creep* (if I can put it that way: it's like soil creep). This is particularly scary in cognitive economics, which is witnessing the coming together of an autonomic economic theory with a certain aspect of neurobiology. One of the things

that *goes,* there, is any sense of responsibility: responsibility for actions in the world. I can see many ramifications of that, but I think that if we grapple with these issues, people can be made aware. It's just that we're still mired in the theory wars.

David Ehrenpreis: As you were speaking, I couldn't help but think of Kant's "What Is Enlightenment?" The talk sounded very much like a version of that essay rewritten for the current moment. I am wary of the tenor of statements like "We are living in a dangerous age, in which the new visual turn has unprecedented ramifications for social control. We need to be more vigilant than before, and that is the role of the teacher." So I am wondering if it really is different now. In the conversation around Richard's question, there seemed to be an imminent threat of mass media and gaming technology, as if we're about to be taken over by them. At James Madison University, we had a video wall: an immersive installation with seventy-two monitors, which could be used to run *Quake II,* but could also be used to run a model of the solar system that can show how comet orbits decay.*

BS: Or *ASC Flash* at the University of Chicago.† Yes, I take your point. I believe I can have both/and. I don't believe that my lecture is about doom and gloom: I deeply believe that there is an opportunity to rethink some of the fundaments that we have been treating for some time. There is also a challenge involved, a peculiar paradox, in that we seem to be inundated by a culture of images, and yet at that precise moment the role of the visual has shrunk. That, to me, puts special pedagogical pressures on us: and that is an opportunity, enormously exciting and not at all pessimistic. That's why I think I can have the both/and.

There are, by the way, areas that are not as self-reflexive as the humanities, and they can be quite scary. The University of Chicago has a Law and Economics group,‡ and I think, *Oh my God!*—it's not the University of Michigan, for example, with their wonderfully humanistic types. It is certainly worrisome, the way in which some of this knowledge is now being applied: but it's not the whole picture.

* See Immersive Visualization System, http://ivs.cs.jmu.edu/.
† See Alliances Center for Astrophysical Thermonuclear Flashes, http://flash.uchicago.edu/website/home/.
‡ University of Chicago Law School, www.law.uchicago.edu/Lawecon/index.html.

Jon Simons: I'm glad you gave that talk, because I am also interested in images and ideas in neuroscience. In spite of your reference to this new material, in the end you seem to come back to quite an old trope—the need for education, and the call for pedagogical initiatives to avoid the danger that humanity will sink back into an eternal state of regarding its own belly button while it plays computer games. The way you presented the contrast between autopoiesis and autocontrol was too sharply drawn. Evolutionary neuroscientists wouldn't draw the distinction that sharply: as I understand him, Antonio Damasio says that the brilliant 10 percent that might distinguish us from less clever animals *relies* on the 90 percent. So it's not a question of pitting the 10 percent against the 90 percent, but the two working together. I would also be more cautious in saying what it is that we should accept from the neurosciences, because when you say, "They can tell us things about perception and memory that we need to update," I'd say we also need to update *them*. They keep using the concepts that come from philosophic roots, without acknowledging the baggage that comes with those concepts.

BS: I believe I said that, specifically about Zeki and Ramachandran, they *need* us. So I agree with you. I take your point exactly: I mentioned Nicholas Humphrey, David Lewis-Williams, and Lynn Margulis, who do not fit into the Ramachandran-Zeki crowd. These people are enormously interesting, and you're right, the evolutionary viewpoint is a different one, and they offer the opportunity for creating a different kind of synthesis. Perhaps the distinction came across in a way that I didn't intend, in its starkness: Damasio has probably become more of a humanist in his *Looking for Spinoza* than a neuroanatomist, because he is constantly thinking about ways that culture, or the 10 percent, inflects the rest.* For him, the homeostatic system is a lovely sea over which our culture somehow floats, and describing that relation is very much an issue for him. Lynn Margulis and Dorion Sagan are also very important to me for using the concept of symbiosis to get the two domains together in an interesting way.†

* Antonio Damasio, *Looking for Spinoza: Joy, Sorrow, and the Feeling Brain* (Orlando, Fla.: Harcourt, 2003).
† Lynn Margulis and Dorion Sagan, *Acquiring Genomes: A Theory of the Origins of the Species* (New York: Basic Books, 2002).

James Elkins: In relation to the 10 percent, here's an interesting statistic I ran across a couple of years ago: over 80 percent of the neurons that enter the lateral geniculate nucleus come from *inside* the brain, that is, not from the optic nerve. Pondering those kinds of information, and the kinds of intellectual genealogies they imply, I was noting a non- or antipsychoanalytic strand in your project, and that in turn made me remember the way that psychoanalysis has traditionally co-opted Nietzsche as one of its forebears—especially the passage in which he says that Leibniz's "incomparable insight" was the realization that most of thinking is not known to ourselves. But from the point of view of your project, or perhaps I should say of neurobiologically inclined scholarship that comes out of the humanities, the psychoanalytic claim on Nietzsche can be rethought. Nietzsche's comment and Leibniz's interests provide another way back through the nineteenth and eighteenth centuries that can be independent of psychoanalysis and its constructions of the unconscious.

BS: Yes, that's interesting, and Leibniz is also pertinent for his universalist aspirations. I am also concerned with the resurfacing of the concept of anonymity. You could say it's the Internet that has produced the current interest in anonymity: somehow it's the system, or systems theory, that's doing the thinking.

Margaret MacNamidhe: I am interested in the role phenomenology plays in this. For example, the somatic trend—I'm a scholar of French nineteenth-century painting, so this is something that's central to what I do—in particular of the associational world-independent modality, and the relation between autocontrol and auto-organizing tendencies. You have *volonté* versus the kind of automatistic notions, for example, in Jean-François Millet's paintings of the 1840s, or especially *The Sower* of 1848, where an automatistic valence creeps into the paintings: a sense of repetition, a somatic element. In one respect, Millet *presses* the role of *volonté*, but you also get a kind of somatic expression in terms of automatistic states of paintings of agrarian laborers. There's a role of will, which goes back to Maine de Biran, and hence before Merleau-Ponty. It's also a kind of blindness. ...

BS: Yes, I can see the generic aspect in Millet ... if you wanted to stay simply within the French trajectory, you could also go back to La Mettrie and materialism. There's a sense in

	which much of the new biology is a kind of materialism; it's a kind of materialistic phenomenology. And here I mean materialism in its historical sweep, going back at least to La Mettrie, but even to Spinoza, because as you know his pantheism was always accused of being, sotto voce, a kind of materialism. One could also find this genealogy in that rather romantically inflected writer on automata, namely, E. T. A. Hoffmann, especially in the *Coppelia* where there is a whole rhetoric of the automaton as a life form that is *self-driven*. I can't dot the *i*'s in that intellectual trajectory, but another thing that happens is the anonymous and the generic—going back to Millet—and it would be important to note the moments when anonymity becomes important in French painting.
MM:	Just one other point, then: the simultaneity of memory and perception, which is a wonderful point you raised—
BS:	That's Gerald Edelman, and his wonderful construct about the "remembered present": it means we have to rethink Freud—
MM:	So just in reference to Freud, then, something like *Nachträglichkeit* would then have to be rethought.
BS:	Yes, but the trouble with that is that it's *after* (the *nach* in *Nachträglichkeit*). Edelman's book is old now; it was published in 1989; but it's back again in George Baer's theory of the mind.* He talks about the fact that in perception, memory and affect are woven together. You might have a split-second stimulus slippage, but in our real-time experience [they] would be experienced simultaneously.
Francis Halsall:	A question about systems theory that you were invoking. Niklas Luhmann comes to mind; it would seem that for him, there is a paradox in your model.
BS:	Why so?
FH:	Talk about the mind would be a closed system; but at the same time you're talking about social systems. In Luhmann you move away from the individual subject as the dominant model; you talk about social systems, art systems, economic systems … it doesn't mean the individual doesn't exist, but rather that they are not the primary object of your analysis. So if you want to understand images or art,

* Gerald Edelman, *The Remembered Present: A Biological Theory of Consciousness* (New York: Basic Books, 1989).

from the systems-theory perspective you wouldn't go to the individual for explanatory models. You'd be asking more general, sociologically inflected questions.

BS: I invoked systems theory for a particular *strand* of the language of automation. I find Luhmann interesting from another point of view, because he is always invoked by people who write on new media—people like Mark Hansen, for example.* People who are interested in the performative invoke Luhmann because he appears as a person who is interested in systems that go beyond both the linguistic and the imagistic, and therefore into the performative. *That* would be my interest in Luhmann: I'm concerned with *mantics*, not hermeneutics. I invoked systems theory in relation to Jim's question, but I don't think it was my dominant model here. I'm not trying to weasel out of the question! I'm just saying that it might be another area in which the discourse and rhetoric of the automatic [are] a major theme.

FH: But in relation to the paradigm of representation, for Luhmann there would be a shift from representation to observation, which would be system contingent. It would not rely on an individual psychic system or cognitive model.

BS: That is an *enormous* issue. What is it that goes on, that binds together, so that we have an image? No one has an answer to that. What is this thing called mental representation? You are using representation in the old-fashioned sense. I want to say that we really need to rethink that in light of the problematic that begins with Locke, that we no longer have the little picture in our heads. What *is* there? What pulls it together? And that returns us to questions of will and will-lessness, and the fact that our physiological systems create their own micro-bindings. (This is also in Zeki.) How does all that get bound into mental representation?

Pierre Laszlo: I have a compliment, an anecdote, and a question. First, the compliment: the works you showed us were extremely interesting for the way they depicted the efforts on the part of a number of people to show the bases of visual perception. On to the anecdote: Panofsky was totally intolerant of

* Mark Hansen, *New Philosophy for New Media* (Cambridge, Mass.: MIT Press, 2004).

	William Blake.* And now, here is the question: why is it that art historians systematically label as minor artists such as Metzinger, Gleizes, Vasarely, Magritte, or Arcimboldo?
BS:	You know I haven't called myself an art historian for a long time! Well, *I* don't know. I *don't* know. I don't *know*. [*Laughter.*]
PL:	Do you share such appraisals yourself?
BS:	No, *au contraire*. We have been in such a negative period, a theoretical morass. What is so exciting for me reading these scientists—when I'm not crying because I can't understand them—is that it makes me look at a whole range of material enormously differently. It goes back to Jon Simon's point. I know Ramachandran and Zeki; Zeki goes to museums, and he really tries to understand; but because of his neuro-anatomizing, cell by cell, he can't make certain leaps. One of the things that looms before us is to reach out and complicate the story in interesting ways. But you need to hear the other side. You really do.

Endnotes

1. Richard Powers, *The Goldbug Variations* (New York: William Morrow, 1991), 48.
2. Jose Saramago, *The Gospel According to Jesus Christ*, trans. Giovanni Pontiero (New York: Harcourt, Brace, 1994), 9.
3. Roald Hoffmann, "Interface," in his *Soliton: Poems* (Kirksville, Mo.: Truman State University Press, 2002), 77.
4. This problem was addressed by I. A. Richards, *Poetries and Science: A Reissue of Science and Poetry (1926, 1935) with Commentary* (New York: Norton, 1970).
5. George Landow, *Hypertext: The Convergence of Contemporary Critical Theory and Technology* (Baltimore: Johns Hopkins University Press, 1992), 103.
6. Recent research has corroborated that brain-damaged people whose ability to use words is severely impaired still can do complex math. See Constance Holden, "Math without Words," *Science* 307 (February 25, 2005): 1197.
7. This taking for granted information coming from brain scans as facts about the world has been explored by Joseph Dumit, *Picturing Personhood: Brain Scans and Biomedical Identity* (Princeton, N.J.: Princeton University Press, 2004), 5. He, however, is looking at issues of normality and abnormality—not the automation of processing.
8. Semir Zeki, *Inner Vision: An Exploration of Art and the Brain* (Oxford: Oxford University Press, 1999), 13.

* William Heckscher, "Erwin Panofsky: A Curriculum Vitae," in *Erwin Panofsky: Three Essays on Style*, ed. Irving Lavin (Cambridge, Mass.: MIT Press, 1995), 171.

9. Heidi Morrison Ravven, "Spinoza's Anticipation of Contemporary Affective Neuroscience," *Consciousness & Emotion* 4, no. 2 (2003): 273–79.
10. Jaak Pankseep, "Damasio's Error?" *Consciousness & Emotion* 4, no. 1 (2003): 112.
11. Zeki, *Inner Vision*, 1.
12. Maurice Merleau-Ponty, *The Primacy of Perception: And Other Essays on Phenomenological Psychology, the Philosophy of Art, History and Politics*, ed. James M. Edie (Evanston, Ill.: Northwestern University Press, 1964).
13. Sarah R. Cohen, "Chardin's Fur: Painting, Materialism, and the Question of Animal Soul," *Eighteenth-Century Studies* 38 (Fall 2004): 50.
14. Daniel Dennett, *Consciousness Explained* (Boston: Little, Brown, 1991), 416.
15. Andy Clark, *Being There: Putting Brain, Body, and World Together* (Cambridge, Mass.: MIT Press, 1997), 69.
16. See my "Romantic Systematics and the Genealogy of Thought: The Formal Roots of a Cognitive History of Images," *Configurations* 12, no. 3 (Fall 2004): 315–48.
17. Bernard Pachaud, "The Teleological Dimension of Perceptual and Motor Intentionality," in Jean-Luc Petitot, Francisco Varela, Bernard Pachoud, and Jean-Michel Roy, eds., *Naturalizing Phenomenology: Issues in Contemporary Phenomenology and Cognitive Science* (Stanford, Calif.: Stanford University Press, 1999), 198–203.
18. See John R. Searle, *Mind: A Brief Introduction* (New York: Oxford University Press, 2004).
19. Chris McManus, *Right Hand, Left Hand: The Origins of Asymmetry in Brains, Bodies, Atoms and Cultures* (Cambridge, Mass.: Harvard University Press, 2002), xv, 168ff.
20. Jean-Luc Petitot, "Constitution by Movement: Husserl in Light of Recent Neurobiological Findings," in Petitot et al., *Naturalizing Phenomenology*, 221.
21. Jeffrey M. Schwartz, *The Mind and the Brain: Neuroplasticity and the Power of Mental Force* (New York: HarperCollins, 2002), 200.
22. On the latter, see Marsha Kinder, "Screen Wars: Transmedia Appropriations from Eisenstein to a TV Dante and Carmen Sandiego," in *Language Machines: Technologies of Literary and Cultural Production*, ed. Jeffrey Masten, Peter Stallybrass, and Nancy Vickers (New York: Routledge, 2000), 169–72.
23. David Leatherbarrow and Mohsen Mostafavi, *Surface Architecture* (Cambridge, Mass.: MIT Press, 2002), 175.
24. William Bialek and David Botstein, "Introductory Science and Mathematics Education for 21st-Century Biologists," *Science* 303 (February 6, 2004): 787.
25. Ilya Prigogine and Isabelle Stengers, *Order Out of Chaos* (New York: Bantam Books, 1984), 302–3.
26. Sharon G. Glotzer, "Some Assembly Required," *Science* 306 (October 15, 2004): 419.
27. Rachel Gelman and C. R. Gallistel, "Language and the Origin of Numerical Concepts," *Science* 306 (October 15, 2004): 441–43.
28. Peter Stern, Gilbert Chin, and John Travis, "Neuroscience: Higher Brain Functions," *Science* 306 (October 15, 2004): 431.

29. Gregory Little, "Synnoetics and the Self: The Construction of Planetary Identity as an Aesthetic Oeuvre," *Technoetic Arts,* no. 2 (2004): 82. The term *synnoetics* was coined in 1960 by the computer scientist Louis Fein.
30. Lynn Margulis and Dorion Sagan, *Acquiring Genomes: A Theory of the Origins of the Species* (New York: Basic Books, 2002), xi.
31. Max Robinson, "Place-Making: The Notion of Centre," in *Constructing Place: Mind and Matter,* ed. Sarah Menin (London: Routledge, 2003), 147.
32. Although unrelated to contemporary cognitive research, see Keith Moxey's provocative study, "Impossible Distance: Past and Present in the Study of Duerer and Gruenewald," *Art Bulletin* 86 (December 2004): 750–51.
33. Charles D. Laughlin, John McManus, and Eugene G. d'Aquili, *Brain, Symbol, and Experience: Towards a Neurophenomenology of Human Consciousness* (New York: Columbia University Press, 1992), 43, 171.
34. Zeki, *Inner Vision,* 16.
35. Dario Gamboni, *Potential Images: Ambiguity and Indeterminacy in Modern Art* (London: Reaktion Books, 2002), 13–14.
36. V. S. Ramachandran and W. Hirstein, "The Science of Art: A Neurological Theory of Aesthetic Experience," *Journal of Consciousness Studies* 6 (1999): 15–51.
37. See my *Visual Analogy: Consciousness as the Art of Connecting* (Cambridge, Mass.: MIT Press, 1999).
38. Laughlin, McManus, and d'Aquili, *Brain, Symbol, and Experience,* 44.
39. See my "Romanticism and the Genealogy of Thought."
40. Antonio Damasio, *Looking for Spinoza: Joy, Sorrow, and the Feeling Brain* (Orlando, Fla.: Harcourt, 2003), 12, 80–86.
41. Constance Holden, "Fear as Action," *Science* 306 (November 2004): 1469.
42. Eva Schürmann, *Erscheinen und Wahrnehmen: Merleau Ponty und James Turrell* (Munich: Wilhelm Fink Verlag, 2000).
43. Robert F. Port and Timothy van Gelder, *Mind as Motion: Explorations in the Dynamics of Cognition* (Cambridge, Mass.: MIT Press, 1995). See, especially, their essay "It's about Time: An Overview of the Dynamical Approach to Cognition," 3 ff., which argues against the computationalists that the cognitive system is not a computer but a dynamical system comprising brain, nervous system, body, and environment.
44. Nicholas Humphrey, *The Mind Made Flesh: Essays from the Frontiers of Psychology and Evolution* (Oxford: Oxford University Press, 2002), 9–12.
45. Joseph Tabbi, Cognitive Fictions (Minneapolis: University of Minnesota Press, 2002), xxiv.
46. Gertrude van de Vijver, "Introduction: Auto-Organisation, Autonomie, Identite," *Revue Internationale de Philosophie* 59, no. 2 (2004): 140, 148.
47. Ernst Mayr, in *What Makes Biology Unique? Considerations on the Autonomy of a Scientific Discipline* (Cambridge: Cambridge University Press, 2004), warns of the attempts to reduce biology to physics under the aegis of E. O. Wilson's ground plan for interscientific "consilience."
48. Paul W. Glimcher and Aldo Rustichini, "Neuroeconomics: The Consilience of Brain and Decision," *Science* 306 (October 15, 2004): 447–52.
49. Robert Sanborn, Adolfo Santos, Alexandra L. Montgomery, and James B. Caruthers, "Four Scenarios for the Future of Education," *The Futurist* (January–February 2005): 27–28.

50. Giambattista Vico, *Principles of a New Science* (1734; reprint, New York: Penguin, 2000).
51. Gelman and Gallistel, "Language and the Origin of Numerical Concepts."
52. David Lewis-Williams, *The Mind in the Cave: Consciousness and the Origins of Art* (London: Thames and Hudson, 2002), 63–65, 93.
53. While much has been written since George Lakoff and Mark Johnson, *Philosophy in the Flesh: The Embodied Mind and Its Challenge to Western Thought* (New York: Basic Books, 1999), 17, 552–55, their insight that neural beings must categorize and that conceptualization only happens through the body still holds.
54. For new light being shed on the relations between phenomenology of a Husserlian kind (as well as that of Merleau-Ponty) and contemporary efforts toward a scientific theory of cognition—still largely under the influence of behaviorism—see Jean-Michel Roy, Jean Petitot, Bernard Pachoud, and Francisco J. Varela, "Beyond the Gap: An Introduction to Naturalizing Phenomenology," in Petitot et al., *Naturalizing Phenomenology*, 9–10.
55. Gianfranco della Barba, *Memory, Consciousness, and Temporality* (Boston: Kluwer Academic, 2002).
56. Lewis-Williams, *The Mind in the Cave*, 127.
57. Yasushi Miyashita, "Cognitive Memory: Cellular and Network Machineries and Their Top-Down Control," *Science* 306 (October 15, 2004): 435–40.
58. See my "Levelling the New Old Transcendence: Cognitive Coherence in the Era of Beyondness," *New Literary History* 35, special issue on Coherence (Spring 2004): 321–38.
59. Ibid., 91, 112.
60. Rodolfo R. Llinas, *I of the Vortex: From Neurons to Self* (Cambridge, Mass.: MIT Press, 2001), 7.
61. Jean-Pierre Changeux, *The Physiology of Truth: Neuroscience and Human Knowledge*, trans. M. B. DeBevoise (Cambridge, Mass.: Harvard University Press, 2004).
62. Elkonon Goldberg, *The Wisdom Paradox: How Your Mind Can Grow Stronger as Your Brain Grows Older* (New York: Gotham Books, 2004).
63. Christian K. Machens, Ranulfo Romo, and Carlos D. Brody, "Flexible Control of Mutual Inhibition: A Neural Model of Two-Interval Discrimination," *Science* 307 (February 18, 2005): 1121.
64. Cognitive control is becoming a research project again; see K. Richard Ridderinkhof and Wery M. van den Wildenberg, " Adaptive Coding," *Science* 307 (February 18, 2005): 1059.
65. See, for example, John E. Dowling, *The Great Brain Debate: Nature or Nurture?* (Washington, D.C.: Joseph Henry Press, 2004).
66. Cited in Christian de Duve, *Life Evolving: Molecules, Mind, and Meaning* (Oxford: Oxford University Press, 2002), 213.
67. John Searle, "Consciousness: What We Still Don't Know," *New York Review*, January 13, 2005, 36–39.
68. Christof Koch, *The Quest for Consciousness* (New York: Roberts and Company, 2004).
69. For the labor implications of autopoiesis and distributed consciousness, see my essay review of Pamela H. Smith's book, *The Body of the Artisan*, entitled "Working Minds," *Perspectives in Biology and Medicine* 48, no. 4 (2005): 131–36.

70. Malcolm Gladwell, *Blink: The Power of Thinking without Thinking* (New York: Little, Brown, 2004).
71. Adam Rogers, "Will Consoles Continue to Rule the Videogame Market," *Wired*, January 2005, 31, www.wired.com/wired/archive/13.01/start_pr.html.
72. Joe Houston, Beverly Fishman, exhibition catalogue (Paris: Galerie Jean-Luc & Takako Richard, 2005), 3.

CHAPTER 3
Nineteenth-Century Visual Incapacities

JONATHAN CRARY

I'm going to start by reading a quote:

> The observer of paintings in the 19th century was always also an observer who simultaneously consumed a proliferating range of optical and sensory experiences. Paintings were produced and assumed meaning not in any kind of aesthetic isolation or in a continuous tradition of painterly codes but as one of many exchangeable and fleeting elements within an expanding horizon of images, displays and perceptual novelty.[1]

I wrote that well over a decade ago, but the project from which my talk tonight is drawn connects at least in part to its content. When I wrote *Techniques of the Observer*, I had made the polemical decision to discuss the modernization of vision in the nineteenth century without artworks or images as primary pieces of evidence. Now, however, I'm addressing some related questions about the historical status of perception but with artworks very much as central objects of interrogation. And most of my talk is an examination of several paintings, each of which diagrams an exemplary and problematic relation between spectator and image.

I'm interested in how the cultural and scientific recognition of the subjective and contingent nature of human vision coincided historically with the spread of new reality effects in the first half of the nineteenth century. Thus I'm looking at some of the broader consequences and manifestations of widespread doubts and uncertainties about the status

of perceptual experience and its representability, in the context of a social environment that included new or updated forms of visual display. I suspect that some of the unique strangeness and heterogeneity of European painting in the first half of the nineteenth century is explained less by the long-standing notions of eclecticism, pluralism of styles, and the failure of institutional authority and more by the adjacency of disparate and dissonant reality effects. And here I am not particularly interested in morphological similarities but rather in the events and contents of a common field in which perceptual capacities, expectations, and responses are in a state of relative instability and modulation.

During a period from roughly 1790 to around 1820, there is a remarkable and in some ways unprecedented openness on the part of the painters to questioning the traditional ground of painting itself, the literal identity and physical limits of its surface—when panorama painting, on one hand, and the painted transparencies, on the other, using an independent light source for illumination, are relatively legitimate possibilities for the practice of painting. But even when these alternatives became plainly illegitimate, or seen as fundamentally alien and threatening to painting by the mid-1820s and after, there is a larger sense in which painting throughout the first half of the century is defining its own possibilities within a crowded arena of visual experiences and new forms of simulation (and I'm concerned mainly with the period before the invention and diffusion of photography).

In *Techniques of the Observer*, I tried to demonstrate the emergence of models of subjective vision in a wide range of disciplines during the period 1810–1840. Within the space of a few decades, dominant discourses and practices of vision effectively broke with a classical regime of visuality, and grounded the truth of vision in the operations of the human body. One of the consequences of this shift was that the functioning of vision became dependent on the physiological makeup of the observer, thus rendering vision faulty, undependable, and, it was sometimes argued, arbitrary. Throughout the first half of the nineteenth century, an extensive amount of work in science, philosophy, psychology, and aesthetics was coming to terms in various ways with the understanding that vision, or any of the senses, could no longer claim an essential objectivity or certainty. There is a general epistemological inconclusiveness in which perceptual experience had lost the primal guarantees that once upheld its privileged relation to the foundation of knowledge.

One of the main ways in which I made this argument was to show how a very different model was dominant in the seventeenth and eighteenth centuries. During this time, most theories of vision, in spite of many individual incompatibilities, had a demonstrable consistency, because of the ubiquity of the camera obscura as a way of explaining the relationship

between perception and the mind. The camera became a flexible figure for indicating how the mind was guaranteed a truthful or reliable picture of the world, in spite of the deficiencies of the senses. In my schema, I positioned Johann Wolfgang von Goethe's *Theory of Colours* (from 1810)[2] to stand for a decisive break with that influential camera obscura model of vision, especially in his discussions of after-images, an optical phenomenon for which the camera is irrelevant. However, the camera obscura model did not suddenly disappear in 1810 but lost its relevance more slowly, especially in the very late eighteenth century. What interests me is how John Locke's model of the camera obscura (perhaps the most influential) becomes slowly but irreparably disabled over the course of the 1780s and 1790s. In this model, there was a law-like orderliness with which knowledge of the world was acquired from images that were effectively projected into a box-like interior space. But this space becomes increasingly difficult to regulate, and the nature of its contents difficult to authorize and control. Especially in the 1790s, there is a broad range of evidence to indicate that the box-like interior of the camera is imagined as occupied or inhabited by figures, images, memories, and sensations that no longer have a clear-cut relation to an exterior world. The camera becomes haunted by quasi-autonomous phenomena whose identity and even physical and temporal location are irreducibly ambiguous. Locke's system for distinguishing between the images of remembrance and those of present perception ceases to function in a consistent way. There is an increasing confusion about what belongs to the subject and what belongs to the world. Certain subjective or interior experiences seem to have more reality than events in the world. And certain external phenomena have an increasingly illusory or deceitful status, in particular forms of spectacle and public display, as Wordsworth and others maintained.

So within a larger frame that encompasses a period from the 1780s through the first decades of the nineteenth century, there is really a twofold and interconnected challenge to some existing certainties about the operation of human perception. On one hand, as I've indicated, there is the growing realization that the appearance of the world is determined by subjective optical conditions. But there is also the proliferation of external experiences, specifically visual displays, exhibitions, and apparatuses that in decisively new ways produce confusion about the status or identity of optical phenomena, that derange visuality from a coherent or rationalizable relation to the world. And I use the word *derange*—it's a French word that only begins to be widely anglicized in the late 1770s—that carried with it then the still pertinent sense of things being dislocated from a position in a line or rank, a disruption of a certain control or spatial discipline, and only later with the notion of mental instability, of an epistemological disruption.

To get more specific, one of the categories of attractions that I'm examining is various forms of transparent or translucent imagery, beginning in the 1780s, which all required an independent light source as part of their exhibition. This category encompasses displays from Philippe Jacques de Loutherbourg's *Eidophusikon* to Louis Daguerre's *Diorama*; the large-scale optical views that Karl-Friedrich Schinkel exhibited in Berlin around 1812; Louis Carrogis de Carmontelle's long transparent reels in prerevolutionary Paris and the *Phantasmagoria*, first shown in the 1790s; as well as the countless imitations of these from all over Europe.

Crucial for such displays were several interdependent material requirements: one was the availability of new lighting techniques in the 1780s, in particular the new powerful Argand lamps and their slightly later modifications such as parabolic reflectors, which introduced the capability for a controlled directedness, as well as techniques for gradual dimming and brightening. The other essential component was the makeup of the image screen or surface, and here one key factor was the availability of products from England's burgeoning textile industry—durable open-weave fabrics that by the early 1800s were called *scrims*. As we know, such strong but gauze-like materials when lit from behind or the side seem relatively transparent but when lit from the front seem completely opaque, creating a range of illusions involving spatial and temporal dissociations. Important here are the epistemological ramifications of image-making materials that had reversible characteristics, that simultaneously had the properties of solid and void, of opacity and transparence, of something both tactile and dematerialized. All of these possibilities, used in various combinations, constituted an unprecedented inventory of effects that would become gradually formalized and rationalized in many different sites throughout the nineteenth century. For example, the origins of the cinematic fade and dissolve have to be, at least in part, traced back to such effects and techniques. I'm interested in how Gilles Deleuze, in his books on cinema, characterizes one constitutive element of film as "the Crystal image." The crystal is his way of bypassing the burden of mimetic categories when talking about filmic realism. The crystal, he argues, is important because of its multifaceted surfaces: some are reflective and function like mirrors, some are effectively opaque, while others are glass-like and transparent. Amid this kind of oscillation, there is no clear means of distinguishing the object from its representation, or of separating optical illusion from artistic illusion. Equally important, any sequential temporality is fragmented into radiant facets of disjunct but adjacent moments. My own sense is that the conditions of possibility for many features of Deleuze's crystal image are embedded in earlier nineteenth-century phenomena, including the luminous imagery I am examining. And it was the mobile shifting properties

of these surfaces that introduced a variety of challenges to the nature of the frame, of the tableau, not to mention the physical and temporal identity of an image.

Like Loutherbourg's *Eidophusikon* and later the diorama, the phantasmagoria required not only the appropriate lamp and translucent screen, but also an interior space that could be darkened to such a degree that the displayed image would take on a relatively autonomous identity, optically detached from its surroundings. Effects derived from the theater could be heightened and refined in smaller, more controllable spaces. One of Étienne-Gaspard Robertson's innovations was to have the audience be seated in a dimly lit room with all the trappings of a ghostly environment: skulls, chains and ruined fragments, and spooky sounds and music contributed to the atmosphere.[3] But before any performance began, his assistants would completely darken the room and then quietly set up the screen in front of the audience so that when the first lantern slides of ghosts appeared out of the darkness, there was no prior awareness of where the screen was located. At the same time, the projector was secured on top of a wheeled table or cart so that it could be moved forward toward the screen or backward away from it, creating various zoom-like effects. Spectators not only saw ghosts approaching and receding but also witnessed skeletons changing into living people and back to bones again, or they saw the severed heads of Georges Danton, Jean-Paul Marat, and Robespierre come alive. These transformations were achieved by a skillful manipulation of overlapping glass slides, allowing one to dissolve into another. Robertson took things further than standard magic lantern projection of the time by carefully blacking out the glass slides around his ghosts so that there was no illuminated field or space around or behind them, which would have at least situated them as figures on a planar ground.

Rather than the concealment of the means of production, which was so significant for Karl Marx and Theodor Adorno, what is important is the ambiguous location of the image. This indefiniteness is, of course, not unrelated to the issue of concealment, but at stake are phenomenological and perceptual questions as much as ideological and economic ones. Of course, throughout the history of art one can find related examples of such effects, but around the end of the eighteenth century and the early nineteenth century there is a sustained development of many strategies for producing images whose spatial position, relative to the viewer, was indeterminate. The diorama and the panorama, despite fundamental differences, each depended on the uncertain distance of their imagery from an audience. This uncertainty was so prominent that there are numerous contemporary accounts of viewers tossing coins or walnut shells toward the image as a way of acquiring additional sensory cues about its actual

distance from them. And it was this perceptual dislocation, experienced in many different forms, that constituted a powerful reality effect by the early nineteenth century. In other words, the mimetic content of an image was amplified or made more consumable by this ambiguous state of detachment from a broader perceptual field, a state of de-rangement, in that sense of out of line, from other planar reference points. It suggests the idea of an effect of reality that is dependent on an incapacitation or curtailment of certain powers of visual discrimination.

I want to turn to the first of three very different paintings that I'm going to discuss, each of which stages the act of looking in relation to the volatility of the particular image that is the manifest object of vision. Here I'm going to examine a work by an artist whose career is preoccupied with the indecisiveness and uncertainties connected with the exercise of vision. It's a work that, by its proximity to the figures of the phantasmagoria and other contemporary displays, disorders the project of historical representation that it seems to affirm. Consider Paul Delaroche's *Cromwell and Charles I*, just one of several major works by this artist in which these concerns are vividly evident. No one disputes that this was the most popular and talked-about image at the first July Monarchy Salon in 1831. It hung directly across from the entrance, one of the two largest paintings that Delaroche ever executed, nearly ten feet wide, larger even than the *Lady Jane Grey*, at the National Gallery in London. The title of the work suggests what is at stake: *Cromwell and Charles I*. In other words, it refuses the precision that would have accompanied "Cromwell and the *body* of Charles

Paul Delaroche, Cromwell and Charles I. 1831. Musée des Beaux Arts, Nîmes, France.

the 1st." But, title aside, Delaroche's enactment of this encounter between these two historical actors amplifies the ambiguous status of both of them. It is based on an enduring if dubious anecdote, most famously recounted by Chateaubriand, that the night after the execution of the Stuart king, when his body had been brought to Whitehall Palace, Oliver Cromwell opened the coffin to reconfirm that the king was indeed dead, and it is the representation of this act of looking that concerns me. Yet Cromwell's gaze at the literally dead body is faced with deeper uncertainties and anxieties about the trustworthiness of his perceptions. As Stephen Bann has argued, one of the key strategies of the historical poetics of the early nineteenth century was the reassemblage of ruined fragments into a recovery of a lost wholeness, what he calls "effects of resurrection."[4] Here, however, the reassemblage that is supposed to give us access to historical truth is carried out with the severed parts of the king's body, reunited in the open casket before Cromwell. In his project of making the past "come alive" through antiquarian reconstruction, Delaroche renders present perception more equivocal.

Here the king is made present through an accumulation of disruptions and reversals. On a narrative level, instead of having the coffin taken to a place of burial, it has been conveyed, on a different pathway, to a room intended for the living, and the two ornate chairs are a crucial indication of this displacement of meanings. Instead of being sealed and interred, the casket is uncovered and reopened. Amid the Rembrandt-like solemnity of this drawn-out moment is the informality of the scene, the jarring precariousness of the coffin as it rests carelessly on the chairs, threatening to tumble off and possibly spill its contents onto the floor. But the coffin has been placed at such an angle that the king's body, in spite of its almost ghoulish verisimilitude, is simultaneously attenuated into a wraith-like upper body whose legs and lower body have dissolved in the abrupt, unexplainable narrowing of the coffin itself. Heinrich Heine in his Salon review said the coffin looked like a violin case. As one kind of reunification has occurred, other deformations disturb it, producing an unforeseen and untimely image. The king's body is present in the coffin, less as a physical body and more as an ungrounded image, drained of volume. Hovering within its framed confines, this image glows with an unsettling luminosity, challenging Cromwell's pose of imperturbability. The body is the only site in the painting that could be designated as a light source, an emanation that amplifies its indistinct status as something both dead and yet not quite dead. Like many other categories of contemporary imagery, it has a specifically modern overlapping of luminous visibility and unreality, of irrefutable presence and unsettling insubstantiality. Cromwell's position in the painting is a figuration of the broader dilemma of the contemporary

spectator, in terms of how to evaluate, to discriminate, the sometimes dubious evidence of the senses.

But his status here is complicated in that he is not just an observer of this perplexing image but also the active organizer of the scene, a stage manager of an exhibitionary event. Despite the relative stasis of the composition, what we see is the termination of a preceding coup de théâtre, for we can't help but imagine Cromwell, in a dramatic gesture of unveiling, pulling the rough covering off the coffin and then opening the casket itself. Obviously Delaroche's well-known proximity to contemporary theater is important, though the relations between art and the stage around this time were distinctly two-way. But the painting is also close to some widely familiar practices of trick performance and display, some openly comical, some mock-serious. One popular routine with many variants, onstage and in puppet shows, presented the illusion of someone's head being severed; the decapitated body would then be sealed in a box or coffin, often draped with a cloth, which when reopened would reveal the original figure restored in one piece. By 1830 the attractions of the phantasmagoria and its various operations and effects had migrated to a much broader range of mechanical and optical contrivances.

For the reassemblage of the king's body here is obviously bound up in larger contemporary anxieties about political restorations, historical reversals. The temporal precariousness of Cromwell's status as nominal victor is amplified by the equivalence of the metal studs on his neck piece to the nail heads on Charles's coffin. He is already fatally encased and disempowered by his own inevitable destiny. As Marx and others have shown us, ghosts come as much from the future as from the past. The painting has long been associated with historical anxieties about the disruption to tradition brought on by a usurper. But Delaroche the visual artist is faced with uncertainties about which signs and figures are legitimate, and which are fraudulent, uncertainty about what can be revived and what must remain dead. I'm less concerned here with the cultural politics of the July Monarchy than I am with the cognitive and perceptual implications of the work's political context. The challenges to visual discrimination, to visual certainty, by a broad range of exhibitionary phenomena took place amid a larger disruption of certainties about social reality. As many scholars have shown, the French Revolution itself, and then its subsequent cancellation and inversion, generated many figures for depicting contemporary history as a collective delusion, subject to abrupt shifts and deviations.

Edmund Burke is only the most celebrated of many who began to intuit that events in a public sphere were damaging an individual's relation to a shared or dependable commonsense reality. His characterizations of the French Revolution with the terms "spectre" and "spectacle" are products of a larger fear that the legibility and coherence of the world are at risk.

But it was not just conservatives who voiced such concerns. As one of many possible examples, I'll mention the work of William Blake. His later prophetic books are an extraordinary disclosure of an external world made ghostly for the individual, and for Blake the phenomenon of repetition in the cycle of history, the endless flux of reversals and restorations, was one of the conditions for this derealization. But it is more than that: Blake shows how one lives and takes on the unreality of what he called the specter. As with most things in Blake, this is an image supporting an enormous constellation of meanings, but within Blake's opposition of specter and emanation, the spectral is sustained by perceptions and impressions received *passively* from the world. His specter is the falseness of the world internalized and inhabited by the subject, but most of all it is a severing of the individual from the active powers of his or her imagination, and thus a devastating crippling of visionary capacities.

Blake in a very general way has to be associated with the other well-known nineteenth-century voices who insist on the deceptiveness and unreality of modern social and economic experience—Thomas Carlyle, Marx and Friedrich Engels, and Max Stirner, among others. Max Stirner, whose thought has been reexamined lately in the wake of Jacques Derrida's *Specters of Marx*,[5] carries this imagination to a rhetorical limit in his 1844 account of the irredeemable ghostliness of European social experience: "Man is an uncanny spook, he is terrified of himself, he is the ghostly being. His head is haunted!!"[6] Of course, for Stirner, men's and women's heads were haunted not only by Christianity and all of its fixed ideas, but also by secular mirages about the nation, civic duty, and the state. One of his mocking examples is the Roman general Regulus, who during the Punic Wars voluntarily returned to Carthage to face torture and death because he had pledged to do so if peace negotiations failed. For Stirner, only a mad delusional belief in the phantoms of civic duty and honor could induce such a suicidal course of action. I am especially interested in how, just a few years earlier, another engagement with the story of Regulus opens up onto some of the same questions of the spectral, and the rift between social experience and individual perception.

Regulus is a crucial work in J. M. W. Turner's later career for many reasons. I'm examining it for the singularity with which it discloses the conflicting claims of different models of perception and for how it rethinks the identity of a luminous image, its location, and even its visibility, issues that are central to a range of contemporary visual practices. And this section of my paper is taken from a much longer discussion that begins with Turner's own experiments with translucent, illuminated imagery in the 1790s. *Regulus* is also an affirmation of how subjective optical phenomena are an inevitable component of any visual experience. Although Turner was a close reader of Charles Eastlake's translation of Goethe's *Color Theory*,

J. M. W. Turner, Regulus. 1828; reworked 1837. Tate Gallery, London.

this text would have only confirmed and expanded his own personal intuitions about the physiological conditions of vision, and nowhere are these intuitions presented more intensely than in *Regulus*. The story of Regulus had been painted and engraved many times before, by artists including Salvator Rosa, Richard Wilson, and Benjamin West. In France, it had long been a familiar subject and was the assigned theme for the Prix de Rome competition in 1791. But it had never been depicted like this. The most startling element of the story, which no one before Turner had attempted to work with, concerned one of the tortures to which Regulus was subjected on his voluntary return to Carthage, against the pleas of family and friends. Prior to his execution his eyelids were cut off, assuring that he would be permanently blinded by the North African sun. There has been a widespread assumption that Turner intended to place us as spectators in the position of Regulus in his last incandescent moments before the extinguishing of his visual world. It is a moment when the distance between observer and world collapses in the physical inscription of the sun onto the body.

Turner knew of the unfortunate fate of his friend the Scottish scientist David Brewster, who severely damaged his eyesight by staring at the sun studying after-images. Other well-known researchers lost their sight altogether. Paralleling Goethe's account, Turner knew from his own experience the effects of solar after-images. Even if the sun was the original stimulus, the subsequent chromatic modulations in the eye were physiological events occurring over time, independent of their original source. Turner clearly understood in so many different ways that vision was always an irreducible mix of elements belonging to the observer's body and of external perceptions.

After-images, of course, had been recorded since antiquity, but for many centuries they were dismissed as irrelevant and deceptive. But by the late eighteenth century, after-images and other subjective optical phenomena received increasing scrutiny as essential elements in any empirical account of human vision. After-images, in their conjunction of luminous visibility and their insubstantiality and placelessness, were fundamentally incompatible with the optical theories of the seventeenth and eighteenth centuries, which all depended on a rationalizable relation of distance between observer and world.

For the sun in this painting is both the sun in the sky and at the same time its effect on the eye itself, generating light and color that belong specifically to the body. René Descartes believed that the sun, if looked at directly without some mediation or re-presentation, would produce a dazzlement similar to madness, and clearly Turner is meditating here on the consequences of such a dazzlement. When he reworked the painting in 1837, the main change was the intensification of the solar illumination, more extreme than any of his previous renderings of the sun. A witness described how, in the days before its exhibition at the British Institution, Turner became preoccupied with scumbling more and more white onto the center of the painting, as if to heighten the blinding nature of the light. When he had finished, "[T]he sun was a lump of white standing out like the boss of a shield."[7] Turner was working with what he knew to be his most opaque material, his white pigment, to render this dematerialization of the visible world. The painting becomes like a shield in the sheer density of accumulated matter even as that same material stands for the radiance that fatally overwhelms an unshielded eye.

A key feature of the work in narrative terms is the uncertainty of what it represents. In addition to being a subjective evocation of the last moments of Regulus, there is a broad consensus that it also shows an earlier episode in his narrative, but whether it is his departure from Carthage to return to Rome, or from Rome to Carthage, there is disagreement. Turner himself seems to have been particularly imprecise, finally satisfying himself with the title *Regulus* for an image in which this person referred to is either absent or difficult to discern. There is general agreement, however, that Regulus is present in the image as a tiny white figure, at the top of a grand staircase, almost lost amid the architectural immensity of the city.[8] His visual insignificance amplifies the exchangeability, the indifference, of the various segments or passages in his life. Leaving and returning dissolve into each other. One city becomes all cities.

Clearly, the work is an overlapping of two or more disjunct moments in the narrative, a crystal-like faceting of time. But I would go further: it is an image in which the observer shares with Regulus an epiphanic realization, at the threshold of death and blindness, of the ephemerality of the social

world that had cultivated his self-annihilating, albeit exemplary, conduct, the delusions of duty and honor. In this reading, the painting is an image of fracture and dispossession, providing a searing apprehension of the divided nature of the self. It is the scene of a subject witnessing his own self made strange or alien and the attainment of a vantage point from which one's public identity and the grandiose edifice that held it together begin to dissolve into the spherical haze. Turner was preoccupied right at this time with the harsh dissonance between individual experience and social imperatives. In this sense, *Regulus* is consistent with the subject of other major works from the late 1830s: individuals who for most of their lives had been loyal servants of the state but are destroyed or discarded—the murdered Germanicus, the doomed Cicero, and the exiled Ovid. It was also a point in Turner's own life when there was a widening and unbridgeable division between his professional existence and the secretive conduct of his personal life.

Questions

James Elkins: About Deleuze and the crystal: one of the things that is going on in that trope is a rejection of various hierarchies: temporal ones, spatial ones, sequences of illusions. In other texts Deleuze attacks the unity of the philosophic subject by dividing it into "thises" and "thats"—he calls them "hicceities." That is critique by atomization, to take a word you used: it's a potentially interminable dissection or division into parts.

For me those strategies raise a speculative question: I wonder if for someone like Deleuze, there is a disintegration of the *structure* of distraction. The structures within the concept, which you've traced, might then have reached a point where they could be ignored or bypassed, or considered to be safely sequestered in a past history. Distraction would then be entering a structureless phase, or a "posthistorical" period.

Jonathan Crary: For better or worse, Deleuze's interests are never primarily historical, even though he does link the emergence of cinema in the 1890s with a parallel crisis in psychology that Bergson and others were discussing. But it's certainly interesting to think about the archaeology of the crystal image … and its future trajectories as well. The study of crystals in the nineteenth century was a crucial part of challenges to various fixed categories and hierarchies, to ideas of what was organic and what was inert. Dynamic processes and becomings could be located and identified in previously unthinkable sites and materials.

Barbara Stafford:	Jonathan, a comment based on the *Devices of Wonder* exhibition: we had a whole section on mirrors, called *Crystallina macchina*—that was the term the Jesuits used for their "metaphysical machines."* In a way Deleuze is going back to that potential of the mirror, that it acts as a *crystallina macchina*. That is also how Leibniz thinks of the mirror, as the root of the *Monadology*: as a universe in itself that is both here and there, that is infinite and yet also reflected and refracted through the monad. So I just want to push the genealogy backward in time a bit, and note that it has this lovely trajectory.
JC:	I didn't want to imply that Deleuze was ignorant of that. It's that his style is so nonhistorical.
David Ehrenpreis:	I have a methodological question. To some extent, methodologically, I'm uncomfortable with metaphor. Take your expression, the "spectralization of social life," which you use in your introduction and then employ repeatedly throughout the paper. By the end, we have a category that includes artists from Blake and Delaroche to Géricault, as well as the notion that a floating raft is like an unanchored perceptual experience, or that a figure opening a coffin can be understood as a mode of visual experience. In those terms, pretty much everything could be fit into your expression. I wonder how one draws the line, where one draws it, and how one decides where metaphor finds its end: I ask this because at the moment, I feel like metaphor could become all-consuming.
JC:	I have to say I don't understand your question. I examined three nineteenth-century paintings from a relatively limited historical framework, of about a decade and a half. Each painting is, as I suggested, a particular figuration of the act of looking, in which the objects of vision have deeply unstable or volatile features, historically and affectively. Also, I did not associate Blake with Delaroche and Géricault.
DE:	I meant the idea of using a metaphorical expression as an interpretive device. At this point, I don't know what "spectralization of social life" means.
Lloyd Spencer:	Turner's image of the sun that can blind as well as illuminate was hauntingly evoked in your presentation. My question concerns that other haunting you touched on. On the one

* Barbara Stafford, *Devices of Wonder: From the World in a Box to Images on a Screen* (Los Angeles, Calif.: Getty Research Institute, 2001).

hand, you talked about real machines and actual apparitions, if that's not an oxymoron; and on the other, you connected them to what I would call an anxiety concerning the changing role of images and appearance which you evoked, I think, when you remarked that "ghosts come not only from the past. Ghosts can come from the future." It seems to me we, here in this debate, inhabit that kind of anxiety about the visual and what is happening to the visual. I wonder if, in this light, you could gloss the phrase "the divergence between experience and its conditions."

JC: Some of my thinking around this paper had to do with another recent project. I was a contributor to a book called *New Keywords*, a collective updating of Raymond Williams's *Keywords*. Participants were assigned entries for many of Williams's words, but also for new ones. One of the words I worked on was *spectacle*. The project had a strong etymological emphasis, so during my research I became interested in the connections between *spectral* and *spectacle*. In the late 1700s, *spectral* begins to assume the meaning of not only "something that appears" but of an appearance that is deceptive and misleading. A related change occurs with *spectacle*. Around the same time these terms, derived from the Latin verb "to look at," shift into indicating a specifically modern suspicion about the act of looking, about what appears to sight, a skepticism about the visual that is very different from a Platonic tradition.

Jon Simons: I wonder if there might be something of a projection of our current concerns about a lack of shared reality, or a mediated or spectacle-driven reality, back onto the material you're talking about. I wasn't quite sure whether there was an overlap between issues of individual perception, on the one hand, and political uncertainty, on the other. Perhaps it was a question of the individual having to shrink back on their own individual experiences *because* of the uncertainty of the times, but not an uncertainty about the perception of the reality of the times. It made sense for Regulus to stick to his own Stoic values and face the consequences; maybe Turner was projecting the uncertainty of *his* times.

So my question is: couldn't it be that we have our own sense of the unreality of the times, rather than having a clear perception that the early nineteenth century, say, was analogously uncertain?

For a physical anthropologist interested in hominid evolution, visual literacy would include the ability to note differences in skull proportions and dentition even before quantitative measurements are made. As in many other areas, visual studies has taken the development and reception of the icons of hominid evolution as its subject, and bypassed the "technical" kinds of seeing that physical anthropologists employ when they study and describe such objects. This particularly striking shape is the "Taung child," an Australopithecine human ancestor from about 1,700,000 B.P.; the original was found in a lime quarry in Bophuthatswana, South Africa.

JC: I think you're quite right about Turner and his ambivalence about the position of the observer in his own historical moment. And I don't think that our experiences of the many perceptual facets of contemporary technological culture are analogous to what I've been outlining in the nineteenth century. I find it notable that in the early eighteenth century, coming out of the work of Hobbes, Shaftesbury, and others, that there is a pervasive belief that the individual has the capacity to overcome the lures and deceptions of spectral phenomena. But there is a disappearance of that confidence in the very late eighteenth century. I mentioned Burke, but Wordsworth and Blake are crucial as well: there is an increasing sense that the external world, and specifically elements of the social world, are becoming permeated with spectacles that in some way damage one's understanding of reality. It is then that the

human imagination becomes a significant counterweight, in terms of its ability to affirm its fundamental truths ... and then throughout the nineteenth century, there is a gradual deterioration in the belief in that ability of the imagination.

Sabine Kriebel: I am fascinated by the way in which your historical account offers tools, or access, to the notion of visual literacy. For me, historization provides a model for theorization; looking at structures and institutions in the past can help us understand present conditions. I want to ask what might then be an annoying question, since it would involve leaping forward two centuries. You use a number of terms to describe the conditions of the subjectivity of vision in the eighteenth and nineteenth centuries, such as *indeterminacy, atomism, unreality, internalization*. How, then, do you see the present world? For me, there is a striking disjunction between the present political situation and the ways in which we, too, are fascinated by things in boxes: not the camera obscura, but the computer, e-mail, the Internet, the cell phone—a lot of that is happening at the subterranean level, and there's a sense of madness about it. Having immersed yourself in the eighteenth and nineteenth centuries, and in these terms, what would you say about our present understanding of technology and vision?

JC: Well, to answer your question would mean giving another talk. My own concerns in terms of the present are very much tied up in problems of vision and community. And all of the technologies you mention are primarily techniques of isolation, of individuation, and only secondarily means of communication. For example, one of the most significant dimensions of Debord's work is his insistence that spectacle, with all its effects of separation, is about the destruction of community. And in this connection I'm also interested in another critical work from the 1960s, far more important than *Society of the Spectacle*, and that's Sartre's *Critique of Dialectical Reason*. Sartre's account of what he calls the "practico-inert" is a far more valuable description of the texture of contemporary everyday life than Debord's. And in it he shows that the accumulated weight of all the passive and habitual activities that hold modern society together can be broken by an act of vision, if I can paraphrase him this way. The key moment is the look of a third person, who is able to perceive in the relations between two others the understanding that what is impossible to

	achieve individually can be achieved collectively, as a group. Going back to your question, until we're able to reimagine technological culture in terms of the needs of groups and communities, rather than atomized consumers, there will be no real ground from which to invent new forms of political action.
Richard Sherwin:	I want to return to Jon's question, about the possibility that we might be projecting our own ontological insecurity back onto the time period you're discussing. Historically, one could go even further back, to the Baroque era, when there was a convergence between the spectral and the spectacle, one which resonates rather strikingly within contemporary conditions. Consider, for example, the way that spectacle and ceremony were exploited as ways of preserving monarchal power in the face of great public anxiety about its legitimacy. (Walter Benjamin, in particular, wrote with remarkable insight about this interconnected cultural and political phenomenon.)* The affinity between the spectacle and the spectral, and the undercurrent of communal anxiety to which they were meant to respond, has been thematized earlier than the mid-eighteenth century.
JC:	My sense is that except for a very marginalized class of cultural critics and artists in various parts of the world, there's a remarkable absence of anxiety or insecurity about the technological-media environment we inhabit. And obviously our current situation is to a large extent incommensurable with the earlier periods you mentioned.

Endnotes

1. Jonathan Crary, *Techniques of the Observer* (Cambridge, Mass.: MIT Press, 1990), 20.
2. Johann Wolfgang von Goethe, *Theory of Colours,* trans. Charles Lock Eastlake (1810; reprint, Cambridge, Mass.: MIT Press, 1982).
3. For a valuable overview, see Tom Gunning, "Illusions Past and Future: The Phantasmagoria and Its Specters," www.mediaarthistory.org.
4. See the important discussion of Delaroche and the poetics of nineteenth-century historiography in Stephen Bann, *The Clothing of Clio* (Cambridge: Cambridge University Press, 1984), 70–76; as well as Bann's indispensable *Paul Delaroche: History Painted* (Princeton, N.J.: Princeton University Press, 1997).

* See Walter Benjamin, *The Origins of German Tragic Drama* (New York: Verso, 1998).

5. Jacques Derrida, *Specters of Marx: The State of the Debt, the Work of Mourning, and the New International,* trans. Peggy Kamuf (New York: Routledge, 1994).
6. Max Stirner, *The Ego and Its Own,* trans. Steven Byington (London: Aldgate Press, 1982), 41–43.
7. Cited in John Gage, *Color in Turner* (New York: Praeger, 1969), 169.
8. See for example Gerald Finley, *Angel in the Sun: Turner's Vision of History* (Toronto: McGill-Queen's University Press, 1999), 98.

CHAPTER 4

From Visual Literacy to Image Competence

JON SIMONS

In this paper my focus is on the notion of "political image," which I take to be both startlingly simple and yet also incredibly complicated. In attempting to consider what political images are, I will discuss three considerations of images in a general sense, all of which have some bearing on the notion of political imagery. The first is commercial branding, which pertains to the connection between image and reputation. Then I venture into some contemporary neuroscientific understanding of mental images. The third consideration I look at is Tom Mitchell's family of images, which I would suggest has as much to do with image studies as visual culture studies. However, I am unable to derive a theory of political imagery from these considerations, but instead use them to complicate the theorization of political images, arguing instead that a pedagogy of political imagery should rely as much on image making as the interpretation and analysis of images.

I am concerned also with the distinction between visual images, or pictures, and images in a broader sense. By drawing attention to the difference between pictures and images, I suggest that an interdisciplinary pedagogy of "image studies" would be significantly different from an interdisciplinary pedagogy of visual studies. The latter would focus, for example, on the visual character of neuroscience as a discipline that relies heavily on imaging techniques. I do not doubt that the alternative

approach, which I take to be an aspect of visual studies as envisioned by our host, Jim Elkins, is a fascinating area of study.[1] Indeed, reflexive consideration of the ideas about images in contemporary neuroscience would have to take into account the visual techniques that are an integral part of the discursive formation of neuroscience. However, I do think that it is quite different for students to learn how to read magnetic resonance imaging (MRI) scans as well as learning to read Australian aboriginal art, than it is for students to learn how to read and respond to political images. Ultimately, the difference comes down to a nonexclusive difference between a formation of students as astute, fascinated scholars of the visual aspects of the world in which they live, and as astute citizens in that world. The difference between students as scholars and as citizens also entails different roles for universities, though each of them is equally anachronistic and unrealistic in current circumstances. Any worthwhile reflection of pedagogy in higher education today, certainly in the British case, must surely meld into an effort not only to understand those circumstances, but also to change them. While these necessarily political reflections go far beyond the current possible scope of this paper, the education of students as citizens entails that academics also act as citizens, taking responsibility for their pedagogic practices.

Political Pictures, Political Images

I will begin by explaining the difference between political images and political pictures with reference to the recently deceased Susan Sontag's essay on the photographs of the torture of prisoners in the Abu Ghraib prison.[2] The photographs are undoubtedly pictures of enormous political importance, and Sontag's essay is a fine example of at least one of the ways in which some pictures can and should be read. The predominant trope of Sontag's essay is nicely summed up by the first page subheading: "Susan Sontag on the Real Meaning of the Abu Ghraib Pictures." Sontag treats the pictures to a political hermeneutic, arguing that "complex crimes of leadership, policies and authority [are] revealed by the pictures." By looking at the pictures, Sontag can read the pathologies of U.S. political power and sociocultural existence.

Sontag's essay, though, is as much about what the photographs do, or what she would like them to do, as what they reveal or mean. First, she notes that photographs have accrued "an insuperable power to determine what people recall of events." Despite the Pentagon's planning, then, these pictures of torture would stick in people's minds as much as, say, the contrived toppling of Saddam Hussein's statue. Second, they "tarnish and besmirch the reputation—that is the image—of America." President George

W. Bush was "sorry that people seeing these pictures didn't understand the true nature of the American heart," while then U.S. Secretary of Defense Donald Rumsfeld worried about the reputation of the U.S. armed forces "who are courageously and responsibly and professionally protecting our freedoms across the globe." Sontag reports that the Bush administration principally deplored the damage done to the United States' image by the pictures. There is an important distinction between the visual images, the photographs that have political meanings and effects, and the political image, or reputation, that is affected.

I am interested in educating students to be engaged citizens, in which case the sort of discussion that would be generated by the photographs and Sontag's essay would be a good starting point. But, if the U.S. administration was so concerned about the damage to its image that the Abu Ghraib photographs could do, we should spend some time figuring out the nature of such images, the reasons for their significance, and how scholars and students can learn to appreciate how they function.

What Is a Political Image?

As I said previously, the notion of political image is at one level remarkably simple. Sontag uses it as a synonym for reputation. Margaret Scammell, a scholar of political marketing, concurs that the industry understands image in terms of "the reputation, trustworthiness and credibility of the candidates or parties."[3] So, *image* simply means something like reputation, overall character, or personality. The problems begin when we academics start picking away at that simplicity and when we encourage our students to do the same. Bush and Rumsfeld are referring to the reputation of the U.S. government and armed forces to bring what they call freedom and democracy to the world, which rests on the image of the United States as a free and democratic nation. To equate image with reputation can only be the very beginning of the elucidation of the notion of political image, because "reputation" is only ever part of the picture. It is always "reputation" with respect to something else (e.g., economic management, family values, being freedom loving, or possessing folksiness) that is part of the image of the party, politician, or country.

A political image is, then, as complex as the notion of "reputation." That is one reason why I cannot simply present a political image for analysis, such as the image of the United States. One might also wonder whether the vagueness of the term *political image* is a helpful use of the term *image*, but whether we like it or not, we are stuck with it, just as we are stuck with a sense of living in an ill-defined "image culture." I am going with the flow of conceptual imprecision, deferring indefinitely the attempt to define the "image"

part of *political image*. In trying to unpack further some of the complexities that are involved with political images, I will look at thinking about images in the contexts of marketing, neuroscience, and visual studies.

Brand and Image

Commercial brands are vital as a means of differentiation in a market environment in which products are very similar. According to Interbrand, an organization that markets branding, brands are used for the "inculcation" of "underlying appeals" to "create an indelible impression" on consumers.[4] The underlying appeal of brands is about "a compelling vision" or "compelling idea," which involves the move from "a commodity product to an emotional product, through to the real attachment and engagement that comes from creating an experience."[5] Branding, then, is about the emotional appeal of visions, ideas, and experiences. In Naomi Klein's account, the real product that is consumed is the brand, or products "presented not as 'commodities' but as concepts: the brand as experience, as lifestyle."[6] By the 1990s the cash value of the corporate brand was quantifiable, as companies such as Nike and Microsoft realized that they did not produce primarily things, "but *images* of their brands."[7] So, Klein usefully shows that corporate brands and images are interchangeable, and that such images involve personalities, consciousness, lifestyles, cultural meaning, and experience. That does not help us specify more precisely what the term *image* means even in the corporate context, but we can see that corporate images or brands are the same sort of images as political images. Scammell and Interbrand refer to similar points about reputation and trust. If the U.S. administration was concerned about the damage to the United States' image, it was also concerned about the falling value of its brand.

Brain and Image

Taking a cue from Antonio Damasio's popularization of his work in neuroscience, we might say that when the U.S. administration worries about the damage done to its, or the United States', image or brand, it is concerned with how people *feel* about the United States, or even what they *think* about the United States. Damasio's contested position in contemporary neuroscience holds that mental "images are the currency of our minds" and that "[t]hought is an acceptable word to denote … a flow of images."[8] He goes as far as to say that "any symbol you can think of is an image, and there may be little leftover mental residue that is not made of images."[9] By *image*, he means "a mental pattern in any of the sensory modalities, e.g., a sound image, a tactile image, the image of a state of well-being."[10] Damasio holds

From Visual Literacy to Image Competence • 81

that in the end, all the images in our minds come down to the body. They are "images of the interactions between each of us and an object which engaged our organisms."[11]

Images are the stuff of consciousness that emerges in evolutionary terms when the "primordial story" about the life states of an organism "can be told using the nonverbal language of body signals."[12] These body signals enable sophisticated life regulation of the organism in its environment. As Damasio puts it, "Good actions need the company of good images. Images allow us to choose among repertoires of previously available patterns of action and optimize the delivery of the chosen action." Images are "unwitting nonverbal signifiers of the goodness or badness of situations relative to the

Alex Trew's Million Dollar Homepage, www.milliondollarhomepage.com, as it appeared in October 2006. Trew made a homepage with a million pixels, and sold them in batches at a dollar per pixel. Advertisers quickly filled the page with their logos, creating a visual chaos that can only be understood by mouseovers and clickthroughs. The site is a nice emblem of the conceptually crowded subject of internet visuality—a field where scholarship can hardly keep up with new developments. The Million Dollar Homepage crashed in January 2006 after Trew refused to pay blackmailers; it has spawned imitations that sell ads by byte, and even one that sells by square inches of space on a picture of the advertiser's body.

organism's inherent set of values."[13] Emphasizing the evolutionary stakes again, he says that "survival in a complex environment ... can be greatly improved by purposeful preview and manipulation of images in mind," while consciousness connects "inner life regulation and image making."[14]

Damasio refers to very complex sets of actions and objects, including socially cooperative behaviors as actions and memories as objects. So, although images always come back to the body, or the relation of the organism to its environment, "we can invent additional images to symbolize objects and events and to represent abstractions."[15] According to Damasio's account we should expect political images of the United States, or of one's own polity, to be images of a general state of well- (or ill-) being. The image that the United States conjured up by the pictures of Abu Ghraib is a sick United States, one that does not ensure the social well-being of its prisoners and those who guard them, of those whose land it occupies and those who occupy it.

I would certainly have more work to make Damasio's notion of image work as political image, but the main point I want to make in this paper is that Damasio's notion of mental image is very amorphous, very difficult to pin down. As we saw above, he uses *image* to refer to all kinds of symbols and perhaps all mental activity. Indeed, his (and others') over-expansive definition of *images* has been criticized by Max Bennett and P. M. S. Hacker, who engage in a philosophical clarification of conceptual confusions that they claim bedevil contemporary neuroscience. They argue, "Mental images ... are a major source of conceptual confusion. For it is deeply tempting to conceive of mental images as species of the genus *image*."[16] Bennett and Hacker insist that "mental images are [not] private pictures, which one sees with one's mind's eye," because they are not pictures at all, and because one does not see with one's mind's eye, but visually imagines or recollects.[17] Mental images are not internal representations of what they are images of, because they are not determined "by convention, by similarity, or by *representational* intention."[18] Bennett and Hacker's basic point is that neuroscientists misconstrue the cogitative human faculty of imagination as a faculty that is always exercised in relation to mental images, yet imagination is not perception.

I take it that Bennett and Hacker would say that no purposeful preview and manipulation of images go on in our minds that enhance our well-being. We think about situations (not images of them) and have unconscious as well as conscious associations (not images) with such situations that would prompt us to repeat or avoid those situations. In brief, they would say that good actions do not need good images, but good thinking, of which imagination is a part. Thought is not a flow of images, or thinking about images, as it is too polymorphous to be characterized so reductively.[19]

I do not intend here to assess in detail the merits of Bennett and Hacker's criticism of loose neuroscientific talk about mental images. I see much merit in their point that neuroscientists need to think carefully about the concepts that they use. It is confusing for Damasio to talk metaphorically about seeing mental images, when such images are not visual images but mental patterns, which he says "we call, *for lack of a better term ... images.*"[20] But I would not rush to ascribe all such confusions to conceptual incorrectness, as if the concepts used in science are only the consequence or correlative of clear or muddled thinking, rather than of the complex social and cultural configurations from which they emerge.

Rather, my point in pitting Bennett and Hacker against Damasio is to show how complicated and involved the use of the term *image* is and how difficult it is to define a political image. Damasio is aware that he uses words as synonyms of each other, and our difficulty is perhaps that we cannot get much further than that without doing violence to the ways we use language. So, when elsewhere Damasio mentions the "experience of an image," we might wonder whether *experience* is another synonym for *image* and hence also for *mental pattern*.[21] *Feeling* may also be a synonym for *mental image* in his work. Idea, image, experience, perception, feeling. Bennett and Hackett might not like it, but I think I know what Damasio means, without actually being able to define a mental image or political image.

What Is an Image?

Tom Mitchell's groundbreaking work on images conceives of a family of images, made up of graphic, optical, perceptual, mental, and verbal images.[22] Bennett and Hacker would like to break up the family, as they do not believe that mental images belong to the same family as graphic and optical images. They fall into the trap Mitchell describes of beginning "by asking which members of the family are called by that name in the strict, proper or literal sense," with the implication that "other uses of the word are figurative and improper."[23] But of course Mitchell's family tree is so interesting because it is so difficult to figure out how all these different types of image end up in the same family, which like all families has unclear boundaries because of its alliances with other concepts and entities. It is also a family rife with disputes, about which type of image really belongs to the family or which type of image most defines the character of the whole family. If I were to try to fit political images in branches of the family, they would be perceptual and mental, yet they also seem to belong to Mitchell's parent concept of image, which refers to likeness, resemblance, or similitude in a nonliteral and nonpictorial sense, "an abstract, general, spiritual 'likeness,'" when *image* refers to something like *model* or

schema.[24] The image of the United States under attack by the Abu Ghraib pictures is thus given a likeness in a model or schema in which the abstract qualities of freedom loving, democratic, prosperous, virtuous, and powerful all play a part.

But my real point is not to decide which branch of the family political images belong to, because, as Mitchell argues, there is no uncontested or correct version of the genealogy of images, and so no uncontested delineation of the branches of the family. As he explains, "[A] book which began with the intention of producing a valid *theory* of images," looking for a "theoretical answer to the [question], What is an image? ... seemed inevitably to fall back into prior questions of value and interest that could only be answered in historical terms."[25]

The main lesson I want to take from Mitchell is humility. I am not going to come up with a definitive theoretical definition of a political image, certainly not on my own, precisely because the ideological stakes about political imagery are so high. This inability to come up with a theory of political images raises pedagogical questions. How am I going to teach students to be astute, informed, and engaged "readers" or interpreters of political images if I cannot begin by explaining to them the nature of that which I would like them to understand?

The Pedagogy of Political Image Literacy

One answer to my question of how to teach students about political imagery is to follow Mitchell, to lead them into a "critical fall into the space between theory and history" in which they can learn about the stakes involved in contemporary discussions of political imagery. I do this at the start of a (post)graduate-taught class called Thought, Image, Critique. I frame the beginning of the module with "the problem of images for politics." The first seminar description reads,

> In this seminar we look at a paradigmatic case of the alleged power of images. Politics, it is said, has been overwhelmed by the mass communications media, curtailing the possibilities for rational, public political discussion. Politics is said to have been subordinated to the marketing of parties and politicians by means of images, sound-bites and "spin." Media images thus appear to be a problem for politics, at least for democratic and socialist politics.

It is relatively easy using the work of Jürgen Habermas and others[26] to establish what is at stake in the debates about the prevalence of images in democratic politics, especially in the debate about the value of words in the form of discursive argumentation as opposed to images for democratic deliberation.

Having said that, it is much easier to find texts that make the case for the value of reasoned argumentation, and against imagery in politics and the pernicious influence of the mass media, than cases in favor of images in politics. A transdisciplinary perspective about the broader family of images, visual and nonvisual, encourages students to develop a range of ideas about the value of images of different sorts, expanding the discussion from iconophobia or iconophilia in relation to political images. Although I am unable to teach students a theory of political images, I have adopted another teaching approach, which relies on what the students already know. Instead of only talking about the texts that talk about political images, I now run class exercises that locate the students not only as cultural consumers (which is where the texts critical of political imagery place them) but also as cultural producers. For example, in the first seminar an exercise asks students to compare a British Labour Party poster from 1929, for the campaign that led to the first Labour electoral victory, with an infamous poster designed by Saatchi and Saatchi for the successful Conservative Party campaign in 1979. In 2004 students preferred to focus on how persuasive the posters were, and why, as if they were telling me that if I began by asking what political images are for, it would be easier to think about them.

The first exercise puts the students in the role of discerning cultural consumers. The second exercise situates them directly as cultural producers, which is where some of them will end up. It goes as follows:

> You are working in an advertising firm that has taken on a brief to promote and campaign for a political issue, party or even personality. Choose whatever political message you want to "sell," and think up a campaign concept together, that you can "pitch" to the rest of the group using an overhead transparency, the whiteboard, or just by speaking (or all three and anything else you can find).

I was happily surprised by the inventiveness of the students, who in minutes came up with some startling ideas. In this example students chose an obnoxious client, the UK Independence Party (UKIP), a populist, anti-European, and generally xenophobic party that has had recent success in elections for the European Parliament. Much of their success was ascribed to Robert Kilroy-Silk, a former Labour Party MP turned TV presenter, whose brief dalliance with UKIP ended when they refused to make him their leader. This poster is a piece of negative campaigning. The students were demonstrating that they knew how to market politically with minimal time and resources. What could they achieve given more time and resources? What would they learn about political imagery if the rest of the module taught them some graphic design, including

86 • Jon Simons

computer graphics; some copywriting; something about marketing; and some psychology? In other words, how much could students learn about being engaged and critical citizens if they learned the skills needed to produce as well as "read" political imagery? Perhaps I project too much from my own ineptitude in these areas, but I imagine that they would learn much of what they need to learn. When we become literate in a language, we learn to write as well as read. Competence in political imagery would thus demand the ability to make as well as interpret political images, just as science students learn to make as well as interpret images that represent data.

The Illiterate University

The university environment in which students (and faculty) could learn to make as well as interpret political imagery does not exist, and there is very little chance of it coming into existence, certainly in the British higher education system. I suggest that the obstacles to learning political image literacy in British universities are the same as those to learning visual literacy, in the sense outlined by Jim Elkins. As I understand Elkins's project for a pedagogy of visual literacy, it is about the formation of students as astute, fascinated scholars of the visual aspects of the world in which they live. But I believe there is another, anti-instrumentalist intention within his eclectic project for visual literacy that includes art history, science images, image-making skills, and non-Western images, only to argue in the end that there is no "general visual literacy." Rather than teaching visual literacy as a transferable skill that could be applied in any discipline or work setting, he says it is that which is "personal, embodied, unpredictable," not the "everyday manner of seeing that comprises habit, directed enquiry, and common experience."[27] Visual literacy is an aspect of an education that encourages students to attend to the world around them, to wonder in its details and in its patterns. The purpose of this is that "the university would be a richer and more challenging place if a range of such images were a *lingua franca*."[28] And the world would be a richer place, thought not literally so, if more people were educated to wonder in it.

Unfortunately, universities in Britain and other places such as Australia are being pushed in more rather than less instrumentalist directions. Higher education is beset by an instrumentalist managerialism characterized by the same audit culture of quality assessment, quality, and control that operates in the rest of public education, in the National Health Service, and in other public services. This audit culture has been introduced as part of the more general neoliberal strategy of governing all social institutions as businesses, with the added twist that all institutions become self-governing, become responsible for their own management according to practices or technologies of government that they have not chosen themselves.[29]

Outwardly, there has been no interference with academic freedom, because the auditing technologies of quality assessment are neutral in terms of content, which is why they can be transferred so easily from profit-making enterprises to public services. Representatives of academic institutions are nominally free to choose the content of the British Quality Assurance Agency's national qualifications framework and subject benchmark statements, which determine (though quite generally) what has to be learned and to what level in each subject area, or what are now

Visual literacy in philately is partly an offshoot of connoisseurship in the fine arts. There are entire books devoted to stamp forgeries; some require the same nearly microscopic attention that is helpful in spotting forged fine art prints. The politics of stamps—and the obliviousness of some collectors to that politics—involves a wholly different kind of literacy. Scholars like David Scott have studied the politics of stamp design, and there are pertinent theories of collection, including Walter Benjamin's, but no full-scale study of the subject. This is the first stamp issued for Zululand, with the profile of Queen Victoria.

to be called "learning outcomes." The benchmarks for communication and for media, film, and cultural studies do include a section on "skills of social and political citizenship" and the ability to "critically appraise some of the widespread common sense understandings and misunderstandings of communications, media and culture."[30] On the face of it, one of the outcomes to be monitored is the formation of engaged citizens.

But it is the "transferable skills" that really matter and in which potential employers are interested; these are also expressed in vague and vapid terms that describe in an inoffensive manner the sort of creative worker or entrepreneurial self who will thrive in the neoliberal environment.[31] Graduates will thus be able to "work in flexible, creative and independent ways, showing self-discipline, self-direction and reflexivity."[32] In brief,

we can teach what we like, subject of course to market demand and the generation of sufficient research funds, so long as the outcome of the learning process is the formation of self-disciplining subjects. And we can teach whatever we like, so long as we reform ourselves as self-reflexive practitioners who suit our teaching practices to the learning outcomes that are in fact the outcome of the managerial technologies of assessment.

I am repeating the complaints of colleagues over lunch and in the pages of the *Times Higher Education Supplement* because pedagogical issues are central to the concerns of this conference on visual literacy. I do not feel that at present I have the luxury of considering or even imagining new curricula in visual literacy or image studies that are not subject to the audit culture. We do not have the freedom to revive the old idea of a university in which a shared, transdisciplinary lingua franca of images can be learned. Nor do we have the freedom to establish courses dedicated to political image literacy that foster astute and engaged citizens, because in a democracy that means citizens who seek and exercise control of the political conditions in which they live, work, and learn. If we academics have lost collective control (if we ever had it) of the discursive practices by which universities are governed, what can we teach students about governing the conditions under which they live? In reflecting on the ideal pedagogy, program, or university, I have been drawn to reflect on how far we are from such an ideal. Politics will have to come before pedagogy, or, rather, only a political pedagogy can bring the sort of university in which dream programs for visual literacy or image studies can flourish.

Endnotes

1. James Elkins, *Visual Studies: A Skeptical Introduction* (London: Routledge: 2003).
2. Susan Sontag, "What Have We Done?" *Guardian,* May 24, 2004, sec. G2, 2–5.
3. Margaret Scammell, *Designer Politics: How Elections Are Won* (London: St. Martin's Press, 1995), 20.
4. Tom Blackett, "What Is a Brand?" in *Brands and Branding, an Economist Book* (April 2004), www.interbrand.com, 4, 2, respectively.
5. Blackett, "What Is a Brand?" 7; and Chuck Brymer, "What Makes Brands Great," in *Brands and Branding,* 2, 5.
6. Naomi Klein, *No Logo* (London: Flamingo, 2000), 21.
7. Klein, *No Logo,* 4.
8. Antonio Damasio, *The Feeling of What Happens: Body and Emotion in the Making of Consciousness* (London: William Heinemann, 2000), 318–19.
9. Ibid., 319.
10. Ibid., 9.
11. Ibid., 321.

12. Ibid., 30–31.
13. Ibid., 30.
14. Ibid., 24. See also Antonio Damasio, *Looking for Spinoza: Joy, Sorrow, and the Feeling Brain* (London: Vintage, 2003), 207.
15. Damasio, *Looking for Spinoza*, 204.
16. Max R. Bennett and P. M. S. Hacker, *Philosophical Foundations of Neuroscience* (Oxford: Blackwell, 2003), 181.
17. Ibid., 187.
18. Ibid., 193.
19. Ibid., 178.
20. Damasio, *Feeling*, 9, emphasis added.
21. Ibid., 323.
22. W. J. T. Mitchell, *Iconology: Image, Text, Ideology* (Chicago: University of Chicago Press, 1986), 10.
23. Ibid., 12–13.
24. Ibid., 33.
25. Ibid., 3.
26. See, for example, Jürgen Habermas, *The Structural Transformation of the Public Sphere* (Cambridge: Polity, 1989); Stuart Ewen, *All Consuming Images* (New York: Basic Books, 1988); and Daniel Boorstin, *The Image* (New York: Vintage, 1992).
27. Elkins, *Visual Studies*, 195, 193.
28. Ibid., 187.
29. See Michael Powers, *The Audit Society* (Oxford: Oxford University Press, 1997); and Cris Shore and Steven Roberts, "Higher Education and the Panoptic Paradigm: Quality Assessment as 'Disciplinary Technology,'" *Higher Education Review* 27, no. 3 (Summer 1995): 8–17.
30. Quality Assurance Agency, "Subject Benchmark Statements: Communication, Media, Film and Cultural Studies," http://www.qaa.ac.uk/academicinfrastructure/benchmark/honours/communications.asp.
31. See Nikolas Rose, *Governing the Soul: The Shaping of the Private Self* (London: Routledge, 1990), for the notion of the entrepreneurial self.
32. Quality Assurance Agency, "Subject Benchmark Statements."

CHAPTER 5

The Visual Complex
Mapping Some Interdisciplinary Dimensions of Visual Literacy

PETER DALLOW

Martin Jay, in his 1988 essay "Scopic Regimes of Modernity," argued that the modern era was "dominated by the sense of sight in a way that set it apart from its premodern predecessors and possibly its postmodern successor."[1] Certainly the scale and penetration of visual technologies, and the scope and range of visual practices and their consumption, expanded in the modern era. Authors and researchers such as Barbara Stafford, Jonathan Crary, James Elkins, and W. J. T. Mitchell, among others, have argued that we have entered a new cultural era where visual technologies, as much as the technology of visualization itself, have reached deep into our everyday lives, as they have into the sciences, architecture and engineering, the media, the arts and entertainment industries, the professions in general, and most of the social spaces we inhabit. The "visualization of knowledge," as Barbara Stafford has cogently argued, is integral to the functioning of all advanced professional activities, and hence to the curricula of all university teaching programs:

> The history of the general move toward visualization thus has broad intellectual and practical implications for the conduct of and the theory of the humanities, the physical and biological sciences, and the social sciences—indeed, for all forms of education, top to bottom.[2]

It is said that we now live in an image-centered visual culture. Marita Sturken and Lisa Cartwright in their *Practices of Looking: An Introduction to Visual Culture* propose that visuality "characterizes our age, because so much of our media and everyday space is increasingly dominated by visual images."[3] In a similar vein, Ron Burnett argues in the introduction to his 2004 book *How Images Think* that images "have become central to every activity that connects humans to each other and to technology."[4] Indeed, Burnett suggests that the understanding of images has become central to debates about the nature of human consciousness, as Barbara Stafford has noted the paradoxical attempts to image the (neural) seat of that consciousness in the sciences.[5] As Walter Benjamin put it, "[T]he mode of human sense perception changes with humanity's entire mode of existence."[6] Modern visual technologies, the "regimes of machine vision," as Jonathan Crary calls them in *Suspension of Perception*, have altered our relation to our world.[7] Visual media have helped to carve up reality, and have forced us, as Paul Messaris suggests in his 2001 essay "Visual Culture," to "see reality in a new and distinctive way."[8]

Studying "The Visual"

It is essential, according to Paul Messaris in *Visual "Literacy,"* to study visual activity in order to understand "the nature of picture-based media as a means of communication."[9] This does not mean that we should be exclusively concerned with the analysis of specific visual artefacts or "texts," or with developing a "good eye," or with developing a visual awareness based solely upon being able to recognize and manipulate basic visual "elements" of line, dot, shape, form, or scale. We need to consider visuality itself, as others have done, and consider looking in a broad cultural way. The task for visual literacy advocates is to consider more particularly the communicative processes of "the gaze" in visual culture, and "the power and importance the visual sense exerts upon our lives," as Donis Dondis suggested, because the ways we organize our response to the world have a "great dependence upon what we see" or "what we want to see."[10]

If we are to understand how "looking practices inform our lives beyond our perception of images *per se*," then we need to acknowledge, as do Gunther Kress and Theo van Leeuwen in *Reading Images: The Grammar of Visual Design*, that an image is not merely a picture, but involves social activity and interaction between people.[11] In a similar vein Charles Goodwin, in his essay "Practices of Seeing Visual Analysis," says that "visual phenomena can only be investigated by taking into account a diverse set of semiotic resources and meaning-making practices that participants deploy to build the social worlds that they inhabit and constitute through ongoing processes of action."[12]

The Visual Complex • 93

A paleontological visual literacy would include the capacity to assess a surface, such as this one. There are no organisms here, but only worm tracks, like those found on muddy beaches at low tide. These, from Newfoundland, are from the Cambrian era (542–488 million years ago). They are evidence of the "Cambrian explosion": the sudden proliferation of marine life that was later modified by catastrophic events and mass extinctions. Climatology is one of the principal subjects of paleontology, and ordinary, even uninhabited, surfaces are common objects of interest.

The perception of manmade "signs"—and so-called bracketed perception, in particular—involves learning and developing visual cultural forms that involve "coding": the construction and/or transmutation of the world into *signs* that work by analogy to what is represented. Bill Nichols

described images as "sensory impressions bearing a correspondence to the physical world."[13] Frederic Jameson, in *Signatures of the Visible*, put it as follows: "What is humanly produced must come in twos, by way of articulated contrast."[14] These "acts of recognition," as Nichols termed them, involve a sleight of hand ("This is not a pipe!") by signifying "presence-through-absence." With an image, he says, "[W]e are dealing with a source of sensory impressions upon which meaning has already been conferred."[15] Nor do we passively absorb these "ready-made meanings," he suggests. We interact with them in our minds. Hal Foster in *Vision and Visuality* refers to this as "the rhetorical conventionality of sight."[16]

Indeed, *the visual*, according to Jameson, is essentially pornographic, in that images "ask us to stare at the world as though it were a naked body."[17] Further, Jameson suggests, visual culture offers us the world as a "collection of products of our own making," of images in a sense made in our own image.[18] However, to cling to this correspondence theory too rigidly, he suggests, is to miss the actuality in which visual signs operate as "semiautonomous loops" in the social totality. Although there has been the potential for the "blanket reproduction of a scene," as Charles Baudelaire put it, since the advent of photography, there is no more critical capacity for "total signification" now, whether a manual or machine-made image, than there ever was. And there is no great awareness of just how entrenched imaging is across what we take to be essentially visual disciplines. The "visualization of knowledge" is integral to the functioning of all advanced professional activities, and hence is relevant to the curricula of all university teaching programs.

Understanding and Using Images

Roberts Braden and John Hortin have suggested that visual literacy has two aspects: the ability to *understand* images, and the ability to *use* them, "including the ability to think, learn, and express oneself in terms of images."[19] Ann Marie Barry, in her book *Visual Intelligence*, expands on the point about understanding images, implying that it should include developing an "awareness of the logic, emotion, and attitudes suggested in visual messages." This reference to the use of images implies "the ability to produce meaningful images for communication with others." Barry relates developing both the understanding and use of images to "a quality of mind developed to the point of critical perceptual awareness in visual communication."[20] Although the emphasis here is distinctly that of determinate outcomes, of being able to deliver a visual *message* via visual communication, Barry does caution that with the ubiquity and impact of the visual upon our lives, there are dire consequences for "actually

believing what we see." Bill Nichols had similarly warned in *Ideology and the Image* that visual "codes" can be "manipulated to our detriment.... [K]nowing how to structure meta-information to achieve a desired effect is a powerful skill." This "pragmatic logic" involves developing what Michel de Certeau would call a certain "tact," which we might think of as a subtle capacity to deploy conceptual and visual tactics.

Persuasiveness, Nichols proposed, "can be a matter of tapping the right set or frame of mind, of evoking one code and form of response over another."[21] This semantic and by extension emotional displacement through cultural coding and recontextualizing in images can be considered in both artistic and "inartistic" terms, Nichols suggests. The artistic is dependent upon "creative invention," and hence is linked to aesthetics and poetics. The inartistic, Nichols suggests, drawing upon Aristotle, is based upon the use of factual information, and hence is linked to rhetoric, and perhaps also could be thought of as what Mikhail Bakhtin termed "prosaics," like the modern difference between literary poetry and prose.

Here we might also think more in terms of journalism and other "realist" applications of visual imagery, because the very idea of an image carries with it also the sense of being a "likeness," of bearing a *resemblance* to something. This is where the "rhetoric of objectivity" inherited from science, and notions of "'hard' exposition" in news reporting, what Paul Messaris terms "concrete representation," comes into play.[22] This is also where images are seen to work primarily iconically, which is to say they work by analogy and visual correspondence to the "real world," and relate to experience of the real world. This is not, as Messaris points out, the same thing as saying that images can operate in the same way as everyday reality. Factors such as framing and prestructured viewpoint, editing, tonal range, narrative, chance, and two-dimensionality are just some of the ways in which they differ.

Complexity and Visuality

Although visuality is often taken uncritically in the public sphere as being associated with dumbing down, the actual complexity of visual activity promotes what Immanuel Kant called "reflective judgement." There is, however, a potential for a sense of overdevelopment of "visual awareness," for the overdetermination of art by a select few, in the quest to identify the universal in the particular—an overdevelopment that arguably contributed to promoting the "alienating effects" of modernism. The interchanges of the past fifty years between "the fine" and "the popular," between the visual and media arts, and between science and technology have perhaps opened up the critical field as widely as they have the fields of creative

visual practice. How can we think about the contemporary field of visual literacy or visual studies coherently within this broad interdisciplinary context? Articulating what may be meant by visual literacy is difficult, given the following:

1. There is no *single* fixed definition of what is meant by visual literacy, or even a prescribed set of objectives for it, or what the essential visual skills are.
2. Notions of literacy—and, indeed, of culture more broadly—are essentially socially constructed, and hence are mobile and situational in nature.
3. There have been, and continue to be, shifts in both the definitions of literacy more generally, and of the standards that they might imply, as well as the range and scope of the competencies encompassed by the term.
4. Literacy is not about acquiring an independent set of definable skills, but according to Gary Olson is something that is "deeply embedded in and produced by cultural forces and practices.... [C]lass, race, ethnicity, and gender all play crucial roles in the production and reception of literate behaviors, as well as in our very notions of what literacy itself is."[23]
5. As Maureen Hourigan argues in *Literacy as Social Exchange*, whichever provisional definitions or standards of literacy have emerged over the past two centuries, they have been products of various historical crises and associated social-political campaigns.[24]

To advance the case here for visual studies as an interdisciplinary initiative across the whole of university curricula, it will be useful to examine the present historical moment of visual literacy.

Literacy in Crisis?

The present circumstance of visual studies across the curriculum might itself be seen against the background of a specific historical moment of crisis in and around various notions of literacy. This has been triggered, perhaps, by the radical shifts in the technological, social, and cultural bases of our society since we entered the "information age." It was Manuel Castells, in *The Rise of the Network Society*, his seminal 1996 account of the arrival of "the Information Age," who proposed that in the late twentieth century a technological revolution occurred that was centered on information. This information revolution, he says, began to reshape industrialized societies across the globe so that information became the key ingredient of social organization, where "flows of messages and images

between networks [came to] constitute the basic thread of our social structure."²⁵ In this view, the visual is increasingly seen as the key to solving the imperatives of speed and efficiency in globally networked communications systems. (As Ron Burnett argues, images have become central to how humans connect to technology, and to one another.) Anne Bamford in *The Visual Literacy White Paper* says that "contemporary culture has become

Manolete sat bolt upright. "Doctor, are my eyes open?

I can't see!"
He fell back dead.

A life of acute visual decisions—the life of the twentieth-century bullfighter Manolete—is celebrated in a gaudy book called *The Death of Manolete*. The book opens with an oil portrait of Manolete, with his eyes lit and the rest in darkness. Sequences of photos, like film stills, are meant to give readers a sense of his unreproducible skill. The book closes with scenes of his deathbed, fetishizing his eyes. In the end, nothing of his visual competence is actually communicated.

increasingly dependent on the visual especially for its capacity to communicate instantly and universally."[26] Edward Tufte is perhaps the most widely read commentator upon the functional role that visual practices have played in the new informational contexts, and in explaining complex informational material by visual means.

But despite the rhetoric about the importance of information and visual *communication* in the digital era, the increasingly instrumental view of the basic informational role of visuality cannot substitute for a broader assessment of the social and educational imperatives around the visual (that is, visual literacy) in the "network society." The prevalence of digital technologies, for instance, has prompted David Buckingham, in his *Media Education: Literacy, Learning and Contemporary Culture*, to suggest that we now need "a broader reconceptualization of what we mean by literacy itself" to suitably advance educational curricula, rather than adopting "merely 'functional'" conceptions of it.[27]

This reconceptualization of literacy requires an attempt to locate visuality in relation to a broader contemporary interdisciplinary context. To use a term with a good deal of currency, we might think of *the visual* as being like an *interface* or cultural *zone* of social exchange, a space where the conventions in the construction of visual imagery and the prevailing or imminent social and cultural practices meet: a social sphere or arena where contemporary views of reality are displayed. Hence, a notion of visual literacy could be the capacity to negotiate or "navigate" this visual cultural zone.

Visual and Other Literacies: One Among Many?

Visual literacy, according to the 2003 *enGauge* outline of *Literacy in the Digital Age*, can be seen as nested within a larger set of "21st Century Skills," which are described as "Digital-Age Skills."[28] Digital-age literacy in this view can in turn be described as the skills needed to negotiate the changing social complexities of contemporary life, which is composed of basic literacy (meaning "linguistic skills"), scientific literacy, economic literacy, technological literacy, visual literacy, information literacy, multicultural literacy, and "global awareness." This is certainly an expanded field for literacy compared to some earlier configurations of the "three Rs." Visual literacy here is described as "the ability to interpret, use, appreciate, and create image and video using both conventional and 21st century media in ways that advance thinking, decision making, communication, and learning." It is interesting that there is no listing here for media literacy among the "literacies," although the description of visual literacy reads more as one would expect a description of media literacy to read. What is telling

and arguably indicative of many other sources is that the visual has been subsumed effectively into what others would describe as media literacy.

Tony Kirwan and colleagues, in *Mapping Media Literacy*, describe media literacy as including the ability to analyze a range of media; to think critically and reflectively about them, and about how reliable and pleasurable they are; and to evaluate their experiences of them.[29] James Potter, in a suitably imagistic turn in his essay "Media Literacy and Culture," defines media literacy not as a category of study, but as a *perspective*, built around our knowledge structures. That is, this perspective can be developed by knowing how to sort through the choices of meaning in media "texts," and the development of an awareness of "the interpretative process." This perspective is comparable to Ron Burnett's notion of the "vantage-point" as the key to an analytical methodology for studying images within their "image-worlds."[30] It revolves around the active processing of messages, where literacy equates having more options about meaning—"the purpose of media literacy is to give us more control over interpretations," according to James Potter.[31]

David Gauntlett expands the view of media literacy by linking it to "emotional literacy," in that the media consumed by young people in particular have them engaging with emotional issues through TV soaps, magazines, and so on.[32] Like Kirwan, he sees media literacy as crucially including the ability to *create* media "texts" as a key way to "cultivate" media literacy. Others describe media literacy as "an expanded information and communication skill" linked to "the changing nature of information in our society"; however, there is little account taken of the role and status of visual imagery or visuality more widely, including the existence of an aesthetic or indeed humanistic aspect to visuality.[33] We can say that the emphasis is toward the technological *mediation* of visual information, and the visual *communication* of relatively determinate functional messages. As with so much else in our societies, it was the advent of the new information and communications technologies (ICTs) and digitization—the computational environment, especially the distributed nature of digital imaging and new media, the much vaunted status of "virtual reality," and the accompanying hybridization of contemporary cultural forms—that shifted the basis of the disciplinary paradigms. The very notions and status of image, medium, and techno-culture were up for debate all over again. There is arguably a need to remap the whole sphere of cultural practices in a twenty-first-century manner; and, as Barbara Stafford has argued, there is a need to assert the role of the visual in this evolving educational environment by articulating to the wider public that "an understanding of the communicative modes and tactics of images is essential to a thorough, humanistic education."[34]

A New Era of Literacy?

We can say that with the rising (global) tide of mediated imagery in the advanced economies, the prevalent visual analogies are overtaking the entrenched educational position of the verbal, mathematical, and scientific analogies as systems to comprehend our world. As Kirk Pillow asserts in *Sublime Understanding*, the introduction of new modes of cultural production and consumption, and hence the introduction of new metaphors bridging mind and world, challenges "the interpretative status quo of participants in a given world."[35] There is a pragmatic need to understand, however provisionally, the whole range of sensory data we are confronted by, especially the visual. A serious concern about such an undertaking, though, as Stafford and Elkins caution, is that we risk allowing a new version of visual literacy to emerge that seems intent upon forgetting its own past.

A key element of the concern about this *new era of literacy* regarding visuality is that little account may be being taken of the analogical nature of visual imagery, or of its metaphoric force. This leaves users with only limited capacity to assess the claims (of truth, objectivity, veracity, and historicity) that are frequently made through visual means in the media—claims that are commonly constrained by the referential relationship to the thing represented, in which images are understood as offering in a sense a transparent window onto the world. Little account is being taken of the transparent associational "dreamwork" and "mirroring" within which the aesthetic aspects of the visual operate, particularly in art and popular culture, where the emphasis is, as Kant would suggest, upon creativity, interaction, and the inexhaustibility of meaning. The symbolic work of embodying ideas risks being left at a relatively naïve, realist level, which actually undercuts the very capacity to use visual imagery effectively for realist and humanist ends.

The ability to analyze the ideas, feelings, and concepts transparently suffused within visual signs risks being left at the level of impulse and supposition. The notion of what I want to term the *visual complex*, with a deliberately Freudian resonance as well as a slang edge, is particularly relevant to refining, if not defining, visual studies in relation to the other competencies. This notion of the visual complex can be thought of as an image of thought about images, and about the inherently complex cultural and material domain of visual phenomena. Knowledge of, and in, complex systems is by definition framed from a particular viewpoint. As Jonathan Crary asserts, "[I]deas about vision [are] inseparable from a larger reshaping of subjectivity" in the modern era, a reshaping that involves broad "processes of modernization and rationalization." Indeed, he claims that

Early Irish coins were minted in London. When they had to be restruck, they were copied, and because the workers were illiterate, the word DUBLIN became DIFLIN, DIFLN, DYFLN, DYFLIM, DY, DNE, IFIM … and finally the letters themselves disintegrated into uprights and simple forms: IN, NIO, HHO, IIIO.... All that mattered to the users of the coins was the shape and the presence of something they presumably took for writing. A literacy became a visuality.

visual perception and visuality "cannot be construed simply as questions of opticality," and asserts that "in recent years, within the expanding study of visuality, vision has too often been posed as an autonomous and self-justifying problem."[36]

Conclusion

Visual literacy, like visual culture, is complex, multidimensional, and embedded within a range of visual, cognitive, aesthetic, and nonvisual (emotional, ethical) dimensions. The notion of the *visual complex*, that is, a relational or situational conception of visual studies, can arguably serve as a multidimensional and embedded working model, useful in providing the practical coherence for *visual studies*. It can provide a *framework for diversity*, as string theory does within contemporary physics, but also should, as Caleb Gattegno proposed in his 1971 book *Towards a Visual Culture*, play a role "in the process of visualizing the future to help mold the present."[37] As

Marshall McLuhan suggested in *Understanding Media* in 1964, visual theory, like communication media, is an extension of ourselves that "depend[s] upon us for [its] interplay and [its] evolution." Education has a requirement to meet in practical ways the unfolding demands of our living visual culture, and to produce "the education that is necessary for our time."[38]

Visual studies needs to be linked to both communicative competence and action. It must offer a way to think about and model a dynamic approach to visual literacy, to visual imagery, and to the interactive experience of visual phenomena—an approach that can be situated coherently alongside the other literacies and the broader sets of professional and social practices being taught at the core of the university curriculum.

Endnotes

1. Martin Jay, "Scopic Regimes of Modernity," in *Vision and Visuality*, ed. Hal Foster (Seattle, Wash.: Bay Press, 1988), 3.
2. Barbara Stafford, *Good Looking: Essays on the Virtue of Images* (Cambridge, Mass.: MIT Press, 1996), 23.
3. Marita Sturken and Lisa Cartwright, *Practices of Looking: An Introduction to Visual Culture* (Oxford: Oxford University Press, 2001), 370.
4. Ron Burnett, *How Images Think* (Cambridge, Mass.: MIT Press, 2004), xiv.
5. Ibid., xv; and Stafford, *Good Looking*, 24.
6. Walter Benjamin, *Illuminations*, trans. Harry Zohn (London: Fontana, 1992), 216.
7. Jonathan Crary, *Suspension of Perception: Attention, Spectacle, and Modern Culture* (Cambridge, Mass.: MIT Press, 2001), 134.
8. Paul Messaris, "Visual Culture," in *Culture in the Communication Age*, ed. James Lull (New York: Routledge, 2001), 181.
9. Paul Messaris, *Visual "Literacy": Image, Mind, and Reality* (Boulder, Colo.: Westview Press, 1994), 4.
10. Donis A. Dondis, *A Primer of Visual Literacy* (Cambridge, Mass.: MIT Press, 1973), 1. Gillian Rose, in her *Visual Methodologies: An Introduction to the Interpretation of Visual Materials*, says writers on visual culture are "concerned not only with how images look, but how they are looked at." Gillian Rose, *Visual Methodologies: An Introduction to the Interpretation of Visual Materials* (London: Sage, 2001), 11.
11. Sturken and Cartwright, *Practices of Looking*, 5; and Gunther Kress and Theo van Leeuwen, *Reading Images: The Grammar of Visual Design* (London: Routledge, 1996).
12. Charles Goodwin, "Practices of Seeing Visual Analysis: An Ethnomethodological Approach," in *Handbook of Visual Analysis*, ed. Theo van Leeuwen and Carey Jewitt (London: Sage, 2001), 157.
13. Bill Nichols, *Ideology and the Image: Social Representation in the Cinema and Other Media* (Bloomington: Indiana University Press, 1981), 25.
14. Frederic Jameson, *Signatures of the Visible* (London: Routledge, 1992), 3.
15. Nichols, *Ideology and the Image*, 21.
16. Hal Foster, *Vision and Visuality* (Seattle, Wash.: Bay Press, 1988), x.

17. Jameson, *Signatures of the Visible*, 1.
18. Ibid.
19. Roberts Braden and John Hortin, "Identifying the Theoretical Foundations of Visual Literacy," *Journal of Visual/Verbal Languaging* 2 (1982): 37–51, cited in Ann Marie Barry, *Visual Intelligence: Perception, Image, and Manipulation in Visual Communication* (Albany: State University of New York Press, 1997), 6.
20. Barry, *Visual Intelligence*, 6.
21. Nichols, *Ideology and the Image*, 95.
22. Messaris, Visual "Literacy," 46–47.
23. Gary Olson, "Foreword," in Maureen M. Hourigan, *Literacy as Social Exchange: Intersections of Class, Gender, and Culture* (Albany: State University of New York Press, 1994), ix.
24. Maureen M. Hourigan, *Literacy as Social Exchange: Intersections of Class, Gender, and Culture* (Albany: State University of New York Press, 1994), 2–3.
25. Manuel Castells, *The Information Age: Economy, Society and Culture*. 2nd ed. Vol. 1 of *The Rise of the Network Society* (Oxford: Blackwell, 2000), 508.
26. Anne Bamford, *The Visual Literacy White Paper*, 2, www.adobe.com/uk/education/pdf/adobe_visual_literacy_paper.pdf.
27. David Buckingham, *Media Education: Literacy, Learning and Contemporary Culture* (Cambridge: Polity, 2003), 177.
28. See enGauge, "enGauge 21st Century Skills: Literacy in the Digital Age" North Central Regional Educational Laboratory, 2003, www.ncrel.org/engauge/skills/skills.htm, as an indication these current views.
29. Tony Kirwan, James Learmonth, Mollie Sayer, and Roger Williams, *Mapping Media Literacy: Media Education 11–16 Years in the United Kingdom* (London: British Film Institute, Broadcasting Standards Corporation, and Independent Television Commission, 2003), 5–6.
30. Burnett, *How Images Think*, 8–10.
31. W. James Potter, "Media Literacy and Culture," in *Readings in Mass Communication: Media Literacy and Culture*, ed. Kimberley Massey (Boston: McGraw-Hill, 2002), 36.
32. David Gauntlett, "Using New Creative Visual Research Methods to Understand the Place of Popular Media in People's Lives" (paper presented at the International Association for Media and Communication Research [IAMCR] conference, Porto Alegre, Brazil, July 25–30, 2004), www.artlab.org.uk/iamcr2004.htm.
33. "enGauge 21st Century Skills."
34. Stafford, *Good Looking*, 22.
35. Kirk Pillow, *Sublime Understanding: Aesthetic Reflection in Kant and Hegel* (Cambridge, Mass.: MIT Press, 2000), 277.
36. Visuality has emerged as the fundamental intellectual "problem" it is today, he implies, because of the modernizing forces of "specialization and separation"; Crary, *Suspensions of Perception*, 3.
37. Caleb Gattegno, *Towards a Visual Culture: Educating through Television* (New York: Discus/Avon Books, 1971), 43.
38. Marshall McLuhan, *Understanding Media: The Extensions of Man* (London: Sphere Books, 1964), 58, 168.

CHAPTER 6

Visual Literacy in North American Secondary Schools
Arts-Centered Learning, the Classroom, and Visual Literacy

SUSAN SHIFRIN

In the last fifteen years or so, the attention of a notable number of art historians, literary critics, and cultural historians—as well as those who have identified themselves as bridging such disciplines by practice and by preference—has turned to questions probing the nature, the definition(s), and the boundaries of visual culture and visual studies.

As James Elkins has written in a prior book with immediate relevancy to this one, "questions of pedagogy and visual studies lead directly to questions of visual literacy."[1] So it is that the debates that have persisted regarding the place of visual culture as an object of study (and visual studies as the means by which it *is* studied) within the existing academic framework—and the terms of those debates—relate directly to the contexts and terms of the debate about what visual literacy is and how it can be achieved. The terms of the scholarly debate naturally influence how scholars teach about visual culture and implement their own particular goals for visual literacy at the college and university level. This essay takes as its point of departure the premise that some aspects of the scholarly debate are relevant to—and can therefore help to elucidate—the pedagogical assumptions, practices, and divergences at the primary and secondary

school levels; and, as a result, that there is a degree of understanding to be gained by examining those practices and perceptions (initially at least) in the context of the larger debate, rather than as divorced and remote from it, as is often the case when secondary educational practices are considered in relation to those of higher education or of the academy in general.

In his 2002 article "Showing Seeing: A Critique of Visual Culture," W. J. T. Mitchell rehearses some of the salient points of the discourse that has evolved regarding the nature of visual studies as an academic pursuit at the undergraduate and graduate levels.[2] "Does it have a specific object of research, or is it a grab-bag of problems left over from respectable, well-established disciplines?" he asks.[3] "If it is a field what are its boundaries and limiting definitions? Should it be institutionalized as an academic structure, made into a department or given programmatic status, with all the appurtenances of syllabi, textbooks, prerequisites, requirements, and degrees?"[4]

The corollary question of whether the concept of visual literacy, however defined, merits the kind of full-fledged academic and curricular accreditation that incorporating it into state and local standards would grant it has been fundamental to discussions of the last twenty to thirty years regarding the integration of visual literacy into the program of curricular goals and outcomes for secondary education in the United States. Advocates, pro and con, have tended to argue their cases from one of two general perspectives.

The first envisions visual literacy as a set of skills and aptitudes that enables the literate student "to access, analyze, evaluate and communicate

Ophthalmological visual literacy involves the ability to use and interpret images that are very strongly modified by optical instruments. This is a drawing of two images projected by an ophthalmologist's slit-lamp microscope, one looking back to the retina and the other cutting a "light section" through the cornea and lens. Actually looking through a slit-lamp microscope is an astonishing experience, because the optics presents the eye as if it were an enormous cavern, like the inside of an I-Max theater. The object of interest here is a stellate or "feathery" cataract, caused by a blow to the neighborhood of the eye.

messages in a wide variety of forms," and, indeed, to support and facilitate the development of more conventionally defined literacies.[5] This kind of approach adopts—whether implicitly or explicitly—the paradigm of "multiple intelligences" put forward by such educators as Howard Gardner, and suggests functional and meaningful continuities among a variety of "texts": verbal, visual, and multimedia. A number of practitioners explicitly describe this approach in terms of a semiotic foundation. Others omit such a label, but describe visual literacy in terms overtly referential to semiotic modes of understanding:

> "Visual literacy uses the same competencies as phonetic literacy—decoding and comprehension—to decipher, comprehend, and interpret images, and critically evaluate the messages such images attempt to convey."... Decoding focuses on two elements of reading: semantics and syntax. Semantics are components of language—its "vocabulary," so to speak. Syntax is the way words are assembled to construct meaning—its "grammar." Transferring these definitions to a visual literacy framework, semantics and syntax can serve as visual elements with representative meanings—the vocabulary and grammar of images.[6]

Further, several analysts of the functions and practices of visual literacy write of it in analogical terms. Paul Messaris defines *analogical thinking* as "the ability to discern some structural similarity between two different objects, events, or situations, and to get a better understanding of one ... on the basis of the characteristics of the other."[7] He notes that the

> capacity for analogical thought is an important component of intelligence, in science as well as in art. ... [A]side from increasing students' fluency in analogical thinking, education about the uses of visual analogy might also improve perspective-taking skills (in the case of point-of-view conventions), as well as students' abilities to think critically about persuasive uses of visual media.[8]

Likewise, Griffin and Schwartz note that "sophisticated media viewing demands an awareness of media presentations as intentionally articulated," and suggest that "failure to recognize the processes of mediation" or to "see the picture frame" are among the most significant stumbling blocks to actualizing visual literacy.[9] The two articulate the process of achieving visual or media literacy as analogical to that of achieving linguistic or verbal literacy, or achieving an understanding of communication systems of any kind.

> [C]ommunication media in the late 20th century increasingly deliver information, advertising, and entertainment through complex arrangements of pictorial images and symbols, increasingly making

issues of media literacy issues of visual communication. Thus a sophisticated understanding of the nature of visual communication is essential to critical media consumption. Such heightened awareness involves moving beyond the naive treatment of pictures as simple records of reality to a recognition of the symbolic and metonymic quality of images within systems of conventionalized media representation. This, in turn, requires experience with the ways in which visual media presentations are created and packaged, experience gained through training in visual analysis and media production.[10]

Those who espouse such intertextual approaches to visual or media literacy tend to promulgate the integration of the arts for pedagogical purposes into a variety of other disciplines, such as language arts and social studies (these are the most frequent), and even math and science, as a means of enhancing the kinds of observational, analytical, and critical thinking skills that are assumed to be fundamental to successful learning in any of these disciplines.[11]

An alternate approach might somewhat reductively be characterized as that of "art for art's sake." Elliot W. Eisner, professor of art and of education at Stanford University, has written that

> carry over to the extra-artistic or extra-aesthetic aspects of life is not, in my view, the primary justification for the arts in our schools. The arts have distinctive contributions to make. I count among them the development of the thinking skills in the context of an art form, the expression and communication of distinctive forms of meaning, meaning that only artistically crafted forms can convey, and the ability to undergo forms of experience that are at once moving and touching, experiences of a consummatory nature, experiences that are treasured for their intrinsic value. These are experiences that can be secured when one attends to the world with an aesthetic frame of reference and interacts with forms that make such experience possible.[12]

The notion of visual literacy itself is defined by those adopting this alternate approach in a more focused, less broad-based manner as, for instance, "involving a number of actions (observations, analysis, speculation as to meanings, discrimination) and [implementing] ... a 'method for looking' intended to sharpen and develop these natural actions/reactions and to bring them into more conscious focus as cognitive operations."[13] The primary goal here is that of learning to look at, perceive, and respond to works of visual art (in this particular instance, though many programs with this approach address themselves to broader categories of "media" in general) in more mindful and cognitively engaged ways.[14]

Here again, there is a crucial point of convergence with the discourse revolving around visual culture and visual studies in the postgraduate and scholarly arena. One of the propositions of the Visual Culture Questionnaire published, along with responses, in the summer of 1996 posited, "It has been suggested that the precondition for visual studies as an interdisciplinary rubric is a newly wrought conception of the visual as disembodied *image*, re-created in the virtual spaces of sign-exchange and phantasmatic projection."[15] Art historian Svetlana Alpers responded,

> When, some years back, I put it that I was not studying the history of Dutch painting, but painting as part of Dutch visual culture, I intended something specific.... The difference [of] image/text was basic, in both historical and in critical terms, to the enterprise. But I was dealing with a culture in which images, as distinguished from texts, were central to the representation ... of the world. I was not only attending to those visual skills particular to Dutch culture, but claiming that in that place and at that time these skills were definitive.[16]

Alpers emphasizes a historicized notion of visual literacy in which the written text is very pointedly distinguished and set apart from the visual image, and visual skills are understood not only as quintessential to a culture, but as productive of that culture as well.

Art historian Carol Armstrong builds further in her own response, just a few pages later, on the desirability of separating text from image and insisting upon fundamental points of difference between the physically crafted, material "cultural object" and the verbal text.

> "[T]ext" [as] the mother-model [in visual studies] for utterances, performances, fashionings and sign collocations of all kinds is not unrelated to this disembodiment of the cultural object. I sometimes wonder if this is not simply a new face put on the old contempt for material crafting, the surface and the superficial, as well as the old privileging of the verbal register that went with traditional humanist notions of *idea* or *ut pictura poesis*, or with the iconographics of the old art history. Certainly it speaks to an indifference to questions of difference—an indifference, even a hostility, to thinking that there might be any foundational differences between media, kinds of production, or modes of sign, or that those differences might matter to either the producer or the consumer of a given object.[17]

Responding to a corollary predilection among those who administer and teach in secondary school programs for distinguishing between verbal texts—privileged by convention as the preferred and natural focus of

literacy initiatives—and audiovisual media, Roger Desmond approaches this contested territory from the vantage point of research on the theorized impact of TV viewing and media literacy development on reading skills and more conventional literacies. He proposes a middle ground between approaches that define themselves in terms of the continuity among disparate, cross-media "texts" and those that insist upon the fundamental differentiation (if not outright opposition) among media.

> One of the consequences of applying the literacy label is an automatic invocation of print as the logical opposite of video; the opposition emanates from a belief ... that video experiences displace reading. Regardless of the validity of the claim, there is accumulating evidence of interdependence among media in the construction of narratives by viewers and readers.... We can acknowledge differences among media without rejecting the notion of media literacy.[18]

Desmond's assertion that "there is accumulating evidence of interdependence among media in the construction of narratives by viewers and readers" finds its counterparts in the cautions of such responders as Jonathan Crary and Thomas Crow to the Visual Culture Questionnaire. Crary warns that

> any critical enterprise or new academic precinct (regardless of its label) that privileges the category of visuality is misguided unless it is relentlessly critical of the very processes of specialization, separation, and abstraction that have allowed the notion of visuality to become the intellectually available concept that it is today. So much of what seems to constitute a domain of the visual is an *effect* of other kinds of forces and relations of power.

And Crow notes that

> [a]dvanced art has always been mapped along a number of cognitive axes, its affinities and differences with other images being just one of these—and not necessarily the strongest. Commonalities with rhetoric, poetics, theology, or the abstractions of natural science could as readily be essential to a satisfactory artistic statement—for these disciplines could not be reduced to a linguistic medium any more than art could be reduced to an optical one.[19]

In these various disciplinary and interdisciplinary interchanges concerning the relative positioning of the visual and the verbal (as well as other sensory engagements), there is at play a question of which set of sensory responses, which set of historical or critical discourses, will take precedence. The Renaissance formulation of the *paragone*—a conventionalized,

rhetoricized contest for supercedence between the visual and the literary arts, and the resulting disposition of acclaim to the respective practitioners of those arts—is, in effect, sustained to this day in debates regarding the usefulness of building visual literacy skills at the secondary school level, as compared with the assumed necessity of building literacy skills revolving around reading and writing in verbal forms. While today's debates appear in general to eschew the philosophical underpinnings of earlier iterations and to privilege instead statistically defined trends and tactical solutions,[20] the notion of achieving cultural empowerment through access to and/or practice of privileged modes of expression and interpretation is still fundamental to the discussion. In general terms, educator and media literacy specialist Renee Hobbs writes that

> media literacy is essential to multicultural education ... strengthening students' knowledge about various media forms, [helping] develop analytic and creative skills in responding to media, [helping] students become skilled in using print, images, sounds and other tools to express and share ideas....[21] The new vision of literacy is centered around empowerment, defined as the "process through which students learn to critically appropriate knowledge existing outside their immediate experience in order to broaden their understanding of themselves, the world and the possibilities for transforming the taken-for-granted assumptions about the way we live."[22]

In more particular terms, ethnographer and film documentary producer Dwight Conquergood discusses what he describes as the "politics of literacy ... how it is implicated in the distribution of power and authority" in the context of his research on the "street literacy" evolved by teenage street gangs in Chicago.[23] Conquergood cites recent ethnographic studies of literacy as having expanded the notion of "what counts as writing" and as having

> (1) ... [foregrounded] the politics of literacy, focusing on how it is implicated in the distribution of power and authority; (2) ... [shifted] emphasis from abstract standards to concrete practices of literacy, a shift from normative to performative literacy; (3) ... [dismantled] the orality-literacy dichotomy that dominated previous literacy research; ... [and] (4) ... [abandoned] the conformist ideal of a singular literacy, opening the door to multiple and nonstandard literacy practices, variously called "local literacies," "vernacular literacies," and "grassroots literacies".... Rockhill (1994, 171) sets forth the tenets of [this ideological model of literacy]: "The construction of literacy is embedded in the discursive practices and power relationships of

everyday life: it is socially constructed, materially produced, morally regulated, and carries with it a symbolic significance which cannot be captured by its reduction to any one of these."[24]

In his study of Chicago gang graffiti, Conquergood describes in essence a visual literacy that manifests the characteristics of a "counterliteracy that challenges, mimics, and carnivalizes the 'textual power' ... that underwrites private ownership of property and the regulation, control, and policing of public space. This outlawed literacy grotesquely mirrors and mocks the literate bureaucracy."[25] As he attends in detail to the sign systems utilized by those subscribing to this "counterliteracy," Conquergood draws parallels between gang members' enactments of literacy-engendered empowerment and the more typical expressions of visual literacy familiar to us from other, more conventional settings, such as that of the art museum—a more routinized and sanctioned site of cultural authority—and that of the classroom, returning us to the discussion of secondary school pedagogy.

> These inventive, playful, and intensifying innovations within the basic signifying system are deeply meaningful to street youth.... Several times during the course of my fieldwork I have been taken on walking tours down back alleys and underneath bridges where articulate gang members take pride and pleasure in delivering detailed and insightful commentary on various graffiti walls in a presentational style that resembles that of docents in art galleries and museums.... If the 'docent' does not have the requisite cultural authority, he or she will be quickly replaced by a more knowledgeable member of the audience who steps forward and takes over the role.... It is the truism of critical pedagogy and emancipatory literacy that schools should teach by engaging the creativities, competencies, and capacities of students.[26]

PRAXIS

Regardless of the camp of the visual literacy advocates—those advocating intertextual, multiple literacies that incorporate and integrate visual literacy, or those focusing on developing visual skills and an understanding of visuality, themselves, as both the means and end—the goal of cultural empowerment is fundamental to the practical implementations of visual literacy at the secondary level. Eisner describes it in the following way:

> Through the arts we learn to see what we had not noticed, to feel what we had not felt, and to employ forms of thinking that are indigenous to the arts. These experiences are consequential, for through them

we engage in a process through which the self is remade.... The kind of thinking students learn to do will influence what they come to know and the kind of cognitive skills they acquire.[27]

In the course of doing the research for this essay, I have directly surveyed a number of educators and program administrators, as well as reviewed the literature to capture information about educational programs and projects of the last decade, across the United States, that have made the implementation of visual literacy initiatives at the primary and secondary school levels an explicit priority.[28] In this section of the essay, devoted to *praxis*, I will provide a brief overview of the ways in which a provisional (and necessarily eccentric) sampling of these programs, spread throughout the country, has defined visual literacy; of what kinds of theories and practices undergird the programs' implementation; and of what kinds of objects, images, or texts form their core curricula (if any are specifically identified). I will note whether they include partnerships with local museums, collegiate programs, and private organizations, and, if so, how these partners define their rules of engagement, as well as the goals and/or "products" of such strategies.

1. California

A. A number of elementary and middle schools in California implemented a program during the 1990s that made use of a "collaborative listening-viewing guide" relating to videotapes viewed during class. The guide was to be used collaboratively by students to assist them in receiving, recording, and processing viewed information by allowing them to preview and review the information before viewing the videos; recording what they saw on an individual basis; elaborating upon what they saw in small groups; synthesizing what they had all seen as a full class; and then extending what they had seen by working in pairs. The guide facilitated deeper learning through the use of flexible groupings during their classes, and the use of the processes of reflection, experiential learning, and constructivism, all in a manner that relied upon the development of multiple literacies. This program implicitly defined *visual literacy* or *media literacy* as the development of skills through the "processes of listening, speaking, reading, writing, and viewing [that] lead to higher order thinking and problem solving."[29]

B. In a 1999 article, Renee Hobbs documented the pedagogical strategies of the Re-Visioning Project, which involved teachers from

high schools in California, Georgia, Minnesota, Massachusetts, New Hampshire, and other states in a professional development institute hosted by Clark University in Worcester, Massachusetts, in 1998. Faculty leaders for the institute included Elizabeth Thoman, founder and chief program officer of the Center for Media Literacy in Santa Monica, California. Hobbs describes the program as an initial, weeklong institute for fifty teachers, followed by regular study group meetings, peer observations, and sharing of lesson plans and student work samples via the project's Web site. The program advocated an inquiry-based pedagogy and the embedding of the basic ideas of media literacy into all subject areas, particularly in the humanities. Media literacy skills were to be developed simultaneously with writing, reading, reasoning, and world knowledge skills.[30]

C. Hobbs writes in a more recent article on a range of programs in such states as California, Maryland, Massachusetts, and Texas. These include a K–6 media literacy program initiated in the 1990s in Malibu, California; magnet schools with curricular "communication arts" focuses, including Norrback Avenue School in Worcester, Massachusetts, offering a K–6 "integrated program of communication arts"; Communication Arts High School in San Antonio, Texas, which is described as emphasizing a "humanities-focused, multimedia literacy approach"; and Montgomery Blair High School in Silver Spring, Maryland, which Hobbs describes as having offered since 1988 a "Communication Arts Program, a highly selective program for students who wish to integrate the study of media and communications across the curriculum."[31] Hobbs notes that in such diverse programs and partnerships, teachers "discover" media literacy as an instructional tool simply from trying to motivate students' attention and interest in learning, without any awareness that a body of 25 years of scholarship and theory exists on the subject.... They start by using newspaper articles, film, or video clips to capture student attention and gradually begin to incorporate discussion, analysis, writing, or media production activities to promote critical inquiry. Other teachers begin with a sense of frustration or anger about some negative or problematic aspect of contemporary media culture, usually media violence, advertising and materialism, race or gender stereotyping, or concentration of media ownership. ... Teachers move from "sage on the stage" to "guide on the side."[32]

D. The educational organization Visual Understanding in Education (VUE), based in New York and cofounded by developmental psychologist Dr. Abigail Housen and museum educator Philip Yenawine (see entries for Massachusetts, Minnesota, New York, and Texas), works with partners in California, as it does elsewhere throughout the country. Their arts organization partners in California include the University of California, Los Angeles' Hammer Museum and the San Francisco Museum of Modern Art. Housen and Yenawine have been influenced in the development and implementation of this program by the work of Rudolf Arnheim, Jean Piaget, and Lev Vygotsky. The so-called core curricula for their programs are selected on the premise that the choice of images used should be "coordinated with the aesthetic development levels of the audience. For example, for beginning viewers we use images of art works that are narrative because beginning viewers are storytellers."[33]

2. Massachusetts

A. In a partnership among the Boston Museum of Fine Arts, the Boston Public Schools, and VUE inaugurated in 1996, twenty public schools' fifth-grade classes participated in a pilot program called Thinking through Art. The program provided professional development for a group of self-selected fifth-grade teachers and museum gallery instructors, teaching them to use VUE's Visual Thinking Strategies. These strategies were implemented as a "stimulant for cognitive growth," engaging teachers and students in changing "roles dramatically, so that the observations and ideas are coming from the students while the teacher listens carefully and facilitates the discussion." VUE's report on the project documented outcomes including "students growing in their viewing skills, developing lasting rapport with art objects, and coming to see the museum as a useful and interesting place ... increasing [teachers'] ... capacities to integrate art in ways that were broadly meaningful."[34]

B. VUE's current organizational partners in Massachusetts include the Museum of Fine Arts and the Isabella Stewart Gardner Museum in Boston, as well as the Cape Museum of Fine Arts. Each of these organizations works with local schools and school districts.

3. Minnesota

A. The elementary and middle schools of Byron, Minnesota, in partnership with the Minneapolis Institute of Arts and VUE, have participated since 1993 in a multifaceted program that includes professional development for their classroom teachers; yearlong, in-class instruction by classroom teachers utilizing art objects and facilitating discussion about them by implementing VUE's Visual Thinking Strategies; museum visits for every class in grades K–8; artist residencies at the participating schools; public and community programs; and an arts festival every spring. The program, consistent with VUE's general programmatic approach, deemphasizes the use of "information as a means to teaching beginning viewers," instead asking learners "to reflect on what they already know as the entry point into finding meaning" and teaching through asking open-ended questions, discussing what students see, and supporting conclusions by means of observations. The

process engages students in dialogues with their peers that expose them "to the more advanced thoughts of peers," and encourages individuals to learn by "'scaffolding' on each other's understanding and growing through interaction."[35]

B. The notion of visual literacy promoted by this program, then, incorporates the act of communicating and comprehending multiple perspectives, as well as the "aesthetic development stage growth" that is the hallmark assessment tool of the VUE projects, based on Abigail Housen's developmental psychology research. During the course of this project, cross-curriculum literacy developments were observed that were assessed as relating to the programmatic development of visual thinking strategies and critical viewing skills.

4. New Hampshire

A. Based at the University of New Hampshire, two related programs—Picturing Writing: Fostering Literacy through Art, and Image-Making within the Writing Process—are described by their developer and administrator, Beth Olshansky, as "art-based literacy instructional models ... that place art at the core of learning." According to Olshansky, the programs center on training teachers how to use visual images created by students to improve reading and writing skills.... Students (usually elementary school and middle school) create visual images as a way to think through, develop, record, and express their ideas. Their images then become a vehicle for accessing descriptive language. Images are used to rehearse, draft, and revise ideas before creating written text. Students read images to access descriptive language. We create multiple opportunities for transmediation to occur as students move back and forth between sign systems.[36]

B. Professional development training sessions for primary and secondary school teachers are taught out of the University of New Hampshire, Keene State College, Plymouth State University, and Antioch New England. Arts organizations involved in partnership with these programs include the Currier Museum of Art and the Vermont Alliance for the Arts, among others. The Exeter School District in Exeter, New Hampshire, has implemented these programs district-wide.

118 • Susan Shifrin

Image-Making Within The Writing Process®

Video
Student Work
Published Articles
Onsite Training
Calendar
Contact Us
Summer Institute
Exhibit

Image-Making Within The Writing Process is a dynamic art-and-literature-based approach to writing that integrates visual and kinesthetic modes of thinking at each and every stage of the writing process. Students begin by creating their own portfolio of beautiful hand-painted textured papers.

These papers not only spark story ideas but also become the raw materials for constructing stunning collage images. As students literally give shape to their ideas through cutting and pasting, they are able to rehearse, draft, and revise their stories long before setting pencil to paper.

As they build a sequence of images to tell their story, they are able to orally rehearse their story-line through "reading their pictures." Rich descriptive language is literally at their fingertips. Brainstorming sheets, especially designed for each page of writing, help students to access and record "silver dollar words." This hands-on process has proven itself to be particularly effective for at-risk students, those who struggle with traditional methods of writing.

Implemented in grades K-12, Image-Making can be used to teach a variety of genres including fairy tales, myths, legends, research-based stories or poetry, and can be easily integrated into the science and social studies curriculum.

Making the collages gave me more ideas for my story. Then I just looked at my pictures and wrote what came to mind. As I kept writing, the words just flowed together to make unique descriptions.

—Amanda, fifth-grade author of *Sarena and the Beautiful Skies*

Sarena and the Beautiful Skies

Sarena lived in the green grassy fields of Ireland that fluttered in the wind like butterfly wings. When the wind swirled over the hilltops, the green grass swayed like waves rolling into the bay.

5. New York

A. In a partnership between the City of New York and the Education Development Center/Center for Children and Technology formed during the 1990s, another initiative was launched to teach participating students new ways of looking at pictures, to integrate multimedia learning across the curriculum, and to utilize multimedia resources as a means of teaching students to critically evaluate the images that they see. Students function in this program both as composers and as consumers of images. The visual literacy skills developed in the course of the program are based on the notion that "to develop a critical understanding of photographic and video images is … to [grasp] that they are constructed."[37]

B. Another constructivist initiative has engaged elementary and secondary school students in New York City's public schools

in utilizing their aesthetic responses and experiences and the process of summoning and creating visual images as a means of "[opening] up spaces for imagination" and encouraging children to "go beyond the familiar" during writing workshops. The arts and poetry are incorporated as part of a curriculum described as a "curriculum of inquiry" based on reflection and creation. Literacy is defined in the context of this program as "a way we ... bear witness ... [and] reach across the barriers that separate us." Looking at visual arts is a means for achieving the goal of writing, predicated on the notion that in "looking to write ... unexpected things happen."[38]

C. In an article devoted largely to media literacy initiatives in the state of Pennsylvania, Renee Hobbs takes note of an Ithaca (New York) Public School District initiative called Project Look Sharp, a program in which Ithaca College has brought together college faculty, undergraduate and graduate students, and K–12 teachers in professional development activities that encourage community-wide critical discourse about media and seek to provide opportunities for media production to elementary and secondary school students throughout the region.[39]

D. The educational organization VUE (see entries for Massachusetts and Minnesota) works with partners in New York as well. Their arts organization partners in New York include the Rubin Museum in New York City and the Everson Museum of Art in Syracuse. Philip Yenawine, cofounder of VUE with Abigail Housen, served as the director of education at the Museum of Modern Art in New York before leaving in 1993. The Museum of Modern Art still utilizes a visual literacy implementation program based in some respects on Yenawine and Housen's work there.

6. Ohio

An initiative implemented in some Ohio elementary and middle schools seeks to enhance children's visual literacy through the use of picture books. The students are engaged in visual literacy-building activities intended to address specific comprehension strategies, such as "comic strip capers" to address the understanding of sequencing, "wordless wonders" that promote the use of visualization to fill in missing information, and "photo phun" to train students to predict and infer meaning in association with events depicted in photographs. As the two authors from Youngstown State University write in an article about this initiative, its programs implement visual literacy skills that encompass the ability to read and comprehend pictures as well as represent ideas in a visual format ... [as] an essential part of absolute or complete literacy ... required in today's society.... It is used by the young, elderly, hearing impaired and illiterate to understand ideas they cannot read in a text. In addition, visual literacy aids other members of society in describing ideas that are too complex to explain in simple text, by incorporating graphs, charts, diagrams, and other graphic organizers. Perhaps most importantly, visual literacy breaks the language barrier, making it an international communication tool.[40]

7. Pennsylvania

In her 2005 article devoted to media literacy initiatives in Pennsylvania schools described earlier, Renee Hobbs compares the state of Pennsylvania somewhat unfavorably with other states such as Maryland, Massachusetts, New Jersey, New Mexico, North Carolina, Texas, and Wisconsin, all of which are said to have implemented "significant district-level or state-level initiatives in providing in-service [media] education opportunities to teachers," and thus—by implication—to have promoted the integration of visual and media literacy into their students' curricula. By contrast, Hobbs

assesses the state of Pennsylvania as having fallen behind in this national movement toward more universal visual and media literacy integration at the primary and secondary school levels. However, she singles out some exceptions to this trend. In particular, she makes note of the Communications and Technology Academy of Roxborough High School, just outside of Philadelphia, whose teachers are involved in in-service training at the University of Pennsylvania on the integration of film and issues of race into curriculum planning at the secondary level. She points to middle school students in Meadville, Pennsylvania, who are working with documentary filmmaker Mike Keeley and a group of senior citizens to create a documentary about dance as a form of creative expression, through a collaborative project with the Active Aging Center. Hobbs also surveys privately sponsored community-based partnerships and private-public partnerships in Pennsylvania. She offers as examples of such initiatives the work of Cinekyd in Willow Grove, Pennsylvania, which provides hands-on audiovisual production experiences for eight- to seventeen-year-olds in a fee-based program; and Pittsburgh Filmmakers, which has partnered with the Allegheny County Library System to establish a media literacy arts lab in the main branch of the library in Pittsburgh, along with fee-based media production opportunities for fourteen- to seventeen-year-olds. The Big Picture Alliance partners with schools, community centers, and arts organizations in the greater Philadephia area to assist students in accessing advanced technologies; use the students' interest in media to develop their language, communication, and critical thinking skills; as well as boost their self-esteem and their affinities for teamwork.

While Hobbs's research indicates that at the state and district levels, Pennsylvania has not yet approached full integration of visual literacy into its curricula, private funders in concert with a range of arts organizations—particularly in the Greater Philadephia region—have led the way in establishing this goal as a priority. Such regranting organizations as the Philadelphia Arts in Education Partnership (PAEP) foster partnerships between public and parochial schools and arts organizations such as museums, theater companies, and dance companies in which artist residencies in the schools and programming designed by classroom teachers in concert with arts organization administrators and curators are integrated across the school curricula at levels ranging from K to 12.

I have designed and participated in such initiatives through my home institution, a college museum in the suburbs of Philadelphia that has ongoing partnerships with schools in Philadelphia, as well as with middle and high schools in the Perkiomen Valley School District, our immediate neighbor. One of these programs in particular cultivates explicitly the

goal of visual literacy in middle school students who undergo training to function as "peer docents" for their classmates. This initiative involves multilayered, cooperative teaching and mentoring by museum staff, classroom teachers, and college students, as well as the ultimate mentoring of middle school students who come to view exhibitions at the museum by their newly trained peer docents, who enhance their own visual literacy skills through an inquiry-based, close-looking approach. Multiple training sessions for the docents take place over a period of weeks at the museum, and involve the implementation of close-looking strategies in relation to objects ranging from the familiar Styrofoam cup to the works that come to the museum in traveling exhibitions.

8. Texas

A. A partnership between the city of Austin and the SouthCentral Regional Technology in Education Consortium (also known as RTEC) implemented a program of professional development for K–12 teachers that revolved around learning and teaching image analysis through the process of creating and reading "visual documents," such as advertising images. Using constructivist, problem-based instructional approaches, teachers learned that "visual literacy uses the same competencies as phonetic literacy—decoding and comprehension—to decipher, comprehend, and interpret images, and critically evaluate the messages such images attempt to convey."[41]

B. In her 1999 article documenting the pedagogical strategies of the Re-Visioning Project, Renee Hobbs cites the Carnegie Council on Adolescent Development (in 1996) as noting, in Texas, for example, twelfth graders are expected to access, analyze, evaluate, and communicate messages in many forms, including the ability to compare and contrast among media genres and the ability to produce a short documentary. Many other states are beginning to recognize that the ability to critically analyze and create messages using media and technology are essential skills for life in a media-saturated society.[42]

C. In "Deep in the Arts of Texas: Dallas Public Schools Are Boosting Student Achievement by Integrating Arts into the Curriculum," a Ford Foundation Report, Christopher Reardon wrote about a visual literacy initiative in the Dallas public schools whose declared goal is to help students make use of close observation, critical thinking, and written reflection, learned initially in response to art objects, in order that such visual literacy skills

"help them [to] remember details and make connections that they can use later when they sit down to write."[43] In the same article, Reardon emphasizes that this initiative is meant to cultivate academic achievement across the curriculum and is based on the premise that the "arts are central to a good education."[44] According to this report, the district-wide initiative is intended to ensure equity in learning, making residences and field trips to cultural sites available in every public school in Dallas; to link those artist residencies and trips to the core curriculum; and to leave decisions about which activities best meet students' needs up to teachers, rather than officials or arts administrators. The program is sponsored by the organization ArtsPartners, a partnership among the Dallas Office of Cultural Affairs, the Dallas School District, and Young Audiences of North Texas (now renamed Big Thought, and responsible for administering ArtsPartners), and funded by the Ford Foundation, which is reported in this article as funding similar projects such as this in Washington, D.C., and Jackson, Mississippi.[45]

The educational organization VUE (see entries for Massachusetts, Minnesota, and New York) works with partners in Texas as well. Their arts organization partner in Texas is the San Antonio Museum of Art.

9. Vermont

The Art and Literacy Connection, launched in Brattleboro in 2004, involves five elementary schools in partnership with the Brattleboro Museum & Art Center and the educational organization VUE (see illustration on the next page). The Art and Literacy Connection, which "seeks to enhance the literacy skills of students by making connections between viewing and discussing art, and carrying that forward to a creative-writing experience,"[46] utilizes a Visual Thinking Strategies program developed by VUE to enhance the cognitive development of the students involved by using "developmentally appropriate images and facilitated, open-ended discussions [of] ... art."[47]

10. Wisconsin

In Renee Hobbs's 2005 article described earlier, devoted largely to media literacy initiatives in the state of Pennsylvania, she notes that Wisconsin has developed a "statewide curriculum framework for media arts, recognizing its intersection with the fields of the arts, communication, and education."[48]

Endnotes

1. James Elkins, *Visual Studies: A Skeptical Introduction* (New York: Routledge, 2003), 127.
2. W. J. T. Mitchell, "Showing Seeing: A Critique of Visual Culture," *Journal of Visual Culture* 1, no. 2 (2002): 165–81.
3. Mitchell, of course, is just one of a number of scholars critiquing the nature of his and others' own practices in this area, as well as seeking to more concretely define their parameters. See, for instance, Mieke Bal, "Visual Essentialism and the Object of Visual Culture," *Journal of Visual Culture* 2, no. 1 (2003): 5–32; and the series of responses that it elicited in the same and following issues of the journal, including responses by W. J. T. Mitchell, Michael Ann Holly, Nicholas Mirzoeff, and Griselda Pollock, among others. The often-cited "Visual Culture Questionnaire" published in the journal *October* in the summer of 1996 (vol. 77, pp. 25–70; see a discussion of this questionnaire and some of the responses it engendered above) is perhaps one of the best-known and most influential of these critiques, and presents under one umbrella a wide range of scholarly perceptions and analyses regarding the purview and purposes of the study and the teaching of visual culture.

4. Mitchell, "Showing Seeing," 165.
5. P. Aufderheide and C. Firestone, *Media Literacy* (Queenstown, Md.: Aspen Institute, 1993), as quoted in Renee Hobbs, "A Review of School-Based Initiatives in Media Literacy Education," *American Behavioral Scientist* 48, no. 1 (September 2004): 42–59, quotation on p. 43.
6. Sebastian Wren, *The Cognitive Foundation of Learning to Read: A Framework* (Austin, Tex.: Southwest Educational Development Laboratory), 30, www.sedl.org/reading/framework/framework.pdf, cited in Mary Burns and Danny Martinez, "Visual Imagery and the Art of Persuasion," *Learning and Leading with Technology* 29, no. 6 (March 2002): 34.
7. Paul Messaris, "Visual Intelligence and Analogical Thinking," in *Handbook of Research on Teaching Literacy through the Communicative and Visual Arts*, 2nd ed., ed. James Flood, Shirley Brice Heath, and Diane Lapp (Mahwah, N.J.: Lawrence Erlbaum, 2005), 48–54, esp. 48–49. Messaris teaches at the Annenberg School for Communication at the University of Pennsylvania.
8. Messaris, "Visual Intelligence," 53.
9. Michael Griffin and Dona Schwartz, "Visual Communication Skills and Media Literacy," in Flood, Brice Heath, and Lapp, *Handbook of Research*, 40–47, esp. 41–42. Both authors teach in the University of Minnesota's School of Journalism and Mass Communication.
10. Griffin and Schwartz, "Visual Communication," 45. It is not uncommon in the literature on visual literacy to encounter the terms *visual literacy* and *media literacy* used interchangeably, particularly as viewing skills enumerated often encompass a range of media (some of which appear to address the eyes alone, and some of which call on other senses to accomplish the act of "viewing"). Canadian educator and researcher Deborah Begoray, for instance, enumerates various media that she conceives to be encompassed in "Viewing ... an active process of attending to and comprehending visual media such as television, advertising images, films, diagrams, symbols, photographs, videos, drama, drawings, sculpture, and paintings"; Deborah L. Begoray, "Visual Literacy Education in Canada, Scotland and England: Motives and Methods of Three Teacher Educators," *National Reading Conference Yearbook* 51 (2002): 117.
11. See a range of articles devoted to explicating and exemplifying this premise in Flood, Brice Heath, and Lapp, *Handbook of Research*.
12. Elliot W. Eisner, *The Arts and the Creation of Mind* (New Haven, Conn.: Yale University Press, 2002), xii.
13. Abigail Housen and Linda Duke, "Responding to Alper: Re-presenting the MoMA Studies on Visual Literacy and Aesthetic Development," *Visual Arts Research* 24, no. 47 (1998): 93. See also the definition of visual literacy articulated by Visual Understanding in Education (VUE) on its teacher training Web site:

[V]isual literacy is the basic capacity to make sense of a wide range of works of art in various media, styles, genre, and categories, at least at a basic level. ... It is the point at which a confident viewer willingly approaches familiar and unfamiliar works of art able to employ a variety of strategies to enter the work, see and think about what is there, and, if curious, pursue and acquire additional information. (Visual Understanding in Education, "Teacher

Training," www.vue.org/training_teach.html; quoted by Alice Anderson, administrative assistant for VUE, personal communication, August 3, 2005, in response to visual literacy questionnaire circulated by author.)
14. This is not to say that the development of such skills cannot be tracked in relation to how it boosts other relevant cognitive functions at the elementary and secondary school levels. However, those correlative data are not conceived as the primary targets of such programs, but rather as beneficial side effects. See, for instance, the documentation of a transition from the use of the so-called "developmentally-based art-viewing curriculum, the Visual Thinking Strategies" (VTS), promoted by Philip Yenawine and Abigail Housen in a collaboration between the Boston Museum of Fine Arts and the Boston Public Schools, and the subsequent development of the Thinking through Art program, which grew out of "reports from teachers that skills fostered by the VTS were transferred by students to assignments in other subject areas"; Karin DeSantis and Abigail Housen, *Report to the Museum of Fine Arts, Boston, on the Teacher Interview Case Study of the Thinking through Art Program, Spring 2000* (New York: Visual Understanding in Education, 2001), n. 7 and p. 2, www.vue.org.
15. "Visual Culture Questionnaire," *October* 77 (Summer 1996): 25.
16. Svetlana Alpers, "Response to Visual Culture Questionnaire," *October* 77 (Summer 1996): 26.
17. Carol Armstrong, "Response to Visual Culture Questionnaire," *October* 77 (Summer 1996): 27–28.
18. Roger Desmond, "TV Viewing, Reading and Media Literacy," in Flood, Brice Heath, and Lapp, *Handbook of Research*, 23–30, esp. 23. Desmond teaches in the Department of Communication at the University of Hartford. His analysis of the general suspicion that has greeted the campaign to integrate media literacy into the curriculum at the secondary level (and to view the process of viewing television in particular as worthy of pedagogical attention) is reminiscent of Mitchell's description of the "defensive postures" adopted by faculty at the college level reacting to visual studies as a "dangerous supplement." In Derridian terms, the study of visual culture is viewed initially as an internal complement to older, more established fields, but then, by pointing to potential lacunae in them, is soon viewed as threatening to displace them or to undermine them by emerging as a necessary supplement; see Mitchell, "Showing Seeing," 167.
19. Jonathan Crary, "Response to Visual Culture Questionnaire," *October* 77 (Summer 1996): 33; and Thomas Crow, "Response to Visual Culture Questionnaire," *October* 77 (Summer 1996): 35. The definition of visual literacy offered on the home page of the International Visual Literacy Association seems to codify these stances that warn against ocular purism or a culturally blinkered approach to interpreting visual culture: "Visual literacy refers to a group of vision-competencies a human being can develop by seeing and at the same time ... integrating other sensory experiences" (Maria Avgerinou, "What Is Visual Literacy?" International Visual Literacy Association, July 28, 2005, www.ivla.org/org_what_vis_lit.htm).
20. See, for instance, the virtually exclusive preference for and reliance on test-based analysis and assessment of educational strategies exemplified in the No Child Left Behind legislation promoted and passed by the administration of George W. Bush.

21. Renee Hobbs, "Literacy for the Information Age," in Flood, Brice Heath, and Lapp, *Handbook of Research,* 7–14, esp. 10.
22. P. McLaren, *Life in Schools* (New York: Longman, 1989), 186, cited in Renee Hobbs, "Strengthening Media Education in the Twenty-First Century: Opportunities for the State of Pennsylvania," *Arts Education Policy Review* 106, no. 4 (March–April 2005): 13–23, citation on 11.
23. Dwight Conquergood, "Street Literacy," in Flood, Brice Heath, and Lapp, *Handbook of Research,* 354–75, esp. 354.
24. Ibid., 354.
25. Ibid., 354–55.
26. Ibid., 365–67.
27. Eisner, *The Arts and the Creation of Mind,* 12–13.
28. Hobbs has written that different approaches to media literacy are emerging simultaneously in the 15,000 school districts in the United States as educators begin introducing students to instructional practices of media analysis and media production. Media literacy education has risen in visibility in K–12 schools throughout the 1990s.... [A] growing number of school-based programs are in place at the elementary, middle, and high school levels ... [with] unifying educational goals ... [of] learning skills rather than learning tools. (Hobbs, "A Review of School-Based Initiatives," 43, 54–55.)

 In the same article, Hobbs articulates in a slightly different manner from what I have written above the basic distinctions between the two "schools" of thought regarding visual literacy and how it should be taught and implemented in our schools: "two general patterns are evident. One pattern emerges from those teachers who seek to develop students' creativity and authentic self-expression; the other is found among teachers who are exploring economic, political, cultural, and social media issues in contemporary society" (43). Other very useful surveys of media literacy initiatives at the primary and secondary educational levels in the United States include the following: Rose Pacatte, FSP, "Riding the Wave of Media Literacy in the USA," July 28 (Boston: Pauline Center for Media Studies, 2005), www.daughtersofstpaul.com/mediastudies/articles/articlemlusa.html; and Robert Kubey and Frank Baker, "Has Media Literacy Found a Curricular Foothold?" October 27, 1999, http://medialit.med.sc.edu/edweek.htm.
29. James Flood and Diane Lapp, "Viewing: The Neglected Communication Process or 'When What You See Isn't What You Get,'" *Reading Teacher* 52, no. 3 (November 1998): 301.
30. See Renee Hobbs, "Teaching the Humanities in a Media Age," *Educational Leadership* 56, no. 5 (February 1999): 55–57.
31. Hobbs, "A Review of School-Based Initiatives," 51.
32. Ibid., 43–44.
33. Anderson, personal communication, August 3, 2005.
34. DeSantis and Housen, *Report to the Museum of Fine Arts, Boston,* 17.
35. Catherine Egenberger and Philip Yenawine, "As Theory Becomes Practice: The Happy Tale of a School/Museum Partnership," *VUE* (1997): 6–10.
36. Beth Olshansky, personal communication with author, August 2005, in response to visual literacy questionnaire circulated by author.

37. Cornelia Brunner, "Teaching Visual Literacy," *Electronic Learning* 14, no. 3 (November 1994): 16–17.
38. Mary Ehrenworth and Linda D. Labbo, "Literacy and the Aesthetic Experience: Engaging Children with the Visual Arts in the Teaching of Writing," *Language Arts* 81, no. 1 (September 2003): 43.
39. Hobbs, "Strengthening Media Education."
40. Philip Ginnetti and Mary Lou DiPillo, "Comprehension and Visual Literacy: What Is the Connection?" *The Ohio Reading Teacher* 35, pt. 1 (2001): 45.
41. Mary Burns and Danny Martinez, "Visual Imagery and the Art of Persuasion," *Learning and Leading with Technology* 29, no. 6 (March 2002): 34.
42. Renee Hobbs, "Teaching the Humanities in a Media Age," *Educational Leadership* 56, no. 5 (February 1999): 55–56.
43. Christopher Reardon, "Deep in the Arts of Texas: Dallas Public Schools Are Boosting Student Achievement by Integrating Arts into the Curriculum," Ford Foundation Report, Winter 2005, www.fordfound.org/publications/ff_report/view_ff_report_detail.cfm?report_index=549.
44. Ibid.
45. Ibid.
46. See the brief report on the program in "Museum Partners with Local Schools," *American Artist* 68, no. 748 (November 2004): 11.
47. Anderson, personal communication, August 3, 2005.
48. Hobbs, "Strengthening Media Education."

CHAPTER 7

Philosophical Bases for Visual Multiculturalism at the College Level

WILLIAM WASHABAUGH

Visual culture studies is poised to make significant contributions to undergraduate programs in North American universities, but in order to do so, it must be repositioned in the curriculum and its role must be made clear. To these ends, I will argue that visual studies can operate most effectively at the undergraduate level when combined with critical multiculturalism in a single mandatory general education course.

The aim of critical multicultural studies contrasts with the mission conventionally associated with multiculturalism.[1] Instead of describing cultural differences, critical multiculturalism aims instead to expose invisible forces that operate below the surface of any single process of cultural formation. The objective is to locate and diagnose problems *within* a cultural system rather to undertake descriptions *across* cultural systems. With these contrasting aims in mind, I argue here for critical multiculturalism as "the stronger multiculturalism" that Jim Elkins suggests is "waiting to be implemented" in conjunction with visual studies at the undergraduate level in American universities.[2]

Let me begin by proposing that the goal of visual studies in mandatory general education should be to enable students to understand, and intervene in, the constructions of race and gender that are mediated by their visual experiences. I will justify this claim in three ways. First, it is appropriate to focus on visual experience in order to comprehend the political ramifications

130 • William Washabaugh

of the judgments that people commonly attach to images. Second, visual experience plays a crucial role in the construction of race and gender. And third, image-mediated constructions of race and gender undergird conventional notions of culture and community—to the point that, without confronting race and gender, one cannot understand the practices of modern social life. I will consider these three justifications in turn.

In the field, geological visual literacy involves the ability to study a rock, either by eye or with a hand lens, and make deductions about its component minerals before they are subjected to laboratory analyses. This is an unusual mineral: Trinitite, a greenish glassy mineral formed by the fusion of desert sand at the Trinity atom bomb test site. It is shown here in a foam holder. The intense interest in the history of the atomic tests remains at the level of the social and political: Trinitite is a succinct reminder of how much more there is to be seen.

Visual Aesthetics and Power

The cultural sea change that transformed social life in late eighteenth-century Europe and America included an elevation of untheorized judgments to unprecedented prominence in the public sphere. Choices among, and preferences for, specific experiences of the eye, ear, nose, and skin suddenly began to carry the weight that faith and reason had carried in earlier regimes. In other words, judgments became—as they are today—authoritative.

By the early nineteenth century, the authority of individual value choices became widely accepted, as a number of scholars have pointed out. William Ray argues that "aesthetic judgments are open to negotiation, revision, even repudiation in terms of reigning styles or norms, but they can never be invalidated as expressions of subjective taste and of the individuals that produce them. As Kant succinctly put it, "taste claims autonomy."[3] This newfound authority of aesthetic judgments is legitimated less by reference to their logical standing or their conceptual rigor than by way of their grounding in bodily experience. In Terry Eagleton's words, "[A]esthetics was born as a discourse of the body."[4]

The new prominence of body-grounded aesthetics depends, in part, on an ambiguity or slippage that facilitates the projection of internal (mental) reactions onto external (public) experiences. Individuals slip unconsciously from judging the value *of* experience to hypostasizing value *in* experience. Barbara Herrnstein Smith describes this slippage as a circularity that enables the weight of an individual's "aesthetic experiences" to be shifted to the art that is experienced.[5]

Visual experiences are especially susceptible to such slippage because images elude the rapid temporal fading of olfactory, auditory, and kinesthetic experiences. Thus, images are typically available for the sort of sustained inspection that can facilitate viewers' transfer of value from its place in their own judgments to the object itself—where it can reside as if it were substantial. This visual objectification of value makes it possible to treat value on a par with matters of logic and reason.

This judgment of the value of visual experience begins a cycle that ends in newfound authority for the individuals who judge. "While aesthetic judgment takes the outward shape of a reaction to a work of art," according to William Ray, "it actually represents the mind formulating it." Or, in Friedrich von Schiller's words, when "he [the aesthete] sets it [the work of art] outside himself or contemplates it ... his personality becomes distinct from it."[6] Portraying this cycle in concrete terms, for example with respect to the experience of a museum, we can say that beautiful objects *standing alone* in a museum provide models for identity. In the face of such models, museum visitors understand themselves to *stand alone* in the world just

as the objects *stand alone* as independently valuable in the museum. As Jean-Luc Nancy suggests, "The fact that the fragmentary artwork declares its autonomy entails that the fragment takes on in one way or another a wholeness, a completeness, and hence an absoluteness that cancels the relativity it was the purpose of the autonomy of art to affirm."[7] In Eilean Hooper-Greenhill's words, "[T]he imagining of possibilities for the self is materialised and made tangible through objects."[8]

This confirmation of the self as a unique and autonomous judge is not automatic or inevitable. Paradoxically, individuals need to be coached into the conviction that they are uncoached judges. The practices that are responsible for this invisible coaching are generally associated with institutions that appeared abruptly at the end of the eighteenth century. William Ray offers a succinct list:

> They include first and foremost schools, but also public libraries, historical societies, natural history museums, art collections, operas, orchestras and chamber music societies, observatories, sculpture gardens, dance companies, literary clubs, public monuments, and poetry readings, to mention just a few. Most of these have clear antecedents in the early modern period as elite practices, but were funded as *public* resources only subsequent to the Enlightenment.[9]

At each of these sites, individuals engage in practices that paradoxically confirm their autonomy while enacting their deference to conventional authority. To draw on one of Ray's examples, "[W]hen we read newspapers we assert our autonomy as individuals, free to endorse or dispute the version of things presented.... [H]owever, we also absorb the categories of analysis proffered by the paper and affiliate ourselves with the normative views it purveys." As a result of such social confirmations of autonomy and deference, we "sort ourselves out," in Ray's words, "becoming aware of where we stand, but sensing that position as a consequence of our own cognitive decisions and feelings. One might say that the public discursive transaction enlists us in the process of our own social distribution." Ray designates this process "autotriage."[10]

Autotriage operates below the level of consciousness, forming identities invisibly in the course of interaction rituals, that is, in "subliminally experienced patterns of interaction ... [that] produce heightened mutual focus and bodily emotional entrainment." In other words, social interaction at the sites mentioned above leads to the construction of subjects that assume themselves to be unconstructed. This process and its outcome are consistent with Randall Collins's characterization of "modern individualism."[11]

To summarize the circularity of autotriage with respect to visual experience, we can say that modern individuals exercise vision within

institutional contexts that encourage them to formulate judgments of value about what they see, to attribute values to the images thus judged, and to conceptualize their own selves on the model of such valued images. The process, circular and fluid, involves a "merging of the sensory and conceptual modes: seeing in the mind's eye becomes embedded with conceptual exercises.... The sensory image gives the imagination body, while the cognitive imagination gives fresh significance to the image."[12]

Given that this circularity is pervasive, invisible, and mediated in large part by images, it is appropriate to recommend that the university, in its core curriculum, take steps to enable students to understand its operation. As Martha Nussbaum puts it, "[T]he successful and stable self-realization of a democracy such as ours depends on our working as hard as possible to produce citizens who examine tradition in a Socratic way.... Our institutions of higher education have a major role to play in this project."[13]

Visuality and Race

Let me now focus on one significant outcome of examining the circularity of autotriage in a Socratic way: the image-mediated self-construction in the United States and, before that, colonial America over the past three hundred years, which has almost always resulted in gendered and racialized identities. As Kalpana Seshadri-Crooks argues, "[R]ace is fundamentally a regime of looking."[14] Vision, she argues in her revision of Lacanian theory, is as deeply implicated in the construction of race as in the construction of gender. Specifically, she advances the claim, with arguments analogous to Lacanian arguments for the master signifier Phallus, that "the structure of racial difference is founded on a master signifier—Whiteness—that produces a logic of differential relations."[15]

I contend that Seshadri-Crooks's revision of Lacanian theory is consistent with Ray's autotriage and with the invisible image-mediated reproduction of race and gender. Just so, Paul Gilroy argues that race and gender generate "historically specific and unavoidably complex configurations of individualization and embodiment—black and white, male and female, lord and bondsman."[16] Moreover, these "complex configurations" are deeply implicated with the cultural shaping of visual experience: the challenge of exposing race and gender takes us

> beyond the discourses and the semiotics of "race" into a confrontation with theories and histories of spectatorship and observation, visual apparatuses and optics ... [requiring] us to rethink the development of a racial imaginary in ways that are more distant from the reasoned authority of logos and closely attuned to the different power of visual and visualizing technologies.[17]

The popular interest in rocks involves visual literacies very different from geologists' skills. Kinds of geodes, very subtle differences in the look of precious and semiprecious stones, and varieties of agate are among the discriminations that are part of commercial trade. This is an ocean stone, which has a naturalistically watery translucent "surf" made of bluish-white stone, which seems to crash against brown "rocks." (The rocks represent themselves, as it were.) The interest in ocean stones is similar to the curiosity about "picture rocks" and ideographic stones, which have been popular since the late Middle Ages.

The critical visual multicultural studies proposed here provides particularly effective tools for exposing the undercarriage of gendered and racialized identities. Just as students can be coached through the steps necessary to raise the veil of naturalness that hides the deeper operations of vision, so too they can be coached to raise the veil of naturalness that hides gendering and racialization in identity formation.[18]

This exposure of gendered and racialized identities is more than necessary in university studies: it is fundamental. It stands at the very core of

the university curriculum. Without such a confrontation, students cannot effectively deal with the immediate consequences of racializing and gendering practices in modern life. Moreover, they cannot respond to ramifications of race and gender in the formation of "cultures," "nations," and "ethnicities."[19] Students of sociology and political science will lack the conceptual tools necessary for interrupting racialized practices. Students of biology and the medical specialties will continue directing attention to superficialities of race and gender as visualized instead of discerning the genetic complexity that undergirds visual simplicity.

The confrontational pedagogy that I propose intrudes into conventional imaging, and provokes students to reflect on their own self-constitution. Teachers can orchestrate such intrusion by challenging students with visual experiences that, like trompe l'oeil projects that create cognitive dissonance, "lead the observer to deconstruct the coherence of the percept and to perceive conflicting cues about the reality status of the scene."[20] An instructive example of just such a visual exercise can be found in Scott McGehee and David Siegel's *Suture* (1993), a movie that interrupts viewers' assumptions about racial visibility, suggesting that racialized reality is a projection of the mind. The goal of *Suture*'s intrusion is to encourage new ways of seeing—not unlike the new way that Auggie suggests to Paul as he wrestles with a confounding photographic collection in Wayne Wang's *Smoke* (1995).

The University

The intrusive teaching of visual multicultural studies that I propose may well be decried by the academy. The reason is that the university is itself a conservative institution and has long been complicit in the reproduction of gendered and racialized identities. As an institution, it cannot help but operate in ways that maintain the invisibility of its own identity-forming operations. In the face of this conservatism, a number of scholars have suggested reconceptualizing the university itself. Bill Readings argued that the university is a dissensual community, one that is "no longer tied to the self-reproduction of the nation-state." Instead, the university should become a place where the practices of teaching refuse "the possibility of any privileged point of view so as to make teaching something other than the self reproduction of an autonomous subject."[21] Along similar lines, Louis Menand has observed that university disciplines have been falling into disarray partly because conventional organizational practices no longer function well in the fast-changing twenty-first-century universities.[22] Readings, Menand, and others refocus attention on the university's core mission, which is to encourage Socratic reflection and to critically examine

the practices of everyday life. Here I have tried to justify just such a refocusing around the aesthetics of race and gender.

Such a recentering effort cannot involve simply shifting more attention to gender and multicultural studies, because, in the conventional university, these interdisciplinary efforts are already marred by fragmentation and dispersal. As Annette Kolodny argues, interdisciplinary studies have traditionally been advanced "in spurts and tremors ... lacking systematic attentiveness [that therefore] makes progress slow and piecemeal."[23] And Martha Nussbaum observes that "the courses listed as satisfying the 'diversity' requirement are unrelated to one another by any common discussion about methodology.... [They] may not even produce a student who knows how to inquire about diversity in a new context."[24] This lack of methodology, together with inattentiveness to core issues, was precisely the problem that gave rise to "critical multiculturalism" in the 1990s.[25]

Critical multicultural studies alerts us to the need for a more profound reflection about the core curriculum of the university. This need can best be met, according to Nussbaum, with "a single basic 'multicultural' course to acquaint all students with some basic conceptions and methods."[26] It would serve the mission of the university by fostering Socratic reflection, enabling students, in the words of Michael Bérubé, "to understand the varieties of evaluative mechanisms by which people actually participate in popular culture."[27] Such a single-course approach would be an effective alternative to the ill-focused array of courses that presently serve to fulfill cultural diversity requirements on North American campuses. Moreover, it would meet what Andrew Delbanco describes as the pressing need for "some measure of commonality" in the curriculum.[28]

Within such a single multicultural course, the issue of ideology would be central. Accordingly, such a course should provide ample opportunity for contemporary studies of whiteness.[29] In place of wide-ranging celebratory descriptions of minority groups and their histories, studies of whiteness focus attention on the ideological forces that create ethnic groups, and on the gendering and racializing processes that reproduce privilege. These studies demonstrate "the impact that the dominant racial identity in the United States has had not only on the treatment of racial 'others' but also on the ways that whites think of themselves, of power, of pleasure, and of gender."[30]

It is important to appreciate this focus on whiteness as a key concept in a core course on visual multiculturalism. It affords the possibility of exposing processes of naturalization that enable gendered and racialized identities to persist. Such a focus enables scholars to penetrate the taken-for-granted experiences that lie at the root of racialization. Moreover, such

a focus on whiteness opens the way for the collaboration of visual studies and critical multicultural studies in a single critical course.

Summary

Visual multiculturalism is the task of exposing the ground on which modern identities are constructed. This racialized and gendered ground is established in the course of living everyday life under the influence of institutional constraints that simultaneously shape aesthetic judgments and confirm their importance. Individuals at play on this ground—in institutional settings—objectify and naturalize themselves as raced and gendered persons.

Exposing this ground and explicating the operations of figuration that it supports comprise the aim and mission of critical visual multicultural studies. Instead of being a conventional program of multicultural studies that generously, or tolerantly,[31] extends the benefits of white males to other races and genders, visual multiculturalism begins with the assumption that all identities are historically reproduced as gendered and racialized figures, and all are complicit in the figuration process because identities reciprocally define each other. Hence, critical visual multiculturalism must interrogate the ground of identity rather than one or more of the figures.

Since the university is itself one of the conservative institutions in which gender and race are reproduced, critical visual multiculturalism must rise above the conventional work of university disciplines and departments. It will operate effectively in a mandatory core that is independent of departments. The core of the core should be reserved for studies in visual multiculturalism insofar as such studies offer methods for exposing the hidden workings of everyday experience.

Coda: A Provisional Listing of College-Level Curricula

Currently in North American universities, a number of undergraduate programs entitled *media studies, film studies, visual studies*, and *art historical studies* offer interdisciplinary approaches to visual aesthetics. Many of these have come to incorporate emphases on race and gender, an indication of a movement toward a common curriculum of visual multiculturalism.

1. At the University of Chicago, the Committee on Media Studies addresses "the cinema in broader cultural, social, and aesthetic contexts, such as visual culture and the history of the senses; modernity, modernism, and the avant-garde; narrative theory, poetics, and rhetoric; commercial entertainment forms and leisure

138 • William Washabaugh

and consumer culture; sexuality and gender; constructions of ethnic, racial, and national identities" (http://humanities.uchicago.edu/cmtes/cms/academics/undergrad.html).
2. The Modern Culture & Media Program at Brown University professes a "commitment to situate the study of media in the context of the broader examination of modern cultural and social formations" (www.brown.edu/Departments/MCM/undergraduate/mcm).
3. The Department of Film and Media Studies at the University of California, Irvine offers undergraduates a major that teaches them "to read and understand the audio-visual languages of modern media and new technologies and to analyze images from socio-economic, political, aesthetic, and historical perspectives." This program is critical insofar as it "involves learning new ways of seeing" (www.editor.uci.edu/catalogue/hum/hum.10.htm).
4. At Columbia University, the Department of Art History and Archeology offers a combined major in art history and visual arts (www.columbia.edu/cu/arthistory, www.mcah.columbia.edu).

Philosophical Bases for Visual Multiculturalism at the College Level • 139

5. The Visual Studies Program at Cornell offers undergraduates a general program; their Web site announces they "combine critical theory and art history in mutually enriching forms. We link traditional visual material to new media, and in the process pose questions for the future that continue to shape our common discourse" (http://dspace.library.cornell.edu/handle/1813/632).
6. The State University of New York at Stonybrook offers an undergraduate major in cinema and cultural studies that considers film as a form of representation in and of itself and in relation to other disciplines such as literature, art, and theatre. By emphasizing the emerging discipline of cultural studies, the major is designed to show how cultural forms such as cinema and the other arts develop and interact with each other and with social, historical, and economic forces (http://naples.cc.sunysb.edu/CAS/ubdepts0305.nsf/pages/ccs).
7. The Pratt Institute offers a Critical and Visual Studies program that enrolled its first students in the fall of 2002, enabling "students to meet new needs in the rapidly changing world of arts and culture. Students learn the theory and practice of Critical and Visual Studies, including cultural production, cultural policy, and cultural intervention" (www.pratt.edu/newsite/index.php).
8. The University of Wisconsin–Madison has begun a Visual Culture Cluster that includes "a commitment to uncovering and investigating the long-ignored social dimensions" of visual experience (www.visualculture.wisc.edu).
9. The University of California, Riverside offers a minor in film and visual culture, described as "an interdisciplinary examination of film, television, digital multimedia, and visual culture, with an emphasis on history and theory, rather than production, in order to develop media literacy" (http://filmandvisualculture.ucr.edu).
10. The University of California, Los Angeles offers an art history major that helps students "understand the visual arts in their contexts. Emphasis is placed on the social, political, historical and religious contexts of art; visual analysis is also stressed" (www.humnet.ucla.edu/humnet/arthist/the_program/undergraduate.html).
11. The School of Communication at Northwestern University offers a minor in film and media studies, enabling students "to acquire the critical tools necessary for the rigorous analysis of traditional and new media, combined with knowledge of some of the crucial historical and interpretive problems raised by the study of media within the broader context of the humanities and social sciences" (www.communication.northwestern.edu/rtf/programs/undergraduate/fms/).

12. The Art Education program at Penn State University has developed a Visual Culture Studies Workshop designed to prepare teachers in critical visual studies (www.sva.psu.edu/arted/program/ vc_vfdillon/).
13. California College of the Arts provides a broad program in studies of visuality emphasizing "the history of art, architecture, and design; film, video, and new media studies; aesthetics; semiotics; and cultural studies" (www.cca.edu/academics/visualstudies/).
14. The University of Nebraska at Lincoln offers an interdepartmental film studies program "designed for students who wish to ultimately work in academic film studies, and also for those students who wish to understand film better as an art form, as popular culture, and [as] a major medium of communication" (www.unl.edu/english/undergrad/filmstudies.html).
15. The Texas Tech program in visual studies "prepares graduates to teach critical reflection and creative visual expression in multiple settings (schools, museums, community and regional arts programs), assume community and state leadership roles within the field of art education, and innovate curricular content based on contemporary cultural developments and community needs" (www.art.ttu.edu).

These are visual studies programs that, in one way or another, recognize the impact of the visual on the social. These visual studies programs shoulder, in their various ways, the shared mission and method of visual studies and critical cultural studies. It seems important also to mention programs that adopt the reverse tactic of working from already established programs in cultural studies toward an increased involvement with visual studies, giving more prominence and a larger role to the latter in

order to advance the former. For example, at the University of Michigan, the American Culture program exposes students to the interdisciplinary study of U.S. society and culture. The mission statement contends, "Our courses integrate a rich array of materials, themes, and approaches from many fields: not only historical and literary study, but also visual studies, musicology, film and media, anthropology, and others" (www.lsa.umich.edu/ac/home.htm). Scores of North American universities offer programs like the University of Michigan's American Studies, and many of them are taking visual studies into consideration.

On a related front, visual and multicultural studies are being pursued between and even beyond universities. For example, the Crossroads project at Georgetown University aims to change the ways universities work, and to do so by promoting collaborative visual cultural studies. Seventy faculty on twenty-one campuses participate in the Visible Knowledge Project (See the illustration on the previous page). Among these campuses, thirteen have been invited to become core campuses: Borough of Manhattan Community College, City College of New York, CSU Monterey Bay, CSU Sacramento, Georgetown University, La Guardia Community College, Millersville University, University of Southern California, Washington State University, Vanderbilt University, University of Alabama, University of Wyoming, and Youngstown State University. Each of these will promote "campus dialogues to foster sustained conversations on campuses about access and use of new learning materials and environments" (http://crossroads.georgetown.edu/vkp/about/three_senses.htm).

Endnotes

1. Vijay Prashad, *Everybody Was Kung Fu Fighting: Afro-Asian Connections and the Myth of Cultural Purity* (New York: Routledge, 2001), 61–91.
2. James Elkins, *Visual Studies: A Skeptical Introduction* (New York: Routledge, 2003), 118. For reactions from within art history to conventional multiculturalism, see James Elkins, *Stories of Art* (New York: Routledge, 2002), 118.
3. William Ray, *The Logic of Culture: Authority and Identity in the Modern Era* (London: Blackwell, 2001), 107.
4. See Marc Redfield, *The Politics of Aesthetics: Nationalism, Gender, Romanticism* (Stanford, Calif.: Stanford University Press, 2003), 11; and Terry Eagleton, *The Ideology of the Aesthetic* (Oxford: Blackwell, 1990).
5. See Barbara Herrnstein Smith, *Contingencies of Value: Alternative Perspectives for Critical Theory* (Cambridge, Mass.: Harvard University Press, 1988), 35.
6. Ray, *Logic of Culture*, 104.
7. See Jeffrey S. Librett's introductory remarks in Jean-Luc Nancy, *The Sense of the World* (Minneapolis: University of Minnesota Press, 1997), xvii.
8. Eilean Hooper-Greenhill, *Museums and the Interpretation of Visual Culture* (New York: Routledge, 2000), 9.

9. Ray, *Logic of Culture*, 116.
10. Ibid., 41.
11. Randall Collins, *Interaction Ritual Chains* (Princeton, N.J.: Princeton University Press, 2004), 125.
12. Colin McGinn, *Mindsight: Image, Dream, Meaning* (Cambridge, Mass.: Harvard University Press, 2004), 163.
13. Martha C. Nussbaum, *Cultivating Humanity: A Classical Defense of Reform in Liberal Education* (Cambridge, Mass.: Harvard University Press, 1997), 27.
14. Kalpana Seshadri-Crooks, *Desiring Whiteness: A Lacanian Analysis of Race* (New York: Routledge, 2000), 2.
15. Ibid., 20.
16. Paul Gilroy, *Against Race: Imagining Political Culture beyond the Color Line* (Cambridge, Mass.: Harvard University Press, 2000), 46.
17. Ibid., 43.
18. W. J. T. Mitchell, "Showing Seeing: A Critique of Visual Culture," in *Art History, Aesthetics, Visual Culture*, ed. Michael Ann Holly and Keith Mosey (Williamstown, Mass.: Sterling and Francine Clark Art Institute, 2003), 231.
19. It is worth reiterating that nation, culture, and ethnicity are constructs that spring out of the image-mediated processes of self-construction that, in modern social life, result in gendered and racialized identities. Marc Redfield, for example, contends that "nation" is gendered and racialized at its root. With respect to gender, he assumes that social reifications are forgettings and that, in Richard Terdiman's words, "there is no process of institution in social life without a preceding and determining destitution"; see Richard Terdiman, *Present/Past: Modernity and the Memory Crisis* (Ithaca N.Y.: Cornell University Press, 1993), 23. What is forgotten or destituted, says Redfield, is "the maternal figure ... given face, defaced and ritualistically expelled." This symbolic expulsion accounts for the centrality of the maternal in the social construction of nation and culture, and explains why "the binary opposition of male and female granted sexual difference the status of a major ideological fulcrum during the era that witnessed the full development of aesthetics"; Marc Redfield, *Phantom Formations: Aesthetic Ideology and the Bildungsroman* (Ithaca, N.Y.: Cornell University Press, 1996), 35. With respect to race, Redfield argues that "as long as the noncanonical cultural objects studied are taken as examples of ethnic or national identity, an aesthetic logic controls the field of dispute, organizing ethnic identity upon the neutrally white background of culture itself, as the (Western, male, etc.) institution of aesthetics has defined it" (Redfield, *Phantom Formations*, 27).
20. Wolf Singer, "The Misperception of Reality," in *Perception and Illusions: Five Centuries of Trompe l'Oeil Painting*, ed. Sybille Ebert-Schifferer (Washington, D.C.: National Gallery of Art, 2000), 52. Visual studies provide appropriate opportunities for such challenges. At first blush, students are hard-pressed to recognize their own complicity with D-Fens as he destroys the corner store run by a man of Korean descent in the movie *Falling Down* (see Cameron McCarthy, *The Uses of Culture: Education and the Limits of Ethnic Affiliation* [New York: Routledge, 1998]), and they are rarely even

Philosophical Bases for Visual Multiculturalism at the College Level • 143

aware of the fact that their own bodies anticipate the events that unfold in the initial street scenes of Los Angeles in the opening moments of *Grand Canyon* (see Henri Giroux, "Living Dangerously: Identity Politics and the New Cultural Racism," in *Between Borders,* ed. Henri Giroux and Peter McClaren [New York: Routledge, 1994], 29–53). As a result, these scenes, despite benevolent intentions, reinforce conventional visual aesthetics as much as they interrupt them. Contrastively, the movie *Suture* forces viewers to reconsider the source of their judgments about racial identity; see Crooks, *Desiring Whiteness.*

21. See Bill Readings, *The University in Ruins* (Cambridge, Mass.: Harvard University Press, 1996), 16, 153. Alasdair MacIntyre considers developments from 1270 to the present, and argues that the conventional disciplinary organization of modern secular universities only emerged in the late eighteenth century, the very epoch during which the university began to exercise its conservative cultural functions; see Alasdair MacIntyre, *Three Rival Versions* of Moral Enquiry (Notre Dame, Ind.: University of Notre Dame Press, 1990). As he reflects on the tenor of discourse in this early modern phase, MacIntyre notes the tendency in the early modern university to "effectively exclude from academic debate and enquiry points of view insufficiently assimilable by the academic status quo" (MacIntyre, *Three Rival Versions,* 219). Consensus, the status quo, is maintained by the disciplinary organization, each discipline tending to marginalize objections to the consensus that has been established. The modern university's support for the status quo has been passed along and dutifully received because of a false assumption. Specifically, the false assumption holds that "human rationality is such ... that it will produce agreement among all persons as to what the rationally justified conclusions of [such] inquiry are"; MacIntyre, *Three Rival Versions,* 225. MacIntyre doubts that consensus is the purchase of the exercise of rationality. Moreover, he regards consensus to be a problem in its own right because it hobbles the ability of disciplines and departments to deal with changing situations and developing needs. Accordingly, MacIntyre suggests that universities reconstitute themselves as communities of dissent.
22. See Louis Menand, "Undisciplined," *Wilson Quarterly* (Autumn 2001): 51; and Louis Menand, "College: The End of the Golden Age," *New York Review of Books* 48, no. 16 (2001): 44.
23. Annette Kolodny, *Failing the Future: A Dean Looks at Higher Education in the Twenty-First Century* (Durham, N.C.: Duke University Press, 1998), 164–68.
24. Nussbaum, *Cultivating Humanity,* 71.
25. Henri Giroux, "Resisting Difference: Cultural Studies and the Discourse of Critical Pedagogy," in *Cultural Studies,* ed. Cary Nelson, Paula A. Treichler, and Lawrence Grossberg (New York: Routledge, 1992), 199–212; Barry Kanpol, "Multiculturalism and Empathy: A Border Pedagogy of Solidarity," in *Critical Multiculturalism: Uncommon Voices in a Common Struggle,* ed. Barry Kanpol and Peter McLaren (Westport, Conn.: Bergin and Garvey, 1995), 177–95; and Paula A. Treichler, Cary Nelson, and Lawrence Grossberg, "Cultural Studies: An Introduction," in Nelson, Treichler, and Grossberg, *Cultural Studies,* 1–22.
26. Nussbaum, *Cultivating Humanity,* 72.

27. Michael Bérubé, "Introduction: Engaging the Aesthetic," in *The Aesthetics of Cultural Studies,* ed. Michael Bérubé (Oxford: Blackwell, 2005), 7.
28. Andrew Delbanco, "The Endangered University," *New York Review of Books* 52, no. 5 (March 2005): 19–22.
29. Henri Giroux, *Channel Surfing: Race Talk and the Destruction of Today's Youth* (New York: St. Martin's, 1997); Ghassan Hage, *White Nation: Fantasies of White Supremacy in a Multicultural Society* (New York: Routledge, 2000); David Roediger, *Towards the Abolition of Whiteness* (New York: Verso, 1994); and David Roediger, *Colored White: Transcending the Racial Past* (Berkeley: University of California Press, 2002).
30. Henri Giroux, *Channel Surfing*, 98.
31. Critical multicultural studies does not seek to overcome prejudice or encourage tolerance. Overcoming prejudice saddles those who have been subjected to prejudice with the responsibility of conveying information that will disperse prejudice. And with respect to "tolerance," "Mirabeau once declared: *Je ne viens pas precher la tolerance.... Le mot tolerance ... me parait, en quelque sorte, tyrannique lui-meme, puisque l'autorité qui tolere pourrait ne pas tolerer*" (as quoted in Hage, *White Nation*, 85).

CHAPTER 8
Bridging the Gap between Clinical and Patient-Provided Images

HENRIK ENQUIST

I will be reporting here on how a group of artists and designers and a group of patients approached the task of visualizing the meaning of specific medical diagnoses without recourse to traditional medical imagery.[1] The purpose was to investigate how people relate to images produced in health care, and how alternative visual aids might complement printed and verbal communications between doctors and patients. One fundamental concern of this study was to evaluate the influence and effect images have on patients' experience and knowledge of their personal health.

The study examined the use of images at three different points in time: the first week after diagnosis (this was investigated by a group of artists who played the role of patients), the second visit to the doctor's (represented by a group of medical students who played the role of patients), and living with a diagnosis (this subject was given to a group of actual patients).[2] In this paper, I will provide examples from the first and third of these—the artists' and patients' workshops—and focus only on the visual material produced. (The results from the group of medical students are conceptually similar to the traditional clinical images produced in health care. As such they do not add anything novel to the visualization of illness.)

I have four simple points to make: that in the near future, the exchange of information in health care will take a different shape; that visualizations not only are a matter of form and content, but also promote action; that

the ability to produce visualizations facilitates thinking, learning, and communication as well as the skill to read new images; and, finally, that there is a wide gap between the clinical images commonly used in health care and the images provided by patients—a gap that reflects differences in interests, perspectives, and means. At the end I will consider these four points in light of four questions Marshall McLuhan suggested should be used to understand new media.

The Gap

An immense amount of visual material on the human body is stored in the archives of hospitals around the world (at least in developed countries), including photographs, videos, drawings, X-ray films, magnetic resonance (MR) images, slides of pathology samples, sonographic data, and several other types of images. This material is of course invaluable for diagnosis and treatment, but has been rarely used by patients. That inequality is what initially sparked my interest in this subject.[3]

Elsewhere in this book there are bountiful examples of how professionals decode and interpret images within their fields of knowledge, so I will not go into detail as to how, for example, radiologists interpret their images. Instead, I want to consider the question of how visualizations can be used

Bridging the Gap between Clinical and Patient-Provided Images • **147**

by patients. The most straightforward approach to this, I found, is to let the patients see their own clinical images. Using two typical clinical images, I will try to illustrate that seeing is knowing, but in a different sense than might be expected—a sense in which it is not necessary to understand an image to find it useful or meaningful.

The image above is an X-ray that shows fractures in both femora. The image is easy to understand and useful in explaining what has happened. But if you were the patient, you probably would know what was wrong with your legs without having to look at a picture of them. Having such an image might not be very helpful, because what would have happened is so obvious: you already have information about it. In other words, there is no benefit for a patient to see such an image.

You may not see what the illustration on the next page shows, but with some help you could see something that you might not know anything about—something you might not feel, like the broken bones—unless you had an image of it. This image is not useful for the patient in the sense that it might provide her with medical information, but the very fact that what is unknown or unclear is made more concrete and real has tremendous impact on many individuals. To see is to know more and to know in another way, even if the image is blurry and diffuse. It is not only a question of seeing more or better, but of seeing anything at all. In that specific sense, this image is worth using, while the one of broken bones is not.

This simple example helps to show several differences in the production, information, and meaning of clinical images, depending on whether they are seen by the patient or the doctor. Thus, there seems to be a gap between the doctor's and the patient's perspectives of clinical images, and there are several dimensions to this gap. It could be a matter of information (Is more information necessarily better?), dependency and power (Who sets the agenda? Who is producing images?), competence and skill (What is necessary to know? What can be done?), focus and perspective (What do we look for? How do we interpret images?), or the general "state of things" (the results of tradition, division of labor, and economy). This list is arbitrary, but it helps to illustrate that visiting a doctor is, in many respects, a complicated matter if you are confronted with a clinical image. In regard to images, the relationship between doctor and patient can work in at least two ways: *send and receive*, or *seek and give feedback*. Traditionally, the doctor and the patient have had a send-and-receive relationship. I will argue that the latter state of seeking and giving feedback will necessarily prevail (and already has, in some respects), and that the key question in creating and using patient-focused images is what the individual wants to be shown.

The Artists' Group

I will turn now to the visual material created by the different test groups. The session in which artists and designers played the role of patients was held at the Malmö School of Arts and Communication in Sweden, and the problem at hand was to create novel visual representations of health from a patient's perspective given certain diagnoses. Elsewhere, I have documented this workshop in detail; here, I will only give a few examples.[4]

The participants, who had backgrounds in visual arts, design, creative production, filmmaking, and other related fields, acted as patients; they were told that they were being hypothetically diagnosed with one of three serious illnesses: multiple sclerosis; myocardial infarction, commonly known as heart attack; and breast cancer. Some information was given concerning various symptoms and impairments, and possible treatments and prognoses. The gravity of the illnesses was stressed, and the "patients" were told to return for a second consultation a week later. A full week's interval would have let them experience a state of limbo until the next time they could see the doctor. During this time the patients were each told to answer the following question: "What do I want to know about my condition and how do I want it to be presented?" Next, the patients were separated into groups of three according to the diagnoses they had been given. They were told to create a concept or prototype to visualize the ideas and questions they had in regard to their given diagnoses. Here, I will comment on the conceptualizations made by two of the groups:

those "patients" who were told they had multiple sclerosis, and those who were told they had breast cancer. (The heart attack group is not discussed in this paper since the findings from this group are largely consistent with the results from the other groups.)

The multiple sclerosis group came up with the idea of creating a game board for the patient's future life—a kind of existential game. The game was intended to be played by patients to provide a tool that would let them explore a multitude of possibilities and paths in their future lives. The key issue of the game was therefore social and emotional, not medical.

First, the player would be asked a number of questions regarding his or her daily life and other important details, such as family, friends, work, special interests, and hobbies. The player would then use the answers to create the game board. By breaking up the horrifying news of multiple sclerosis into small familiar steps, and focusing on specific circumstances, the patients made the week of waiting in limbo for the second visit to the doctor's more manageable. The game was based on these local factors, and its purpose was to enable the players to construct hypothetical future scenarios, depending on their specific mood or their hopes at the moment. With this game strategy, the group wanted to emphasize that there are several possible options

and outcomes. Another reason they gave for choosing a game format was the tendency in modern life toward (often irrational) calculated risks such as smoking, bad eating habits, and poor exercise routines.

The patients were continuously involved in constructing the game by creating the stories to be played; in that, they were guided by a manual they created together.[5] In the process, players were faced with a number of choices for creating different paths on the game board. These paths, finally, led to various endpoints in the game: in the extreme cases, death or total recovery. The players did not give themselves full knowledge of the medical and statistical facts concerning their diagnoses, nor did they set out rules in advance that would show them how to continue playing the game. When making a choice at a crossroads in the game, each player would consult the manual and follow the directions it provided. In this respect, the game was an organized structure that could guide the patients through the difficult period in which they had been placed.

This game also treats the day-to-day life of the individual. It was possible to play ahead of time—to experience the future by trial and error without risking anything. As such, it was a visual and interactive tool, displaying present and previous choices and enabling backtracking—a strategy that revealed the influence of certain choices. It also allowed several players to interact with one another, combining their individual game boards, facilitating learning and mutual support.

If we compare this game to a clinical MR image, the two differ in more than appearance and subject matter. There is also the inherent feature of interaction and choice in the game board version, which is absent in the ready-made MR image. The game is a narrative rather than a simulacrum. It is open-ended rather than final. It is a negotiation, not a verdict.

Paraphrasing Bruno Latour, this is not a matter of following a context, but rather of following the simultaneous production of a "text" and a "context."[6]

The second group, those who were told they had breast cancer, responded differently. The most important issue for the breast cancer "patients" was how to cope emotionally during the week of waiting for the next consultation. During this period of time there would be a great deal of worry and anxiety, confusion, and possibly denial. The concept of distraction or escape was chosen by this group to be a way of dealing with those emotions. A paper toy, well known to all the participants from their childhoods (in Sweden, it was called a "flea"), was produced and renamed "move focus."[7] As every child who has played this game knows, the player picks a number between one and five, and flips the sides of the toy that many times. At that point the child—or in this case, the "patient"—chooses one of four questions

that are visible on the inner side and inverts the paper to see the appropriate proposals on how to act. These were the questions and answers:

Question	Answer or Advice
Do you want to win?	Buy a lottery ticket.
Do you want to deny?	The diagnoses must have been mixed up.
Do you want to act?	Gather all people with good energy.
Do you want a good prognosis?	Buy it! (Bribe the doctor to lie.)
Do you want to take control?	Turn on the autopilot.
Do you want to hide?	You cannot hide from yourself.
Do you want to dream?	Rent the video *Total Recall* seven times.
Do you want to run?	Travel around the world in seven days.

This toy provided a distraction and a more or less irrational response to the difficult diagnosis and the passive situation created by the week's interval between doctor's visits. The hypothesis was that it would help the "patient" to cope during a limited period of time when action was almost impossible. The visual tool, as we called it, did not deal with the disease or even the diagnosis, but was used to divert their emotional effects. This was similar to the approach of the multiple sclerosis group, which also partly focused on the effects of the disease rather than the medical information.

Patients' Group

Another group, composed of actual patients (not people simulating patients, as in the first two groups), received a kit we called a *cultural probe*, consisting of a single-use camera, a diary, a large sheet of paper, a notebook, some blank images of paper, instructions, information about the study, and a short evaluation form. The instructions for the use of the probe were very simple: use the material provided to describe what is important to you and to record whatever affects you and your health in your daily life. The intention was to provide tools to help patients express themselves. We weren't sure what to expect, but the hope was that the cultural probe would result in documentations and images representative of what the patients themselves considered important. (These were outpatients suffering from chronic rheumatoid arthritis.)

Of the eleven probes that were distributed, ten were returned with contents and one was empty. Taking a quick look at the returned material, it was obvious that the diary and the collage were the least used options.[8]

The collage depicted on the next page was made by a woman in her mid-forties (the picture is a detail of a larger sheet). She considered it to

Bridging the Gap between Clinical and Patient-Provided Images • 155

be a very stimulating and rewarding way to express herself. In a vivid and colorful fashion, she covered several important aspects of her everyday life. Her strategy of mixing humor and seriousness seemed to be of help to her in trying to cope with her difficult situation. The way she chose a funny picture and combined it with serious and sometimes negative text seemed to provide an opportunity to defuse a potential feeling of resignation or hopelessness. It's also significant that in her choice of images and the accompanying texts, she also described her situation as "living" rather than "surviving."

The second example, shown below, is different in style as well as content. It is more structured, and lists important events or activities. It should be stressed that the person who drew this "storyboard" was not used to drawing, but found it useful and inspiring. Hence, it is not the quality of the final pictures that was important, but the quality of the action of drawing, and of describing the drawings.

By combining images and cutouts with their own texts, the patients succeeded in telling their stories. It could be that the images worked as an inspiration for the brief texts that the patients also made, or that the images abbreviated what they had to write. The collages were sometimes redrawn, with the addition of new features and the removal of old ones, as if the collages were moments in a continuous loop.

All of the participants who returned the probe had used the camera we had included. This was a bit of a surprise, because the single-use camera we gave them was rather difficult for the arthritic patients to handle due to its small parts and mechanisms. Because of the problems and, in many cases, the pain that the patients experienced in handling the camera, I take the number of photographs as a sign of their significance.

All but one of the participants reported that the camera was fun to use and helped them think in another way; and this was before they had even seen the photographs they had taken. This means that it was not

Bridging the Gap between Clinical and Patient-Provided Images • 157

really the photographs as such that were so important, but rather the act of taking them. The patients appreciated the opportunity to share important things in their lives, and they said they found it thought-provoking to be able to have something meaningful to say through their images. The simple fact that someone was interested in what they had

to say proved very significant. In the context of visual literacy, I think this portion of the study shows that it is important to be able to "read" images, but it is equally important to possess the skill to "write" and share them.

A look at some of the images made by the patients reveals some contrasts with clinical images of rheumatoid arthritis:

Patient-Provided Images		**Clinical Images**
Personal	versus	"Objective"
Nonintentional	versus	Intentional
Encoding	versus	Decoding
Narrative	versus	Descriptive
Giving (telling)	versus	Receiving information (being told)
Performative	versus	Analytical
Active	versus	Passive

Building a Bridge

What has been learned during the workshops? Using four questions posed by Marshall McLuhan to describe the essence of new media, I will present one possible interpretation of the outcome of the study; and in doing so, I will also try to clarify the four points I mentioned in the introduction.[9]

1. What Does the New Medium Enhance or Intensify?

Is the communication between patient and doctor really working? It is well known that there is a discrepancy between information asked for by the patient and information the doctor considers important. A Swedish case study examining this issue reports that the patients

> want more information. Most often it is the kind of information the doctor cannot provide. ... The patient wants to talk about his or her fears and worries. ... The doctor wants to talk about tumour biology, prognoses and possible treatment options, statistical calculations of the outcome, etc. From the patient's point of view, such knowledge sometimes appears both unintelligible and inadequate.[10]

Bridging the Gap between Clinical and Patient-Provided Images • 159

Since a specific visualization acts as a translation of a person's body or a diagnosis, it is by nature arbitrary and depends, among other things, on the intentions of the enunciator (producer). The language used to translate an illness or a diagnosis into an image gets what meaning it has through

the uses to which it is put. It is therefore crucial that the patient is involved in the image production, if he or she is going to be able to "read" the results. To put it simply, it is a matter of learning by doing, and what is gained is not only skill in image production and usage, but also knowledge of the relevant medical and personal information. Paraphrasing Gilles Deleuze and Félix Gauttari, this new situation is *rhizomatic*, in the sense that it is continuously evolving, subject to redefinition, nonhierarchical, and decentered.[11] The contexts I have described in this paper are composed of dimensions, not units, and they always take place in a middle region—a milieu, from which the patient looks out. These contexts are matters of negotiation rather than information or prescription. I feel many doctors would agree with this last statement when it comes to the problematic issue of compliance—the degree to which patients follow prescriptions and act according to rational information.

2. What Does It Render Obsolete or Displace?

Patient-provided images also generate empowerment. Because most of the treatment actually is performed outside medical institutions, for example in the patients' own homes, it is appropriate and useful to provide tools requiring individual responsibility and initiative. This is also a matter of the direction of the flow of information and knowledge. Through visual methods, a patient can seek knowledge in a way that does not need interpretation or translation by a medical professional, and requires less knowledge of the specific jargon of medicine. The image can become something concrete to talk about; it can be a starting point for discussion and self-reflection, and it can reshape the dialogue between patient and doctor, removing the dialogue from the traditional hierarchical relationship of a sender and a receiver and turning it into a seek-feedback loop.

3. What Does It Retrieve That Was Previously Obsolete?

The patient-provided image displaces the focus from the pure clinical "problem" to the patient's individual abilities. It takes into account the dimension of the "lived" disease or disability and the knowledge of the individual's everyday life—factors important for well-being that would not always be mentioned in a clinical setting. From a patient's perspective, these images are a question of creating *meaning*. By constructing meaning, the experience of a medical condition can be altered, and it is even possible to influence the actual healing progress itself. The expression *meaning response* in relation to medical conditions is discussed in Daniel Moerman's *Meaning, Medicine and the "Placebo Effect"*; he notes that

"meaning can make your immune system work better, and it can make your aspirin work better too."[12] Images used to create a meaning response could be useful in health care, not only as "placebos" but also as emancipatory and participatory tools.

4. What Does It Produce or Become When Taken to Its Limits?

Visual artifacts, including clinical and patient-provided images, are part of the construction of a narrative of health. They function as interacting actors (*actants*, to use Latour's term), and as such they contribute in ways that are complementary to speech and text.[13] In other words, images are an active part of a complex interaction that is at once social, political, and personal. Hence, visual artifacts might prove useful as self-reflective, generative, and proactive tools, as well as provide a common, nonhierarchical ground for dialogue and discussion. That common ground could be called a *writing space*: a shared domain of control and exchange that bridges the gap between clinical and patient-provided images. Visualizations, as loaded artifacts, could function as social objects in various relationships.

Visual studies classes in a medical curriculum would help students and future professionals to understand the potential of visualizations. Such classes could also include the active use of images as carriers of meaning from a patient's perspective—that is, not only as means of extracting medical information (as in the protocols of reading X-rays), but also as ways of creating images that are meaningful for the patient—and that would be especially true of images produced by patients. A strategy based on meaning and participation could then be regarded as an addition to existing practice in the fields of clinical medicine and rehabilitation. Well-designed, patient-focused images stimulate self-reflection and participation: they are epistemological agents, and agents of change and learning.

Endnotes

1. I would like to thank Rådet för Hälso- och Sjukvårdsforskning (Council for Health and Medical Care Research) and Region Skåne for financial support, Ingemar Petersson and the staff at Spenshult Hospital for Rheumatic Diseases, as well as all the workshop participants and interviewees for their input and creativity.

2. The interviews were carried out with medical professionals who work daily with images in a health-related context, including a midwife, a radiologist, and a physical therapist.
3. Henrik Enquist, "Emotional Images in Medicine," in *Proceedings from the 4th International Conference on Design and Emotion, 2004,* Ankara, Turkey, July 12–14, www.certec.lth.se/doc/emotionalimages/emotionalimages.pdf.
4. Henrik Enquist et al., *Methods 2.0,* ed. Jonas Löwgren, Studies in Arts and Communication #04 (Malmö, Sweden: Art and Communication, Malmö University, 2005), www.certec.lth.se/doc/eatmethods/eatmethods.pdf.
5. A manual was provided with the game, explaining the rules and possibilities as well as giving specific medical, statistical, and other information such as home page addresses of support groups and personal accounts by other patients with similar diagnoses. The manual of the game would have been designed by international patient organizations and research departments, ranging from medicine to social studies, and it would have been adapted for each individual player based on the answers provided during the game.
6. Bruno Latour, "Technology Is Society Made Durable," in his *A Sociology of Monsters: Essays on Power, Technology and Domination,* ed. J. Law (New York: Routledge, 1991), 103–31, quotation on 106.
7. [The game seems to be well known for having no fixed name. A Web site gives names in use in Russia (*gadalotschka*), Norway (*spå*), France (*cocotte en papier*), Austria (*Nebo Peklo*), and the United States (cootie catcher). See "About Folded Paper Fortune-Tellers," www.sunderland.ac.uk/~as0bgr/coot/about.htm.—J. E.]
8. This could have several possible explanations. For one, the majority of the participants experienced pain in their hands and fingers while writing. The collage required them to use scissors, which also could have been a problem. Many of the patients also reported that the diary was unimportant, because they already had written short texts in the notebook provided with the camera. They said that the collage was unnecessary since they already had taken images with the camera. It was expected that they would not use all of the material in the probe, and the reason that there was redundant material was to provide them with optional means of communication.
9. Marshall McLuhan and Eric McLuhan, *Laws of Media: The New Science* (Toronto: University of Toronto, 1988).
10. Lisbeth Sachs, *Kommunikationen mellan patient och läkare vid svåra beslut* (Stockholm: Socialstyrelsen, 2003), 18, author's translation.
11. Gilles Deleuze and Félix Gauttari, *A Thousand Plateaus: Capitalism and Schizophrenia* (Minneapolis: University of Minnesota Press, 1987), 3–7.
12. Daniel Moerman, *Meaning, Medicine and the "Placebo Effect"* (Cambridge: Cambridge University Press, 2002), 20.
13. Bruno Latour talks about humans and nonhumans involved in a chain of events as actants. The central issue is the relationship between the actors, not their individual existence. Latour, "Technology Is Society Made Durable."

CHAPTER 9

The Image as Cultural Technology

MATTHIAS BRUHN AND VERA DÜNKEL

Technology is inscribed in the visual culture of modern societies in various ways, and it influences their general perception: there are as many different techniques of generating and rendering images as there are numerous technical tasks that images are to comply (like for diagnostic or constructive purposes) or technical matters that they represent. In a culture dominated by media, visualization in natural sciences, medicine, or engineering takes on new functions and readings. Even complex forms of imaging like, for instance, ultrasonic or electromicroscopic pictures, which require a specific training for their interpretation, become part of the public and its visual order, unfolding their discursive impact in mass media where they can be transformed into symbols of science in a very general way, as they encounter a greater audience that has its own expectations toward the message of images showing the latest innovations from medicine or space.

Das Technische Bild (The Technical Image), a research project at Berlin's Humboldt University under the direction of Horst Bredekamp, was founded in 2000 in order to examine the technologies that serve for the visualization of scientific objects and processes that are characterized by the use of specific media and devices. It subjects the different types of scientific visualization to a comparative formal analysis, uncovers the latent traditions and strategies that shape the image-making process, and thereby describes the historical interaction of art, technology, and culture. In the present reader, it may stand for the latest research trends in the German-speaking countries.

In particular, the project deals with images generally qualified as "non-art." It does not aim at transforming these images into art; the issue is, rather, how the interplay of visible forms and invisible imaging techniques raises theoretical questions that are constitutive for the formation of an interdisciplinary "picture criticism," which would broaden our understanding of the history of visual culture in general. *Visuality* has a specific rhetoric, with significant communicative and mnemological laws, not only effective in the sphere of so-called high art but in the production, design, and interpretation of scientific representations and records as well.

One of the first issues connected with the analysis of "technical images" is the definition and description of *form*. *Form* is, not by chance, the key term for several different scientific methodologies and disciplines; it can imply the structure and evolution of organisms or the significant elements of language (as in *morphology*), and is central for those disciplines that apply comparative and descriptive means to their visible objects (like archeology and history of art). The interpretation of a graph and its course, the coloring of an object or its distortion caused by photographic recording: these are some of the typical "formal" aspects that not only determine the value and effect of a scientific statement but also give us a deeper insight into the potential of images in general. The abstracted and simplified representation of the human body in medical diagnostics and research can neglect a number of physiological factors requisite for the interpretation of measurement data and may lead to rash diagnoses or operations—a formal analysis includes the criticism of those imaging technologies that act as visual guides in the operational procedure. The case studies given below will attempt to describe this approach.

Furthermore, the interpretation of technical images has to reflect the *historicity* of the "visual" in general: the form, use, and function of images depend on a continuous historical process in which visual traditions and new imaging techniques intersect. The project thus intends to examine the role of perceptual traditions and historically imparted visual forms and their impact on the introduction and reception of new media and new signs. Reproductive media, as result of the industrial revolution, have become a mass phenomenon (with photographs, prints, and TV news being the most efficient forms of everyday communication, as shown and criticized by media theorists like Walter Benjamin and Siegfried Kracauer); the fabrication of pictures is thus a matter of course, an everyday affair in a culture-generating system, a *Kulturtechnik*, which may even take place unreflectedly, since it does not require more than pushing a button.[1] This changed medial situation affects the use of images in science to the same degree as laws of visual representation and exchange affect the use of images in a scientific context.

The project administers and updates a digital picture library that permits users to obtain a selected view over the research topics treated by the project staffers. By creating a proprietary, object-related thesaurus of keywords, it aims at structuring the visual material in order to permit a more precise and comprehensive description of the origins, properties, and functional contexts of scientific images. By generating groups of motives on the screen, its interface invites unforeseen and associative structural comparisons between the various entries, thus making visible formal and functional similarities and differences between them and, in the manner of a *Bilderatlas*, inciting new questions, laying out a cartography for future objectives and destinations of historical research. Also, by operating with tools like the multimedia database it becomes obvious how far previous formal analysis has been based on two-dimensional, nonmoving images and motives, in particular when it comes to imaging technologies that are dominated nowadays by dynamic representations.

The questions arising from the encounter of art, technology, and science are the starting point for the interdisciplinary themes discussed in a yearbook titled *Bildwelten des Wissens* (*Visual Worlds of Knowledge*), which is edited by the project group and devoted to its very objective of a timely "picture criticism."[2] Here, international guest authors are invited to outline their recent topics and to present their results. In order to support their arguments, the yearbook tests alternative forms of layout and illustration, for example by arranging tableaus and pairing pictures in a way that resembles the modes of display of the project's database.

Looking into Nature: Three Research Examples

The following figures, three pictures out of three periods corresponding to some of the treated subjects in our research project, have been chosen to exemplify the kind of approaches and questionings as well as the methodological questions raised by the analysis of technical images.[3]

The first example concerns the examination of the eighteenth-century European "culture of knowledge": a picture stemming from the microscopy handbook of Martin Frobenius Ledermüller, first published in 1761. The decorative, well-composed, colored etchings in this book mirror a widespread culture of depiction that was nonartistic but of a natural-scientific and technical orientation. Richly illustrated scholarly books of this kind were very popular at that time, and they served a number of purposes: first of all, new microscopic observations, for example of microorganisms, were published through them and thereby disseminated for public discussion. Secondly, those popular scientific books (if we are permitted to use the term *popular science* for the time around 1800) served for the training of

the spectator's eye. They provided visual archetypes for the reader's own microscopic experiments and helped him classify and construe new and unfamiliar observations. Interestingly, the "needle-sharp" and precise microscopic views reproduced in the plates set visual standards insofar as the optical quality of the microscopes of that time could keep up with the accuracy of the printed etchings only with a certain delay.

The picture below shows microorganisms in water—in this case, polyps in an aquarium that are observed by means of a magnifying glass. These organisms, only of a size of a few millimeters in nature, are in a glass container standing on a desk. The reader can easily relate them with large-scale reproductions of the same objects that are arranged in

Martin Frobenius Ledermüller, *Aquarium, Lupe und Polypen.* 1763.

symmetrical order on the left and right of the aquarium. The blowups were made possible by the use of a magnifying glass on flexible ball joints that can be seen in front of the glass container: this instrument for observation forms the center of the scene in a concrete technical sense, as well as in the metaphorical sense that it stands in the middle of the cosmos. Within a single picture the experimental arrangement, the microscopic experience, and the object details are collated. The composition of the etching reflects the operational mode of the optical technique of that epoch, which could be depicted with this clarity only by the means of special artistic skills and tools. Being the sum of technical developments, visual training, and experimentally explored nature, etchings like these became technical images par excellence.

In January 1896, Wilhelm Conrad Röntgen introduced to the public the discovery of "a new kind of rays" and the method for their visualization. At this moment, it was not clear what the process could be used for. The indeterminateness opened a wide range of possibilities, in regard to the application of the method and its interpretation. It required a phase of experimental testing to survey its imaging potential; technical as well as iconographic aspects played a constitutive role.

During a public lecture introducing the new method, Röntgen asked one of the attendants, the famous anatomist Albert von Kölliker, to photograph his hand. The production and presentation of the results constituted the climax of the whole event. At the same time, numerous newspapers and journals published X-ray pictures choosing the same motive that then became a sort of *leitmotiv* of Röntgen's discovery, playing a decisive role in its propagation; a critical contemporary newsletter reported that "it was the hand that did it." How can the choice of the hand, its relevance, and its success be understood?

The X-ray photograph on the next page shows a hand and its wrist. There are three levels of slightly different shades of gray that can be distinguished: the dark bones emerge out of the lighter contour of the hand. As a third layer that seems to float above the lower levels, the oval form of a ring appears as the darkest structure of the picture. Thus the effect of the discovered rays—that is, the different degrees with which X-rays penetrate matter, depending on the properties of the substance—becomes visible at one sight. The chosen object, the hand, was permitted to demonstrate the X-ray effect thanks to its anatomical structure and bodily consistence. The flatness of the hand allows the rays to easily pervade and depict it with accuracy on the photographic plate. Thus the choice of the hand was technically motivated. The ring, too, helped to understand the process, adding a further tone to the black-and-white scale; its floating apparition increased the fascination of the image, pointing to the corporal presence of the

170 • Matthias Bruhn and Vera Dünkel

Wilhelm Conrad Röntgen, *Hand of the Anatomist Albert von Kölliker*. 1896, reprinted ohne Retouche ("without editing").

carnal hand, which was transformed into a shadow-like half-transparency. By revealing a completely new perception of the body, this kind of image stimulated the application of the method in various domains including medical ones; but first of all, it simply inspired people's imagination of how the visible world around them could be visualized in a different manner.

It seems that in the subsequent years after its introduction, the new imaging method was perceived as a playful way of transforming reality into surprising pictorial appearances. Simultaneously, the produced pictures could be associated with well-known motives (such as the iconography of death, like in the *danse macabre* or memento mori), as can be observed in contemporary illustrations, such as newspaper caricatures.

In the present case, the iconographic background of the motive of the hand may have played an important role. The hand as such has always been one of the most eminent symbols in art and culture. It may stand for the human person and its relation to the world and for the human body. It is a magic sign of defense, control, or power, and has countless different functions in judicial, religious, or social contexts. In combination with the caption referring to von Kölliker's personality, the motive of the hand was a witness of the memorable event and supported the authority of the anatomist whose hand, in return, served as a body of evidence for the value and authenticity of the discovery.

The evocation of known and familiar forms and structures is also a characteristic element in the testing and design of the newest imaging technologies. In the year 1982, Gerd Binnig and Heinrich Rohrer developed a new imaging procedure that allowed resolution on the atomic scale for the depiction of metals and semiconductors. Afterward, they experimented with the applicability of this method to further samples. At an international conference for physics in 1984 that assembled specialists from various subdisciplines, they presented the range of applications of the scanning tunneling microscope (STM) by using the picture of a scanning of DNA on a graphite background.

The detail on the next page shows bright and horizontal lines crossing the picture and forming a "peak" or deflection in the center, where they are connected by an undulating vertical streak; this forwards the impression that there is a ridge on which the white strand runs from top to bottom across the image. Each horizontal line represents the trace of the fine tip of the microscope that has read off the sample. In the lower corner of the figure, the letters *DNA* have been inserted. In the proceedings of the conference in which the picture was reproduced, Binnig and Rohrer noted in its caption that it had been turned by 180 degrees "for better viewing."[4] Why did they do so?

Originally, the lines had formed a depression so that the white strand connected their lowest points. This was due to the operating mode of the instrument scanning the DNA. In consequence, turning the picture "for better viewing" meant that DNA became visible *on* instead of being carved *into* the surface.

Only those familiar with the technical device in full detail were able to expose the manipulation. The possible disturbance among this small

First investigation of DNA with the scanning tunneling microscope by Gerd Binnig and Heinrich Rohrer, IBM research laboratory, Zürich, 1984.

circle of specialists was accepted to meet the expectations of a bigger audience of physicists who would read the image as an adequate representation because it corresponded to a common way of perception. Not only was the editing process written into the picture, using the letters *DNA*, but also the viewer was instructed how to look at it. In consequence, the picture was reproduced in a later review article, with the same orientation and the note "upside down image."[5]

Without delivering any scientific news about DNA, the picture could be regarded a success, as it inspired further examinations of biological material with the STM. When the debate—if and how DNA and its pairs of bases could be sequenced with this sort of visual technology—radicalized in the early 1990s, Binnig made the decisive contribution once again: he demonstrated the possibility that in STM images, the irregular structures of the graphite surface mimic DNA. Thereby it became doubtful whether there was any DNA to be seen at all in pictures like the one he had presented in 1984. However, even without gaining definite information about the sample, the picture was "effective" in another sense, in that it gave research a new direction and conditioned our notion of what DNA looks like. Only the reference to certain formal patterns allowed its broader reception.

These three examples show that technical images have different layers of meaning and fulfill manifold functions at the same time. This multiplicity of aspects and functions demands a precise methodology of observation and description that may also lead to an update and critique of the applied methods themselves. The project aims at interpreting the modes of action of this genre of images through the analysis of their "forms," here understood in a differentiated and complex way that takes their historical derivation as well as their technical specifics into consideration. Images of all kind are links in a longer, historical chain of pictorial phenomena; on the other hand, they are formed by the tools and appliances needed for their production. For this reason, the history of scientific images is also a history of visual media and technology and a history of science and its contexts. The "iconological" method, usually connected with art history, displays its full operability within this common, interdisciplinary approach, in that it unveils the origins and traditions of visual patterns, the collective visual language they refer to, and the hidden messages they may transport throughout history. An updated iconology reflects the changing conditions of image production and is able to describe the *metamorphosis* of those messages and the actual uses that scientists have made of images.

τεχνη: Art and Technology

Archeology and art history have always developed and refined their methodology by means of images that lay outside the realm of fine arts. From its beginnings as an academic discipline, art history included "non art images" for the demonstration of aesthetic forces, and by doing so extended the current notion of art. Classical authors in art history, like Adolph Goldschmidt, Alois Riegl, Heinrich Wölfflin, and Aby Warburg, have excelled in that they studied the less appreciated fields of aesthetic practice, such as ivory carving, numismatics, and prints. By doing so, they have altered our view of the visual environment; as well, they have turned art criticism into a "picture criticism" of a much broader relevance. According to the ideas of humanistic education and a "school of seeing" as part of public education (Alfred Lichtwark), the trained hand and eye have always been considered indispensable for the development of people's personality (*Bildung*).[6] This is why art historians deal with perception and vision as they do with automatic pattern-recognition and computer games; and this is why the project draws such an explicit line back to art history as its major methodological basis, even if its members come from other fields (e.g., physics, media studies, and computer science) or collaborate with them.

Caused by the emigration of German-speaking art historians after 1933, their comprehensive intellectual approach that combined philosophical,

psychological, and anthropological interests for the first time was scattered into the world, and was almost completely wiped from academic thought in their home countries. Like the younger disciplines of sociology, ethnology, or media studies, which were also almost completely expelled, such interdisciplinary approaches could only achieve and unfold their programs after the Second World War; in the case of art history, the revitalization first took place abroad in countries like England and the United States, before the discipline started to remember and bethink its advanced predecessors in the 1960s and 1970s.

Today's discussion of images, which has grown to a *Bildwissenschaft* ("image science") of its own kind, resumes to a considerable extent this older tradition, in particular the *Kunstwissenschaft* ("art science") of the late nineteenth century that had already formulated a notion of "form" and "style" that included psychological and physiological aspects as well as technical and social conditions. With reference to those older authors, art historians have dealt with visualization technologies and scientific illustrations for decades.[7]

In European society, pictures of all kinds have always been understood (or suspected) as symbols of specific social interests, like religious imagery and political propaganda in high art or mass media, sometimes leading to extreme clashes and expressions of contempt, like in the iconoclastic movement (*Bildersturm*) of the Reformation. The consideration of such phenomena in the 1970s, partly under the influence of *Ideologiekritik*, has led German art historians to reintroduce political and social themes and to extend their disciplinary view once again. The classification and description of works of art were completed, for instance, through the method of a "political iconography" (Martin Warnke) that placed a "profane" language of art next to the established classical and Christian iconography. This particular branch of iconography intends to expose the political functions of art and their role in the rise and emancipation of the modern art system.

Studies with a methodological background in literary studies, sociology, or cultural anthropology have followed; they applied themselves to popular visual genres like calendars, postcards, or art reproductions, and systematically carried on, with a stronger focus on empirical methods, a quantitative analysis of "mass pictures" that completed the program of a "visual history," as proposed by Aby Warburg and his followers. Studies by Wolfgang Brückner, Christa Pieske, and others, published since the early 1970s, correspond to the English-language research of the same time, as presented by Alan Gowans, Lena Johannesson, and Estelle Jussim, and are also echoed by a more recent "visual sociology."[8] At the same time, visual communication was introduced as a new discipline at German schools for fine art and design, in order to expose the contemporary language of advertising and its ideological impact.

This trend coincided with the increasing interest in photography as a historiographical source, as it is in the center of a complementary science for historiographers called *Bildkunde*; a *historical picture research* intends to widen this discipline by incorporating the social uses of photography and the history of reproductive technologies.[9] This interest in the practice and theory of photography dates back to the beginnings of photography itself and is thus well represented in most European technical collections and in a vivid scene of private collectors, researchers, and specialist groups investigating all aspects of old and modern picture production, distribution, and preservation in their analog and digital forms.

The analysis of popular imagery and new media has led twentieth-century art historians to a particular attention for the latest visual technologies as essential parts of a common cultural practice. Art historians were thus involved in the setting up of Ars Electronica in Linz, the Austrian "interface of art, technology and society" that organizes annual meetings for artists and theorists,[10] as well as in initiating conference series such as Interface, launched in Hamburg in 1990.[11]

The intellectual movement found its paramount expression in the founding of the Center for Art and Media Technology (ZKM) in Karlsruhe, Germany, an outstanding place for researchers and artists working in the field of electronics that maintains a museum for the preservation of electronic media. The ZKM was again initialized by an art historian, Heinrich Klotz, in 1989; a part of its mission was to keep alive recent and ephemeral technologies and phenomena like video and Internet art for future generations and to participate in the development of improved tools and interfaces.[12] Seen from this perspective, the splitting of art history and visual studies that has become widely accepted appears to be quite problematic.[13]

As part of a broader and international discussion, scientific illustrations and mechanical imaging technologies are now being analyzed with more attention than ever before. The discussion inspired younger disciplines like the history of science to renegotiate their understanding of the acquisition and communication of knowledge through images, by focusing on the use of visualizations and illustrations, be it in the experimental process, for diagnostic ends, or in publications. This led to further research programs that investigate, from a critical viewpoint and sometimes with surprising insights, the neurological and psychological, discursive, and ideological aspects of the scientific progress and the different forms of scientific communication and popularization.[14]

The current success of terms like *pictorial turn* or *iconic turn* may obscure the facts that the *relevance* of their object is much older and that scholars who introduced these terms into the German discussion (Gottfried Boehm, Horst Bredekamp) did so from a long-range historical and philosophical

perspective. However, they have become the most prominent voices in the public discussion of images and their social importance, which has also increased the public and academic interest in scientific visualization practices and strategies. Since then, the stream of publications on the "power of images" or "art and science" has not run dry. While moving and still images find their allies with all kinds of media (be it a music video or a TV ad), and the definition of what is to be taken for an "image" is challenged every day by electronic and digital technologies,[15] the strong *interest* for images and their effects has roots that are to be found in another, historical context.

The ongoing discussions of the potential and relevance of interdisciplinary studies in visual communication have also led to the establishment of German projects like the Bildwissenschaftliches Kolloqium in Magdeburg;[16] the graduate program Bild—Körper—Medium (Image—Body—Medium) in Karlsruhe, initialized by Hans Belting;[17] and the private initiative Iconic Turn by Munich publisher Hubert Burda,[18] to name only a few exponents. In Austria, the International Research Center for Cultural Studies in Vienna[19] and a new course in image studies at Krems University[20] pursue similar targets, like the Swiss interuniversity "competence center" eikones, founded in 2005, with its headquarters in Basel.[21]

Such a renaissance would hardly be thinkable without an educative and intellectual tradition that understands images as carriers and shapes of ideas and emotions and that appreciates the "engineering aesthetics" (J. A. Lux) manifested in the combination of art and technology as a genuine form of "visual thinking" (Rudolf Arnheim).[22] Arnheim's essay is pivotal for a project like the Technisches Bild; it is one major step in a longer intellectual evolution of cultural analysis that is now closely linked with Aby Warburg.

Prospects

Das Technische Bild is part of the Berlin Center for Cultural Techniques named after the famous physiologist Hermann von Helmholtz (1821–1894). It has anticipated and influenced a number of comparable institutions that deal with the inter- and transdisciplinary points of contact between the humanities and natural sciences, and it promotes the scholarly discourse on nonartistic imaging, maintaining a pioneering role in that it documents the predominant modes of visualization of contemporary science.

The publications and collections of the Berlin project Technical Images may indicate that the formulation of an adequate and complex "picture criticism" still requires a number of methodological, terminological, and strategic adjustments. Technical developments challenge the objective of the project to gather a representative collection of scientific images and to present solutions for their storage, classification, description, and display.

Furthermore, it will be inevitable to reinforce the exchange between the various hard and soft sciences, also on an international level, in order to coordinate their activities. It is likely that, as one result of these efforts, it will become visible again how deeply images and technology have been linked with each other right from the start.

Endnotes

1. As described by Vilém Flusser, *Ins Universum der technischen Bilder* [Into the Universe of Technical Images] (Göttingen, Germany: European Photography, 1985).
2. Horst Bredekamp, Matthias Bruhn, and Gabriele Werner, eds., *Bildwelten des Wissens: Kunsthistorisches Jahrbuch für Bildkritik* (Berlin: Akademie Verlag, 2003).
3. The chosen case studies were administered by the project members Angela Fischel (eighteenth-century microscopy), Vera Dünkel (nineteenth-century X-ray photographs), and Jochen Hennig (twentieth-century scanning tunneling microscopy).
4. Gerd Binnig and Heinrich Rohrer, "Scanning Tunneling Microscopy," in *Trends in Physics: Proceedings of the Sixth General Conference of the European Physical Society,* ed. J. Janta and J. Pantoflícek, vol. 1 (1984), 38–46, quotation p. 44.
5. Paul Hansma and Jerry Tersoff, "Scanning Tunneling Microscopy," *Journal of Applied Physics* 61 no. 2 (1987): R1–R23, quotation on p. R19.
6. Alfred Lichtwark (1852–1914), director of the Hamburg Kunsthalle, was the author of instructive books like *Die Erziehung des Farbensinnes* (Berlin: B. & P. Cassirer, 1901) and *Übungen in der Betrachtung von Kunstwerken* (Hamburg: Lütcke & Wulff, 1897; reprint, Frankfurt am Main, 1986), in which he reflected on the objectives and results of his popular tutorials for museum visitors. Compare the study by Carolyn Kay, *Art and the German Bourgeoisie: Alfred Lichtwark and Modern Painting in Hamburg, 1886–1914* (Toronto: University of Toronto Press, 2002).
7. See, for example, Dieter Lübeck, *Das Bild der Exakten—Objekt: Der Mensch. Zur Kultur der maschinellen Abbildungstechnik* (Munich: Moos, 1974), which explicitly refers to Heinrich Wölfflin's *Principles of Art History* (first German edition as *Kunstgeschichtliche Grundbegriffe* in 1915; New York: Dover, 1950) as a model for his daring, 1970s-style catalogue of the latest imaging technologies such as scintigraphy and ultrasonic and infrared photography. A recent and comprehensive example is Hans Holländer, *Erkenntnis, Erfindung, Konstruktion. Studien zur Bildgeschichte von Naturwissenschaften und Technik vom 16. bis zum 19. Jahrhundert* (Berlin: Gebr. Mann, 2000). Compare Horst Bredekamp, *The Lure of Antiquity and the Cult of the Machine: The Kunstkammer and the Evolution of Nature, Art and Technology* (Princeton, N.J.: Wiener, 1995).
8. See Wolfgang Brückner, *Massenbilderforschung. Eine Bibliographie bis 1991/1995* (Würzburg, Germany: 2003); Christa Pieske, *Bilder für jedermann. Wandbilddrucke 1840–1940* (Munich, Germany: Keyser, 1988);

Karin Walter, *Postkarte und Fotografie. Studien zur Massenbild-Produktion* (Würzburg, Germany: Böhler, 1995); Alan Gowans, *The Unchanging Arts: New Forms for the Traditional Functions of Art in Society* (Philadelphia: Lippincott, 1971); Estelle Jussim, *Visual Communication and the Graphic Arts: Photographic Technologies in the Nineteenth Century* (New York: R. R. Bowker, 1974); and Lena Johannesson, "Pictures as News, News as Pictures: A Survey of Mass-Reproduced Images in 19th Century Sweden," in *Visual Paraphrases: Studies in Mass Media Imagery, NS 21* (Uppsala, Sweden: Acta Univ. Upsaliensis, 1984), 9–68; compare Lena Johannesson, *Den massproducerade bilden* (Stockholm: Carlsson, 1997).

9. Jens Jäger, *Photographie. Bilder der Neuzeit: Einführung in die historische Bildforschung* (Tübingen, Germany: Edition Diskord, 2000).
10. Ars Electronica, www.aec.at.
11. Hans-Bredow-Institut, "Interface," www.hans-bredow-institut.de/publikationen/ interface/.
12. Zentrum für Kunst und Medientechnologie Karlsruhe, www.zkm.de. This is also the mission of German projects like the Database of Virtual Art, http://virtualart.hu-berlin.de; the Digital Art Museum, www.dam.org; and the Computer Game Museum, www.computerspielemuseum.de/english.html; see also the Swiss project Aktive Archive, which develops strategies for the technical preservation of electronic arts, www.aktivearchive.ch.
13. Horst Bredekamp, "A Neglected Tradition? Art History as Bildwissenschaft," *Critical Inquiry* 29 (2003): 418–28.
14. As a small extract from recent publications, see for instance David Gugerli and Barbara Orland, eds., *Ganz normale Bilder: Historische Beiträge zur visuellen Herstellung von Selbstverständlichkeit* (Zürich: Chronos Verlag, 2002); Wolfgang Coy, "Die Konstruktion technischer Bilder," in *Bild Schrift Zahl*, ed. Horst Bredekamp and Sybille Krämer (Munich: Fink, 2003), S. 143–53; Olaf Breidbach, *Bilder des Wissens. Zur Kulturgeschichte der wissenschaftlichen Wahrnehmung* (Munich: Fink, 2005); and Martina Heßler, ed., *Konstruierte Sichtbarkeiten. Wissenschafts- und Technikbilder seit der frühen Neuzeit* (Munich: Fink, 2005).
15. William J. T. Mitchell, *The Reconfigured Eye: Visual Truth in the Post-Photographic Era* (Cambridge, Mass.: MIT Press, 1992).
16. Bildwissenschaftliches Kolloqium, www.computervisualistik.de/kolloquium/bwk/html/english/.
17. The Graduate School "Bild Körper Medium" (Image, Body, Medium) is a part of the Staatliche Hochschule für Gestaltung in Karlsruhe, Germany (www.hfg-karlsruhe.de/hfg/) [last visit: April 15, 2007]. For all temporary Internet resources, see www.archive.org.
18. Iconic Turn, www.iconic-turn.de.
19. IFKnow, www.ifk.ac.at.
20. Donau-Universität Krems, www.donau-uni.ac.at.
21. eikones, www.eikones.ch.
22. Joseph August Lux, *Ingenieur-Aesthetik* (Munich: Lammers, 1910); and Rudolf Arnheim, *Visual Thinking* (1969; reprint, Berkeley: University of California Press, 2004).

CHAPTER **10**

Visual Literacy in Action
"Law in the Age of Images"

RICHARD K. SHERWIN

In this essay, I explore how a deeper appreciation of visual strategies helps students to grasp the various ways in which legal advocates invoke their audiences' intuitive beliefs and how the right image can help move decision makers toward a desired outcome in a given case. I will present a range of images to illustrate the kind of visual legal rhetoric that is now being deployed both in American courtrooms and in the court of public opinion.[1] These images dispel traditional notions of an autonomous legal domain dominated by linear-causal rationality[2] and draw attention to the role of alternative cognitive and cultural models in the legal meaning-making process.[3]

Consider, for example, a criminal trial in which a home video depicting police officers surrounding and beating a lone civilian is digitally replotted to "demonstrate" how the civilian's movements "caused" the police to beat him. When George Holliday's fortuitously captured images of a group of white Los Angeles police officers repeatedly striking black motorist Rodney King with their batons were broadcast on the television news, public sympathy for King was strong. What could justify that kind of concerted violence against an unarmed civilian?

Indeed, the prosecutor in the state criminal case that was subsequently brought against the officers seemed to echo this popular sentiment. "Just watch the videotape," he repeatedly told the jurors. But his trust in the

simplicity of visual truth turned out to be misplaced. Locked into his own naïve realist perspective, the prosecutor never paused to consider the persuasive impact on the jury of the defense's strategy. By digitizing Holliday's images, the defense team gained significant control over the re-presentation and renarratization of what the jurors saw at trial. For one thing, slowing down and isolating specific visual frames defused the violence of the police blows. Even more importantly, however, by altering the sequential flow of the images, the defense managed to reverse causation in the jurors' minds. The premise was simple. Psychologists have long known that when we see two objects come together and one immediately move away, our mind reads causation into the scene. It looks as if one object *caused* the other to move. Similarly, when jurors watched the digital version of George Holliday's videotape first, they saw Rodney King's body rise up off the ground (in direct violation of the officers' instructions), then they saw the officers' batons come down upon his body. When King resumed the prone position, the police batons rose up again. And so the pattern continued, with King rising up and batons coming down.

In short, the defense had effectively renarrated the scene to establish that King's own movements caused the batons to strike him. Instead of the prosecutor's story about white racist cops beating an innocent black motorist, jurors now "saw" a series of images in which police officers carefully (and professionally) "escalated and deescalated" levels of force in direct response to King's aggressive resistance of arrest.

Or consider the case in which a closing argument was presented in court *entirely on video*. This was a civil dispute involving the largest accounting firm in the world: Price Waterhouse. In arguing their case, the plaintiff's lawyers used a visual montage showing a broad range of visual images, borrowing from both documentary and feature film sources. The central image, however, remained the same throughout. There on the screen was the unsinkable *Titanic*, the largest oceangoing vessel in the world at the time (See the illustration on the next page). Why the *Titanic*? The plaintiff's case theory was as simple as it was ingenious. Price Waterhouse had been hired to investigate the financial standing of a bank that the plaintiff wanted to take over. In the course of their analysis, however, Price Waterhouse made numerous accounting errors, and their carelessness caused the plaintiff to unwittingly take on massive unsecured loans. The upshot? Price Waterhouse might be the largest accounting firm in the world, but just like the *Titanic*, being the largest is no guarantee against carelessness and disaster.

As a matter of everyday practice, in courtrooms across the United States, legal and nonlegal realities are being visually projected in a variety of ways inside the courtroom:

- from "day in the life" documentaries in personal injury lawsuits,
- to reality-based police surveillance and security videos,
- to amateur and news journalist videos (together with their digitized reconstruction),
- to computer graphics and digitally reconstructed accidents and crime reenactments, and
- to video montage as a form of legal argumentation (including the interweaving of documentary and feature film images, as occurred in the *Titanic* closing argument).

Visual closing argument:
Price Waterhouse = the Titanic

As electronic screens proliferate in both public and private domains, the mind's adaptation to novel forms of information packaging proceeds apace. We have learned to simultaneously view multiple "windows" onto the real and the virtual, we have come to accept simulations of reality interspersed with real-life documentation, and we have willingly absorbed narratives with fragmented timelines shaped by nonlinear ("associative") forms of logic that flaunt self-reflexive allusions to the interpretive process of meaning making itself. In short, human perception and cognition are rapidly adapting to the nature and demands of new communication technologies.

In contemporary, visually literate, multimodal societies, the meaning-making codes of television, film, and, to an increasing extent, the Internet have become a part of our visual common sense; that is, they have been unconsciously assimilated. The seamless blending of fantasy and reality that we often find on film, television, and computer screens is a notable feature of this visual common sense. Of course, this is not an isolated phenomenon. Recent studies in cognitive psychology have shown that our world knowledge is often scripted by a mixture of fictional and nonfictional claims.[4]

Law is not exempt from popular meaning-making processes. Nor should this prove surprising. To succeed in the business of persuasion, lawyers (especially trial lawyers) must operate within the available bandwidth of popular culture. This means that they must learn to emulate common patterns of thinking, speaking, and seeing. If persuasion is a matter of mobilizing the categories and meaning-making tools that people commonly carry around in their heads, where else would lawyers turn but to

the screen? As Philip Meyer has written, "[J]urors seem to make sense out of increasingly complex simulations through references to *other* imagistic stories." Based on his own in-court observations, Meyer claims that there is a newly emerging, open-ended legal storytelling style that is "remarkably influenced by the conventions of contemporary popular imagistic storytelling."[5] In short, the visual storytelling practices of contemporary popular culture are finding their way into courts and the legal culture proper.

The blurring of Hollywood fictions and legal reality is also occurring in the stories trial lawyers tell. Consider the prosecutors in *real* homicide cases who compare the accused to film characters from Francis Ford Coppola's *The Godfather* or Oliver Stone's *Natural Born Killers*, or the state's attorney who establishes a "knowing and voluntary" waiver of Miranda rights based on the defendant's familiarity with a popular TV show.[6]

The law's assimilation of popular content takes other forms as well. Consider in this regard the movies and television shows that we watch. They tend to cycle and recycle through our minds, and the more compelling among them end up as templates for understanding and belief. This helps to explain social phenomena like the so-called Perry Mason effect, referring to the early, highly popular American TV show that led some jurors in real cases to expect to hear a confession from the witness stand at some point during the trial. These jurors experienced doubt when the expected admission of guilt was not forthcoming. Or consider the *People's Court* phenomenon, referring to the spate of popular American reality judge shows that has led some jurors to conclude that if the judge is not shouting her skepticism from the bench, she must find the witness on the stand credible. Or consider the more recent *CSI* phenomenon, referring to a cluster of popular American television shows featuring "criminal science investigators" armed with new forensic technologies, like DNA analysis. These shows have led some jurors to experience doubt when the prosecution's science falls short. "Where's the DNA evidence?" some jurors have been heard to protest. "Something must be wrong with the state's case."[7]

Lawyers have no choice but to adapt to the cognitive environment in which they work. This is why prosecutors who do *not* have DNA evidence to present (and, contrary to the popular impression film and television may create, forensic evidence is not collected at every crime scene) may feel compelled to explain why "real law" is not like "TV law." Of course, it may also be with TV law in mind that a shrewd defense attorney might harp on the state's "missing" evidence.

Today, savvy lawyers know and are putting to practical use what advertisers and politicians have known and practiced for quite some time: how to get the message out, how to tailor content to medium, and how to spin the image, edit the bite, and seize the moment on the screen and in the mind

of the viewer.[8] Lawyers are storytellers, and the best, most compelling stories are the ones that adapt familiar narrative forms featuring recognizable character types driven by ordinary human emotions, motives, and desires. Advocates who can weave their legal theory into an effective story form, and play it out in court within evidentiary constraints, are more likely to be persuasive before a jury than those who simply state the facts and recite the applicable rule.

Reliance upon the strength of deductive and inductive logic alone will not do—not when characters need to be evoked, motives understood, and states of mind laid bare. This kind of persuasion requires the fictional method, the imaginary ground plot, and the apt image—fruits of the advocate's facility with the raw materials out of which meanings are made, and made to *stick* in the decision maker's mind. In short, legal persuasion requires familiarity with the narrative resources of popular culture.[9]

It warrants noting here that the rise of digital technology and the proliferation of visual mass media are double-edged swords when it comes to law. On the one hand, digital technology inside the courtroom makes it possible to depict objects and events with previously unimaginable clarity. Images offer an immediacy of access to trained as well as untrained eyes. Yet, precisely because of their ease of access and credibility ("seeing is believing"), visual images introduce new challenges—as the unwary American prosecutor in the Rodney King case would have done well to note.

Of particular concern in this regard is the peculiar efficacy of visual representation and visual persuasion. There are three factors to consider. First, because photographs, films, and videos can appear to resemble reality, they tend to arouse cognitive and especially emotional responses similar to those aroused by the real thing depicted. Movies, television, and other image-based entertainments have overwhelmed text-based media in popularity largely because they seem to simulate reality more thoroughly, engulfing the spectator (or, in the case of interactive computer and video games and immersive virtual environments, the participant) in vivid, lifelike sensations. To the extent that persuasion works through emotion as well as reason, images persuade more effectively than words alone. Second, because images appear to offer a direct, unmediated view of the reality they depict, they tend to be taken as credible representations of that reality. Unlike words, which are obviously constructed by the speaker and thus are understood to be at one remove from the reality they describe, photograph, film, and video images (whether analog or digital) appear to be caused by the external world, without the same degree of human mediation and hence interpretation; images thus seem to be better evidence for what they purport to depict.[10] Third, when images are used to communicate propositional claims, at least some of their meaning always remains implicit.

Images cannot be reduced to explicit propositions. In this respect, images are well-suited to leaving intended meanings unspoken, as would-be persuaders may prefer to do,[11] especially when evidentiary rules forbid making a given claim explicitly.

Images, therefore, do not simply "add" to the persuasive force of words; they transform argument and, in so doing, have the capacity to persuade all the more powerfully. Unlike words, which compose linear messages that must be taken in sequentially, at least some of the meaning of images can be grasped all at once. This rapid intelligibility permits visual messages to be greatly condensed (it takes a lot less time to see a picture than to read a thousand words), and allows the image creator to communicate one meaning after another in quick succession. Such immediacy of comprehension enhances persuasion. When we think we've gotten the whole message at once, we are disinclined from pursuing the matter further. And, increasingly, rapid image sequences disable critical thinking because the viewer is too busy attending to the present image to reflect on the last one. For both reasons, the visual message generates less counterargument, and is therefore more likely to retain our belief. Images, moreover, convey meaning through an associational logic that operates in large part subconsciously, and through its appeal to viewers' emotions. Finally, images readily lend themselves to intertextual references that link the communication to other works and other genres, enabling arguments to draw on the audience's presumed familiarity with those other works and genres and thus to appropriate meaning from the culture at large. An audience's pleasure in the familiar, their belief that they are perceiving reality, combined with quick and easy comprehension make it more fun to watch than to read. And because viewers are occupied and entertained, they are both less able and less willing to respond critically to the persuasive visual message. Hence, the message is more likely to be accepted.

The dissemination of popular culture in a virtual flood of visual images has had an impact on law in the United States and beyond. The rapid globalization of commerce has sped the exportation of American popular culture together with its representations of law and the legal process. Consider, for example, the Canadians who insist on being told their Miranda rights when stopped by Canadian police. Having been virtually "naturalized" by an inundation of American law films and popular TV shows, these Canadian citizens apparently feel entitled to the same constitutional rights and protections as the characters who appear on the screen. Or consider German lawyers who rise in court to contest rulings from the bench or who dramatically cross-examine witnesses on the stand. Here, too, the habitual consumption of American popular legal culture, together with the adversarial norms that it embodies, seems to have led some jurists to forget the inquisitorial (nonadversarial,

dossier-oriented) character of their own Continental legal tradition.[12] Such developments lead one to speculate whether the transnational appeal of adversarial legal melodrama, a genre prominently featured within Anglo-American popular culture,[13] might be reconstituting global common sense about legal process and the search for truth inside the courtroom.[14]

In a schematic sense, one might express the premise of these remarks as shown below. Four "rules of thumb" may help us think about law's life on the screen.

Consider the first rule of thumb: *simplify the complex*. New digital simulation technologies enable lawyers to accurately represent complex phenomena with compelling clarity. For example, in a recent class action against some of the world's largest tobacco companies, plaintiffs' lawyers contended that the defendant companies were being deceitful when they denied knowledge of the addicting properties of nicotine. At trial, a simple simulation demonstrated how nitrogen molecules had been added to cigarettes for the sole purpose of facilitating the rapid intake of nicotine. The color-coded images made plain that the tobacco companies had designed their product as a maximally efficient nicotine delivery system. Through their use of this cogent and simple visual simulation, the plaintiffs were able to immediately distill for the jury the essence of their claim.

Let us turn next to the second rule of thumb: *exploit the iconic*. The term *iconic* in this context is meant to convey the strategic use in court

'Rules of thumb' for law on the screen

- (1) "simplify the complex"

- (2) "exploit the iconic"

- (3) "emulate the generic"

- (4) "respect the medium"

of familiar pop cultural templates. For example, consider the illustrative visual that was used in an insider trading case involving Martin Siegel, who was accused of providing Ivan Boesky with inside information about a bank takeover. Possession of this nonpublic information allowed both Siegel and Boesky to profit handsomely, albeit unlawfully, by buying undervalued stock shares and selling them at a significantly increased market value once news of the takeover had been made public.

At the trial, the plaintiff's lawyers made effective use of videotaped depositions (i.e., pretrial interviews) of the defendants. Indeed, at one point in their closing argument, the jury saw Marty Siegel's image replicated on the screen in three rows of three—precisely the design of the old, popular television game show called *Hollywood Squares* (See the illustration on the next page). In that show, celebrities (somewhat past their prime) took their seat in a large-scale tic-tac-toe board. In the trial version, Siegel was the sole player, and in each of nine exchanges he had but one thing to say: "On advice of counsel, I invoke my fifth amendment right against compelled self-incrimination." The effect of hearing and seeing nine Marty Siegels simultaneously invoking the right to silence while ensconced in nine boxes inside a tic-tac-toe board is comical. It was just the humorous effect needed to take the edge off of the real strategy that these images deploy: demonizing the defendant for refusing to explain himself in his own words from the witness stand at trial. An iconic cultural template, a popular TV show instantly familiar to most members of the television-watching public, served the plaintiffs well, for it instantly and wittily communicated the character of the man the jurors had been asked to condemn.

Consider next the third rule of thumb: *emulate generic fictions (to produce truth)*. This rule reflects insights from recent social psychology

studies. These studies have shown that different sources of information are not always kept neatly separated in people's minds. Truth readily intermingles with fiction. Our world knowledge is often scripted by a mixture of fictional and nonfictional claims. In fact, the credibility of a particular image or story may depend on its faithful emulation of fictional storytelling techniques that fulfill popular expectations about what reality looks like on the screen. Consider in this regard the credibility of the "home video" aesthetic. Several years ago, this low-tech style was exploited in a popular American horror film called *The Blair Witch Project*. In this film, three amateur filmmakers go off into the woods in search of a fabled witch. The rough, ill-lit images produced by an unsteady camera, the off-center framing, and seemingly unscripted exchanges all contribute to an enhanced sense of immediacy and visual truthfulness (Top illustration on the next page).

What began as a distinct cinematic visual style, however, may have serious consequences outside the realm of popular entertainment when the chief evidence in a law case is a film. Consider a recent criminal case prompted by an "amateur" video that was made by a group of college students (Bottom illustration on the next page). They used a camcorder to film what state prosecutors called a kidnapping and assault of a young woman, and what defense lawyers described as nothing more than an amateur horror film.

Is it real horror, or is it staged? If this case had gone to trial,[15] a jury would have been called upon to watch and judge for themselves the "truth" or "simulation" of what they saw on the screen. This would be a criminal trial

that turned on a jury's response to aesthetic cues, where the jurors' perception of truth might just depend on the degree to which visual evidence effectively emulated a popular fictional genre. This case may be unique in the vividness with which it presents the fiction-nonfiction dilemma, but it is not an isolated example. Trial lawyers, judges, jurors, and the lay public must deal with similar challenges as visual evidence and visual storytelling become more commonplace in courtrooms, and elsewhere where legal meanings are being disseminated.

My last illustration addresses the fourth rule of thumb: *respect the medium*. Whenever we shift to a new medium, whether it is print, film, or massive multiplayer online gaming, we not only encounter new content but

also become accustomed to new ways of experiencing content. Just as the cultural templates and cognitive heuristics that we learn from early childhood on help to shape and inform the way we perceive the world outside our skin, so too digital image-making machines embody an underlying program that helps to shape our sense of reality. Once our minds learn these artificial programs, they become "second nature" to us. Their commonsense logic is immediately at hand and "invisible" (i.e., unconscious). Like the classic "restaurant script" in Roger Schank and Robert Abelson's seminal study,[16] once a cognitive template is internalized as a norm, every time we confront the same or a sufficiently similar situation, we expect the same script to play out. I believe we encounter a similar expectation with respect to technology-based templates.

This applies to our expectations generated from interactive popular computer software and video gaming (an industry that has now exceeded film sales among the younger generation). In the early days of the Internet, there was a saying: "information wants to be free." In light of subsequent developments, particularly in the sphere of massive multiplayer online gaming, one might propose a slight revision: "information wants to be played with." People expect to be able to interact with data on the screen. And, indeed, this norm has begun to play out in the law.

In a recent, highly publicized homicide case in England, the trial judge satisfied this expectation. I have in mind the notorious Soham murder trial. This was a circumstantial evidence case. The heart of the state's case was fibers—sweater fibers from the clothing worn by the two young female victims at the time of their disappearance. The jurors not only got to see in court digital representations of those fibers, but the judge also gave them a DVD to play during their deliberations. The DVD contained images of not only sweater fibers, but also the sweaters they came from, the crime scene, the girls' route home, videotaped witness testimony, as well as other evidentiary material.

During their deliberations, the jurors got to move freely among this digital evidence. In this way, the trial judge "respected the digital medium," and fulfilled ordinary expectations about multimodal, on-screen images. That expectation says that we should be able to interact with what we see on the screen. How this might have opened up the lawyers' carefully crafted narrative frameworks to new juror-inspired replottings, and with what impact on the outcome, is but one more question that the introduction of new visual technologies in the courtroom raises. It is a matter that warrants further study.

I will close with a final thought. As film and television genres, video games, and mass media advertisements converge with visual legal evidence and persuasion inside the courtroom, it becomes imperative for law students

Visual Literacy in Action • 191

and teachers alike to appreciate that the making and display of images are not simply matters of aesthetics. When the life of the law imitates art, aesthetics are not ancillary to legal reality. They are constitutive.

The stakes here could not be higher, for law always implicates the use (and legitimacy) of force in its name. In this sense, then, helping students become more visually literate is essential to doing justice, and to the continued flourishing of participatory democracy in contemporary society.

Endnotes

1. See, generally, Richard K. Sherwin, *When Law Goes Pop: The Vanishing Line between Law and Popular Culture* (Chicago: University of Chicago Press, 2000); see also Christina O. Spiesel, Richard K. Sherwin, and Neal Feigenson, "Law in the Age of Images," in *Contemporary Issues of the Semiotics of Law*, ed. Anne Wagner, Tracey Summerfield, and Farid Samir Benavides Vanegas (Oxford: Hart Publishing, 2005).
2. As stated by Judge Jack Weinstein, forensic courtroom teaching is expected to be grounded in the real world. Evidence of that world is produced, and from that evidence, using hypotheses, generally based on knowledge the trier brings to the case, opinions are formed. They are based upon rational syllogisms, leading to conclusions about statements of fact that are material propositions (sometimes called operative facts) defined by the law. (Verizon Directories Corporation v. Yellowbook USA, Inc, 338 Federal Supplement 2d 422 [2004].)
3. See Anthony G. Amsterdam and Jerome Bruner, *Minding the Law* (Cambridge, Mass.: Harvard University Press, 2000); and Dorothy Holland and Naomi Quinn, *Cultural Models in Language and Thought* (Cambridge: Cambridge University Press, 1987).
4. Richard Gerrig, *Experiencing Narrative Worlds* (New Haven, Conn.: Yale University Press, 1993); and Daniel Gilbert, "How Mental Systems Believe," *American Psychologist* 46 (1992): 107–19.

5. See Philip N. Meyer, "'Desperate for Love': Cinematic Influences upon a Defendant's Closing Argument to a Jury," 18 Vt. L. Rev. 721 (1994).
6. See Thomas M. Kemple, "Litigating Illiteracy: The Media, the Law, and The People of the State of New York v. Adelbert Ward," *Canadian Journal of Law and Society* (1995): 1. See also Adam Liptak, "New Trial for a Mother Who Drowned 5 Children," *New York Times*, January 7, 2005:

 Andrea Yates, the Texas woman convicted of drowning her children in a bathtub, was granted a new trial by an appeals court in Houston yesterday. The court ruled that a prosecution expert's false testimony about the television program "Law & Order" required a retrial.

 Ms. Yates, who had received diagnoses of postpartum depression and psychosis, confessed to the police in 2001 that she had drowned her five children, ages 6 months to 7 years. A Houston jury convicted her of murder the next year for three of the drownings, rejecting her insanity defense. The case ignited a national debate about mental illness, postpartum depression and the legal definition of insanity. Yesterday's ruling was narrow and novel. It turned on testimony by Dr. Park Dietz, a psychiatrist who was the prosecution's sole mental health expert. Dr. Dietz testified that Ms. Yates was psychotic at the time of the murders but knew right from wrong. The latter conclusion meant that she was not insane under Texas' unusually narrow definition of legal insanity. On cross-examination, Dr. Dietz was asked about his work as a consultant on "Law & Order," a program Ms. Yates, the appeals court said, "was known to watch." He was asked whether any of the episodes he had worked on concerned "postpartum depression or women's mental health."

 "As a matter of fact," he answered, "there was a show of a woman with postpartum depression who drowned her children in the bathtub and was found insane, and it was aired shortly before the crime occurred."

 That statement was false: There was no such episode. The falsehood was discovered after the jury convicted Ms. Yates.

7. See Jamie Stockwell, "Defense, Prosecution Play to New 'CSI' Savvy: Juries Expecting TV-Style Forensics," *Washington Post*, May 22, 2005, A01, which stated, "Prosecutors say jurors are telling them they expect forensic evidence in criminal cases, just like on their favorite television shows, including 'CSI: Crime Scene Investigation.'… [I]ncreasingly, jurors are reluctant to convict someone without [forensic evidence], a phenomenon the criminal justice community is calling the CSI effect."
8. See, e.g., G. Christopher Ritter, *Creating Winning Trial Strategies and Graphics* (Chicago: American Bar Association, 2004). See also Bernd H. Schmitt, David Rogers, and Karen Vrotsos, *There's No Business That's Not Show Business* (Upper Saddle River, N.J.: Prentice Hall, 2004). See, generally, Stuart Ewen, *PR! A History of Spin* (New York: Basic Books, 1996).
9. See Sherwin, *When Law Goes Pop*.
10. See S. Kassin and M. Dunn, "Computer-Animated Displays and the Jury: Facilitative and Prejudicial Effects," *Law and Human Behavior* 21 (1997): 269–81.
11. For example, in his 1988 presidential campaign, George Bush ran television ads accusing his opponent, Massachusetts governor Michael Dukakis, of being soft on crime. The ads prominently featured the face of an African

American man named Willie Horton, a convicted murderer who raped a white woman and stabbed her fiancé while on furlough from a Massachusetts prison. A number of commentators believed that the Bush campaign was playing upon racial fears by using Horton's face as a symbol of the threat that black males posed to innocent whites. See Susan Estrich, "The Politics of Race: When George Bush Made Willie Horton Part of His Campaign Team, the Issue Wasn't Just Crime—It Was Racial Fear. Michael Dukakis' Campaign Manager Saw It Happening, and Blames Herself for Not Speaking Out," *Washington Post*, April 23, 1989, magazine section, W20. See generally Paul Messaris, *Visual Persuasion: The Role of Images in Advertising* (Thousand Oaks, Calif.: Sage, 1997).

12. See Stefan Machura and Stefan Ulbrich, "Law in Film: Globalizing the Hollywood Courtroom Drama," *Journal of Law and Society* 28 (2001): 1117–32.
13. See Carol Clover, "Law and the Order of Popular Culture," in *Law in the Domains of Culture*, ed. Austin Sarat and Thomas R. Kearns (Ann Arbor: University of Michigan Press, 2000), 97–119.
14. See Edward S. Herman and Robert W. McChesney, *The Global Media* (London: Cassell, 1997).
15. According to Elba County, Michigan, prosecutor Byron Konschuh, the defendants in this case chose to plead guilty to attempted kidnapping and felonious assault. They spent two months in jail. Konschuh learned that the victim had not given her consent to partake in this prank. Apparently, the defendants could not get their story straight. They did not unanimously assert the "amateur horror movie" defense. And when one defendant pled guilty, this prompted the other to follow suit. Telephone conversation with Byron Konschuh, March 1, 2004.
16. Roger Schank and Robert Abelson, *Scripts, Plans, Goals, and Understanding: An Inquiry into Human Knowledge Structures* (New York: Halsted, 1977).

Afterword

CHRISTOPHER CROUCH

Do I contradict myself? Very well then I contradict myself....

—**Walt Whitman**

This essay is an attempt to establish a broad conceptual framework for theories of visual literacy in the university in response to the wide-ranging research and observations presented in the previous pages. Rather than mark out the differences between the papers, I wish to draw together some concepts that link the essays. That isn't to say everything raised in the papers is necessarily compatible, but then why should it be? Walt Whitman's lines are always useful in circumstances like these.

The concept of visual literacy is large and its framing is indeed multitudinous, and as one might expect the notions of *competence* and *literacy* have been posed by the contributors in subtly different ways. What I would like to suggest is a working definition that frames competence in terms of functionality, which then allows me to adopt literacy as defining that productive and flexible condition that comes with the sense of mastering a process of communication. This aligns with attempts to define literacy in other disciplines, and in particular that newest of the many literacies, information literacy, which proposes a range of skills that extends from knowing how to use and access information to understanding information's social, cultural, and philosophical contexts. I like Jeremy Schapiro and Shelley Hughes's definition of literacy, which adopts the concept of critical reflection as the highest aim of the "information literate person."[1] This concept can then be transferred to the idea of treating visual literacy as an active process—as it is in the previous chapters—and developed so that it involves a critically analytical reading of visual texts.

By using the prosaic term *visual texts* (which I acknowledge lacks any literary elegance, is redolent of the reductive language of educational bureaucracies, and conveys little of the imagination, whimsy, and willfulness that sometimes constitute the creation of images), I wish to privilege the consciously produced visual document—for example, the visual depiction of a woodland scene—rather than the firsthand, visual experience of such a place. To read a visual text critically implies an understanding of the way in which the text has been constructed in order to communicate. This reading may address the manner in which the codes of communication have been used and the way in which those codes and their context are negotiated in order to find meaning in them; such a reading also involves finding a purpose for that meaning and giving that purpose a context. In the spirit of interdisciplinarity, this process can be linked with theories of reading developed by P. Freebody and A. Luke, who have developed a model they call *Four Roles/Resources* in response to the changing and developing role of reading.[2] Their approach acknowledges that the reader brings social and cultural capital to a text, and it argues that reading is about reading cultures, and not just sentences.

In expanding upon Jonathon Crary's observation that ideas about vision are inseparable from a larger shaping of subjectivities, Peter Dallow provides a context in which the consideration of visual literacy has to go outside debates that concentrate on the purely perceptual. He convincingly maps out an environment for the discussion of the social role of the visual, where a way to conceptualize and model a dynamic approach to visual literacy "can be situated coherently alongside the other literacies and the broader sets of professional and social practices being taught at the core of the university curriculum."

All of the processes of using visual texts that have been identified by the papers' authors are dialectical, and involve both an understanding of the act of communication and an engagement with its procedures. It could be educationally productive to adopt interpretive strategies that emphasize the dialogue between the individual and the institution in the interpretation and creation of visual texts, whether it be in the clinic, the court, or the classroom. If we accept that reading the visual text is an active process, it instigates a dialogue or discussion with systems of meaning, and even the value judgments that have been made as to the purpose and worth of the meaning(s) revealed. The value of this observation, as some of our authors have demonstrated, is that visual literacy is not a solitary, individual act, but part of a wider set of social practices. To find meaning is to negotiate with the visual text, to engage with it on any number of levels, and to be involved in discovering how that act of negotiation itself is constructed. I think that the papers demonstrate that it is often the process of finding

meaning that demands our attention as much as the meaning itself. The alternative is that the individual passively accepts the act of communication fait accompli, the way an empty page records a pencil mark.

University art departments and art schools have traditionally laid greater emphasis on establishing canons in art history courses than on finding ways for the individual to negotiate, or to renegotiate, her relation with the visual text. As universities (particularly in Australia and the United Kingdom, where my main experience lies) increasingly demand specialized training that responds to economic rather than educational needs, so visual practice retreats into fixed, competency-based systems for administering information. A cursory glance at the curricula of art schools reveals design courses disappearing into the bunker of standard histories of typography and style movements, Web page designers who are encouraged to consider HTML codes rather than communicative ones, and students who are given curricular menus from which they devise personal strategies for acquiring skill sets—rather than being encouraged to see skills in a wider perspective.

Barbara Stafford observes that despite the explosion of sensory media, teachers of the visual are paradoxically faced with a shrinking arena of influence, and that we are confronted with a culture of the "obliteration of conscious thought." In her examination of the hegemonic principle of "automatic knowledge" in neurology, she challenges the notion of literacy as an unreflexive, desocialized activity. She makes two closely linked points that are valuable in conceiving of literacy as an active principle. She reinforces the proposition that, firstly, there has to be an exterior contextualization of the mind and its interior functioning; and, secondly, that the individual's consciousness is part of the physical world while at the same time highly reliant on the laws of its own neurobiology. In adopting this dialectical approach toward mind and environment, she helps move the visual away from the mechanical materialism of cultural technicists, and liberates a space that allows for creative attitudes toward both the production and consumption of visual texts. In so doing she also redirects the contemporary debate about autopoiesis away from the conception of our consciousness as automatic and unreflexive, and back toward the humanism of one of its progenitors, Humberto Maturana, who has observed "that as structure determined systems we exist through our structural dynamics.... In that sense we are machines, molecular machines. But our human existence, our human identity does not take place in our structure."[3]

Given the increasingly technicist solutions to college education, it is heartening to see William Washabaugh privilege the social and ethical processes of finding meaning and value in visual texts. He clearly demonstrates that, if embedded in the ideal of the Socratic university, visual literacy has an

198 • Afterword

An unusual kind of visual literacy: the ability to look at the brand on the cheek or rump of a camel in Iraq, Syria, Jordan, Iran, or Saudi Arabia, and tell it apart from other people's camels. This is one of a number of plates from a specialized study published in 1952, which includes the associated rock-cut graffiti identifying the owners' territory. The study includes information on collecting and local informants, but does not actually tell readers how to decipher individual brands. It is more an explanation of the conditions of a possible literacy than a full account of a visual practice.

empowering role for the individual's discovery of herself and her relationship with the institutions that have framed her. He persuasively presents an argument for the university to become a place where visual literacy could have an important role in enabling the individual to navigate meaning in visual texts across discipline areas, and so elucidate the boundaries of her knowledge, to be aware of the relationship between how we act and how we are acted upon.

Antonio Gramsci abjured the auxiliary language Esperanto's declared egalitarianism because it obscured the power relations between language groups. He argued that if language usage—the adoption of outside terms, changes in stresses and pronunciation, the suppression of dialects, and the attempt to dismantle whole cultures based around minority language groups—reflects the often unequal relationships between cultures, then an antiseptic simulation of discussion across cultures in an artificially constructed language obscures those power relationships.[4] With this concept in mind, Washabaugh's paper clearly demonstrates that the idea that all visual texts can be evenly, dispassionately, and unproblematically consumed across cultural boundaries must also be qualified. Without confronting the way in which visual texts are produced and consumed, Washabaugh argues, one cannot understand the practices of modern social life.

But what of those market-orientated universities, where a life unexamined is not an existential disaster but simply a life where negative equity has yet to be realized? In a world of specialization, visual codes are necessarily fixed in order to sustain the stable environment that specialization needs in order to exist—just as nation-states attempt to fix the meanings of nationalist iconography in order to secure their legitimacy. Context plays a powerful role in creating the meaning and purpose of the visual text, and any account of visual literacy cannot ignore the context of the university as a place for study, a place that validates certain learning strategies and denies others. A reading of the papers reveals the expectations the university puts upon educators to think and teach in certain ways, and also reveals the creative ways in which educators work around institutional expectations.

Understanding the contexts that provide meaning for visual texts does not in itself create an even-tempered, nonconfrontational culture. Contexts can be contested, and by doing so meanings and values change. This is what is so stimulating about Jon Simons's and Richard Sherwin's papers. Both papers contest the normative contexts of the visual text, one in legal and the other in political practices. Contesting normative cultural values is a common theme in modernity, and, as Peter Dallow reminds us in his paper, modernity's visual texts have forced us to see the world in a different way. He points out that how we organize our response to the world is dependent

upon what we see or how we want to see it. Whatever this might be, it is the result of a dialogic engagement between the individual and the world.

In theorizing this relationship, Jürgen Habermas has used the term *communicative action* to describe a reflexive dialectic, where individuals are conceived as both the initiators and products of the cultural debates that surround them. Anthony Giddens talks of the *self-actualized* individual moving backwards and forwards between personal knowledge—gained through lived experience—and the testing and revision of that knowledge when faced with institutional structures and values.[5] The research embodied in this book gives us very clear indications of how this theorized condition might be diagnosed and articulated through visual texts, in a participatory form of literacy. William Washabaugh raises the potential of visual texts to create the conditions of cognitive dissonance necessary to stimulate a testing of personal knowledge against the body of socialized knowledge, ultimately involving the transformation of both the individual and institution.

Students who have learned how visual texts operate under the tutelage of Richard Sherwin and Jon Simons have undergone a similar process and have become empowered as practitioners within their field, even though their specialism is not specifically in the visual, and through their newly acquired knowledge they will transform the way in which their specialism operates. Competency-based teaching strategies within specialist areas militate against the rupturing of paradigms, and a visual literacy conceived within such a pedagogical environment may well be unable to accommodate the moment when a visual text becomes disruptive. What is intriguing about Richard Sherman's paper is the way in which he has approached the relationship between students and the visual "fictions" they will have to navigate in a court of law. He has created an educational environment where the student is led to discover that the meaning of visual texts is unstable and can be contested, and validated that process institutionally. The consequence of this is that the contingency of meaning becomes a given, and once this concept has been assimilated, the shock value of cognitive dissonance within a specialism diminishes.

What makes Washabaugh's paper so rich in its applications, and what subtly distinguishes it from Richard Sherwin's approach, is the way in which visual texts are used to shatter the relationship between specialist spheres. Simons and Sherwin use visual texts as a way of investigating the construction of legal and political "truths," and demonstrate the processes by which visual literacy can illuminate the ways that specialisms maintain their stability. William Washabaugh, however, advocates a continuing interdisciplinary rupturing of normative values that enables the student not just to understand but also to intervene in the processes of the construction of her own cultural identity.

SAMARITANS

Some visual literacies are bound up with the history of racist ethnography, and have been justly forgotten. These Samaritans are from a monographic study of "the racial anthropology of the Near East," purporting to allow anthropologists to recognize Muslims and other groups by skull measurements and by photographs. As in the previous picture of camel brands, the visual knowledge or skill is lost—no one practices it, and very few could explain it—but racist ethnography is studied as a literacy, in a kind of second-order scholarship. That second-order interest is one of the hallmarks of visual studies.

When the reader of a visual text crosses a cultural boundary, it becomes obvious that both visual text and reader are operating unsettlingly between the borders of cultures. Those cultures do not necessarily have to be discipline-based or ethnic cultures; they may well be gendered or, as Jon Simons has demonstrated in his paper, class-based cultures. The adoption of reflexive strategies toward the production and reading of visual texts enables individuals to discern the gap in their understanding and realize that a reading of a visual text could be incomplete. We have examples in the presented papers of the cognitive dissonance and misreading that can derive from the sophisticated and deliberate misuse of imagery, but the individual, of course, is quite capable of misreading a visual text unaided,

through unfamiliarity with either the significance of visual texts or the social context in which they operate. Cultures of marginalized sexuality, for example, produce extremely problematic visual texts for mainstream visual cultures. More socially acceptable, but equally problematic, is medical imagery. How can individuals navigate undecipherable texts in a context they do not understand? Henrik Enquist's paper sheds light on this dilemma, and develops the agenda of an active literacy.

Enquist's research has established that visual texts are not merely passive decipherable signs but have the potential to "promote action." Under his tutelage, patients produce texts that are actively constructed as exploratory tools. The gap between the use of clinical visual texts by specialist staff and the creation of texts by patients articulates the different perspectives between the institution and those upon whom it acts. In this particular instance, the patient is creating a new space for dialogue between the ill individual and the doctor. In so doing the specialist is forced to move away from the unambivalent realm of professionally secured visual signification such as scans and X-rays, and move into that fully aware but "half-knowing" state where meaning has to be negotiated. In this way dialogue is opened, and the ensuing discussion about how the patients' constructed visual texts relate to and amplify the doctors' own specialist texts enriches both participants.

Read together, the papers presented in this book cogently demonstrate that an active visual literacy is a reflexive one, and further suggest that the reflexive process has an importance not just for the individual finding a way to read a visual text, but also for the educator in helping to determine the function and role of unraveling the visual text for the student. In varying degrees, all the papers demonstrate a negotiation with the multiple meanings generated by visual texts, rather than suggest that there is a suitable or correct way of reading or making images.

It would be productive to ask how active the institution is in providing a space within which these skills are encouraged and developed, and to further enquire how active the institution is in facilitating the adoption of methods and teaching that can often cause the erosion of specialist bodies of information. I do not think that the erosion of specialisms is necessarily a bad thing, but neither do I think that specialisms themselves are *by necessity* restricting. We have ample evidence articulated in the authorship of the papers that within specialist areas of investigation, wide-ranging observations about the function and reading of visual texts are possible. Both models prescribe the way in which we conceive of our competency or our literacy. I would argue that the represented papers are evidence that the role of specialisms might militate against Socratic principles of visual literacy far less than the universalizing strategies of commodity culture.

Specialized visual literacies, like the ones in most of the photographs I have interpolated into this book, melt away into ordinary life, where combinations of visual skills merge and blend. This little book is a mystical and ecstatic but ultimately plodding religious allegory. Whoever owned it in the mid-nineteenth century amused herself—assuming that the reader was female, and that it was an amusement—with embroidery. The facing page and others in the book are pricked through with flower patterns.

The visual texts of globalized commerce create the illusion of a transparent visual culture where cultural tensions surrounding meaning have been eradicated, and it is globalized commerce that is increasingly setting the agenda for the functions of specialisms, and purposes of the visual, within the university.

The ethical dimension of the production and consumption of visual texts, and the role the ethical could play in visual literacy, is raised explicitly by Washabaugh and Enquist. The development of an ethical reflexivity in the visually literate individual would involve a critical understanding of the reader's contextual frames of reference and interpretation, and would need to address the potential inequities inscribed in unequal social exchanges and intercultural negotiation. It would imply a constant remodeling of the context of the visual, where, as Henry Giroux has raised in past debates, the context is always understood as a reflection of social and political power relations. It would involve an active participation between student, educator, and university in realizing that by consuming and producing meaning

in visual texts, individuals can contribute to and directly promote social influences that are ultimately global in their consequences. Utopian? Yes. Ambitious? Yes, but it would be heartening to think of universities as places in which the active principle of visual literacy is best exemplified by the aspirations, teaching methodologies, and research of the papers that precede this essay.

Endnotes

1. Jeremy Shapiro and Shelley Hughes, "Information Literacy as a Liberal Art", *Educom Review* 31, no. 2 (1996): 31–35.
2. Peter Freebody and Allan Luke, "Literacies Programs: Debates and Demands in Cultural Context" *Prospect* 5, no. 7 (1990): 7–16.
3. Humberto Maturana, "Metadesign," Chilean School of Biology of Cognition, www.inteco.cl/articulos/metadesign_parte2.htm, accessed November 2005.
4. Antonio Gramsci, "Universal language and Esperanto," in *History, Philosophy and Culture in the Young Gramsci,* edited by Paul Piccone and Pedro Cavalcanti (St. Louis, Missouri: Telos Press, 1975), 29–33.
5. Anthony Giddens, *Modernity and Self-Identity: Self and Society in the Late Modern Age* (Cambridge: Polity, 1991); Jürgen Habermas, *On the Pragmatics of Social Interaction: Preliminary Studies in the Theory of Communicative Action* (Cambridge, Mass.: MIT Press, 2002).

Photo Credits

Page 2	From Friedrich Schmalfeld, *Lateinische Synonymik* (Altenburg, Germany: Pierer, 1869), 146. Photo: James Elkins.
Page 4	Thanks to Zhivka Valiavicharska. Photo: James Elkins.
Page 9	From Joseph Lipka, *Graphical and Mechanical Computation* (New York: John Wiley and Sons, 1918), n.p., folded insert.
Page 12	Photo: James Elkins.
Page 17	Copyright 2006 Corbis.
Page 20	Copyright 2006 Corbis.
Page 46	Courtesy of the artist.
Page 47	Courtesy of the artist.
Page 64	Musée des Beaux Arts, Nîmes, France.
Page 68	Tate Gallery, London.
Page 73	Photo: James Elkins.
Page 81	Photo: James Elkins.
Page 86	Photo: Jon Simons.
Page 88	Photo: James Elkins.
Page 93	Thanks to Linda Elkins. Photo: James Elkins.
Page 97	From Barnaby Conrad, *The Death of Manolete* (Cambridge Mass.: Houghton Mifflin, 1958), n.p. Photo: James Elkins.
Page 101	From William O'Sullivan, "The Earliest Irish Coinage" [reprinted as a pamphlet, and originally in the *Journal of the Royal Society of Antiquaries of Ireland, Centenary Volume*] (Dublin: National Museum of Ireland, n.d.), detail of plate 17. Photo: James Elkins.

Photo Credits

Page 106	From James Doggart, *Ocular Signs in Slit-Lamp Microscopy* (St. Louis, Mo.: C. V. Mosby, 1949), plate XXVI, fig. 75. Photo: James Elkins.
Page 115	www.vue.org/index.html. October 2006.
Page 119	www.ithaca.edu/looksharp/. October 2006.
Page 124	www.brattleboromuseum.org/education/education.html. October 2006.
Page 130	Photo: James Elkins.
Page 134	Photo: James Elkins.
Page 138	www.columbia.edu/ca/arthistory
Page 140	Crossroads.georgetown.edu
Page 146–163	All photos in this chapter: Henrik Enquist.
Page 168	From Martin Frobenius Ledermüller, *Mikroskopische Gemüths- und Augenergötzung* (Nürnberg, Germany, 1763), Tafel 82. Photo: Das Technische Bild.
Page 170	Deutsches Röntgen-Museum Remscheid. Credit: Deutsches Röntgen-Museum Remscheid.
Page 172	From Gerd Binnig and Heinrich Rohrer, "Scanning Tunneling Microscopy," in *Proceedings of the 6th General Conference of the European Physical Society (Prague), Trends in Physics (1984)*, vol. 1, edited by J. Janta and J. Pantoflicek, 38–46.
Page 180	Courtesy *Court TV*: "The Rodney King Case: What the Jury Saw in California vs. Powell 1992," Law & Crime/Social History MPI Home Video.
Page 181	Courtesy *Court TV*: "The Rodney King Case: What the Jury Saw in California vs. Powell 1992," Law & Crime/Social History MPI Home Video.
Page 182	Courtesy of Richard K. Sherwin.
Page 186	Graphic: Richard K. Sherwin.
Page 187	Courtesy of Avi Stachenfeld.
Page 188	Courtesy of Avi Stachenfeld.
Page 189, top	Courtesy of Artisan Entertainment, 1999.
Page 189, bottom	Courtesy of *NBC Dateline*.
Page 191–192	Courtesy of *BBC News*.
Page 198	From Henry Field, "Camel Brands and Graffiti from Iraq, Syria, Jordan, Iran, and Arabia," *Supplement to the Journal of the American Oriental Society* 15 (October–December 1952): 1–41 and plates. Photo: James Elkins.

Photo Credits • **207**

Page 201 From Carl Seltzer, "Contributions to the Racial Anthropology of the Near East," *Papers of the Peabody Museum of American Archaeology and Ethnology, Harvard University* 16, no. 2 (Cambridge Mass.: Peabody Museum of American Archaeology and Ethnology, 1940). Photo: James Elkins.

Page 203 Photo: James Elkins.

Index

A

Abu Ghraib pictures, 78–79, 84
Adoration of the Golden Calf (Poussin), 19
Adorno, Theodor, 63
Aesthetic experience, 32
Aesthetics, 95
 engineering, 176
 natural history of, 39
 visual, 131–133
After-images, 68–69
Allegory of the Cave, 19
Alpers, Svetlana, 109
Analogical thinking, 107
Analogies, illustrative, 19
Anonymous autonomy, 44
Archeology, 173
Archetypes, 17
Archiving, 27, 28
Aristotle, 17
Armstrong, Carol, 109
Ars Electronica, 175
Art and Literary Connection, 123
Art history, 14, 28–29, 173–174, 175
Artificial perspective, 15

Arts
 integration of, 108
 technology and, 173–176
Art science, 174
Atlas of images, 29
Attractors, 36
Auto-control, 37
Automatic knowledge, 33
Automatic life regulators, 32
Automatic systems, 40–41, 42, 46
Automaton, 51
Autonomic systems, 40
Autonomy, 41, 44, 131–133
Auto-organization, 35–36, 37–42, 44
Autopoietic devices, 45, 47
Autotriage, 132–133

B

Baers, Bernard, 34
Bakhtin, Mikhail, 95
Bamford, Anne, 97–98
Baroque era, 75
Barry, Ann Mair, 94
Baudelaire, Charles, 94
Belting, Hans, 16
Benjamin, Walter, 75, 92, 166

Bennett, Max, 82–83
Berkeley, Bishop, 13
Bildwissenschaft, 14
Binnig, Gerd, 171
Biogentic structuralism, 38
Biology
 culture and, 36
 symbiosis in, 36–37
Biopictures, 14, 21, 27
Blake, William, 67
Boehm, Gottfried, 15
Book of Kells, 26, 27–28
Books
 eating of, 25, 26
 scanning, 27
Bracketed perception, 93
Braden, Roberts, 94
Brain
 asymmetric, 34
 auto-organization of, 35–42
 images and, 80–83
 understanding functioning of, 32–42, 44, 49–50
Brain-imaging techniques, 36, 78, 151
Branding, 77, 80
Bredekamp, Horst, 165
Brown University, 138
Buckingham, David, 98
Burda, Hubert, 176
Burke, Edmund, 66
Burke, Peter, 23
Burnett, Ron, 92, 97, 99
Bush, George H. W., 193n11
Bush, George W., 78–79

C

California College of the Arts, 140
California secondary schools, 113–115
Cambrian explosion, 93
Camera obscura, 60–61
Carlyle, Thomas, 67
Carmontelle, Louis Carrogis de, 62
Cartwright, Lisa, 92

Castells, Manuel, 96–97
Cellular state metaphor, 19–20
Center for Art and Media Technology (ZKM), 175
Certeau, Michel de, 95
Changeux, Jean-Pierre, 44, 45
Chinese language, 13
Christian iconography, 24–25, 174
Churchill, Winston, 17, 18
Cinema, 62
Clark, Andy, 33
Clinical images, 146–148, 158
Clones, 18, 21
Co-apperception, 34
Cognition, 33
Cognitive construction, 35
Cognitive control, 44
Columbia University, 138
Commercial branding, 77, 80
Communication media, 107–108
Complexity, of visuality and vision, 95–96
Computationalist-symbolic approach, 34
Connectionist-dynamic approach, 34
Conquergood, Dwight, 111–112
Consciousness, 32, 34, 37, 45, 81, 92
Contemporary culture, 97–98
Cornell University, 139
Counterliteracy, 112
Courtrooms, use of images in, 22, 179–192
Crary, Jonathan, 92, 110
Creation story, 21
Creativity, 45, 95
Cromwell and Charles I (Delaroche), 64–66
Crow, Thomas, 110
Crystal, 62–63, 70–71
CSI phenomenon, 183
Cultural empowerment, 112–113
Cultural objects, 109
Cultural probe, 154
Cultural technology, image as, 165–177

Culture
　biology and, 36
　contemporary, 97–98
　ethnicity and, 142n19
　image, 79, 92
　techno, 99
　visual, 14, 15, 29, 105–106, 109
Culture of knowledge, 167
Cyborgs, 21

D

Daguerre, Louis, 62
Damasio, Antonio, 39–40, 49, 80–82, 83
Darwinism, 45
Das technische Bild, 165–167, 176–177
Debord, 74
"Decade of the Brain" project, 36
Delaroche, Paul, 64–66
Deleuze, Gilles, 16, 62, 70–71
Dennett, Daniel, 33
Derrida, Jacques, 16, 21, 26, 67
Desmond, Roger, 110
Digital-age literacy, 98–99
Diorama, 63
Direct education, 41–42
Discourses, of race, 133–135
Distribution of the sensible, 22
Diversity, framework for, 101
DNA evidence, 183
DNA images, 171–173
Dolly the sheep, 18
Dondis, Donis, 92

E

Eagleton, Terry, 131
Easel painting, 15
Edelman, Gerald, 45, 51
Education, 47, 49
　art history and, 28–29
　image studies, 77–78
　visual literacy in secondary, 105–124

Eliasson, Olafur, 35
Elkins, James, 105, 129
Elkins, John, 78, 87
Embodied-enactive approach, 34
Emotion, 32, 40
Emotional literacy, 99
Empowerment, 160
Engels, Friedrich, 67
Engineering aesthetics, 176
Environment, interaction of, with internal, 39–40, 41, 45
Ethnicity, 142n19
External experiences, perception and, 61

F

Family of images, 83–84
Family resemblance, 18
First-person perspective, 39
Fishman, Beverly, 46, 47
Form, 166
Foster, Hal, 94
Foucault, 22
Framework for diversity, 101
Frankenstein, 21
French Revolution, 66
Futurists, 40

G

Gaming technology, 47, 48
Gang graffiti, 112
Gardner, Howard, 107
Gattegno, Caleb, 101
Gauntlett, David, 99
Gendered identity, 133–135, 142n19
Genetic fictions, 187–189
Geological visual literacy, 130, 134
Georgetown University, 141
Gilroy, Paul, 133
Gladwell, Maxwell, 45
Globalization, 185–186
Godworthy, Andy, 35
Goethe, Johann Wolfgang von, 61

Golden calf, 15, 16, 19
Golem, 21
Goodman, Nelson, 18
Goodwin, Charles, 92
Graffiti, 112
Graven images, 24
Gregory (pope), 23, 24

H

Habermas, Jürgen, 84–85
Hacker, P. M. S., 82–83
Head of state, 19
Health care, use of imagery in, 145–162
Helmholtz, Hermann von, 176
Hicceities, 70
Higher-level consciousness, 32
Historical picture research, 175
Hobbes, Thomas, 19
Hobbs, Renee, 111, 113–114, 119–123
Hoffmann, E. T. A., 51
Hoffmann, Roald, 31
Holliday, George, 179–180
Hooper-Greenhill, Eilean, 132
Hortin, John, 94
Horton, Willie, 194n11
Human reproductive cloning, 21
Humphrey, Nicholas, 43, 49
Hypericons, 19
Hypertext, 32

I

Iconic signs, 18
Iconic turn, 175–176
Iconoclasm, 21
Iconology, 14, 186–187
 Christian, 24–25, 174
 philosophy as, 16
Icons, vs. symbols, 24
Ideology, 136
Ideology critique, 21
Idolatry, 15
Illustrative analogies, 19

Image culture, 79, 92
Image-picture distinction, 14, 16–18
Imagery, translucent, 61
Images, 15–16
 atlas of, 29
 brain and, 80–83
 brands and, 80
 clinical, 146–148
 convergence with words, 27–28
 as cultural technology, 165–177
 defining, 83–84
 family of, 83–84
 historicity of, 166
 medical, 145–162, 166
 mental, 82–83
 metaphysics of, 16
 political, 77, 78–80, 82–89
 power of, 176
 quality of, 27–28
 scientific, 166–177
 understanding and using, 94–95
 visual, 77–78
Image science, 14–21, 174
Image studies, 77–78
Image-worlds, 99
Imagination, 73–74, 82
Imaging technologies, 36, 78, 171–173, 175
Inartistic, 95
Indexical, 22
Individual value choices, 131–133
Inference, 32
Information Age, 96–97
Interdisciplinary studies, 176
Internal events, of the mind, 32
Internal systems, interaction of, with environment, 39–40, 41, 45
International Association for the Study of Word and Image (IAWIS), 14
Irwin, Robert, 40

J

Jameson, Frederic, 16, 94
Jay, Martin, 91

John Paul II, 26–27
Johnson, Mark, 21
Judgment, aesthetic, 131–133

K

Kant, Immanuel, 95
Keeley, Mike, 121
Kessler, Herb, 28
Kilroy-Ailk, Robert, 85
Kinesis, 35
King, Rodney, 179–180, 184
Kirwan, Tony, 99
Klein, Naomi, 80
Knowledge
 automatic, 33
 culture of, 167
 structure of, 16
 visualization of, 91–92, 94
Kolodny, Annette, 136
Kracauer, Siegfried, 166
Krauss, Rosalind, 28
Kress, Gunther, 92

L

Lacan, Jacques, 22
Lakoff, George, 21
La Mettrie, Julien, 33
Language
 of images, 25
 natural, 13
 of thought, 42
 universal language of nature, 13
 of vision, 13
 visual, 13
 visuality in, 11–13
Language acquisition, 13
Latour, Bruno, 152
Law profession, use of images in, 179–192
Leatherbarrow, David, 35
Ledermüller, Martin Frobenius, 167–169
Leeuwen, Theo van, 92

Legal persuasion, 182–184
Legisign, 24
Leibniz, 50, 71
Leviathan (Hobbes), 19
Lewis-Williams, David, 34, 43, 49
Lexicon, of visuality and vision, 12
Lighting techniques, nineteenth-century, 62
Limbic system, 38
Linguistic turn, 15–16
Literacy, 96–98; *see also* Visual literacy
 counterliteracy, 112
 digital-age, 98–99
 emotional, 99
 media, 98–99, 107–108, 110, 166
 new era of, 100–101
 politics of, 111–112
 reconceptualization of, 98
 verbal, 14, 25, 28, 110–111
Llinas, Rodolfo, 43
Locke, John, 61
Logocentrism, 16
Loutherbourg, Phillippe Jacques de, 62
Luhmann, Niklas, 51, 52

M

MacIntyre, Alasdair, 143n21
Margulis, Lynn, 49
Marx, Karl, 63, 66, 67
Massachusetts secondary schools, 116
Mass media, 46, 47, 48
Materialism, 33, 50–51
McLuhan, Marshall, 102
Meaning response, 160–161
Media
 communication, 107–108
 mixed, 15
 visual, 15, 92
Media HyperAtlas, 29
Media literacy, 98–99, 107–108, 110, 166
Medical imagery, 145–162, 166
Medium, 189–190

Medival period, 24, 26
Menand, Louis, 135
Mental images, 82–83
Mental representation, 32, 42–43, 52
Merleau-Ponty, Maurice, 33
Messaris, Paul, 92, 107
Metaphors, 71
 metapictures as, 19–21
 visual, 18
Metaphysics of the image, 16
Metapictures, 14, 18–21
Metzinger, Thomas, 34
Meyer, Philip, 183
Middle Ages, 24, 26
Millet, Jean-Francois, 50
Million Dollar Homepage, 81
Minnesota secondary schools, 116–117
Mirrors, 71
Mitchell, Tom, 77, 83–84
Mitchell, W. J. T., 106
Mixed media, 15
Modernism, 95
Modernity, 15
Moerman, Daniel, 160–161
Morphology, 166
Moses, 15, 19
Mostafavi, Mohsen, 35
Motif, 17
Motion, 38, 40
Multiculturalism, visual, 129–141
Multiple intelligences, 107

N

Nancy, Jean-Luc, 132
Nation, 142n19
Natural languages, 13
Nature-nurture debate, 45
Networked communications, 96–97, 98
Neurobiologic sciences, 33–35
Neurophenomenology, 33
Neuroplasticity, 35
Neuroscience, images in, 77–78, 80–83

New Hampshire secondary schools, 117–118
New York secondary schools, 118–120
Nichols, Bill, 93, 95
Nietzche, 50
Nineteenth-century painting, 59–75
Northwestern University, 139
Nussbaum, Martha, 133, 136

O

Ohio secondary schools, 120
Olshansky, Beth, 117
Ophthalmological visual literacy, 106

P

Panofsky, Erwin, 14, 17, 29
Panorama, 63
Pantheism, 33
Paragone, 110–111
Patient-provided images, 145–162
Pattern recognition, 44, 173
Peirce, C. S., 18, 22, 24, 25
Penn State University, 140
Pennsylvania secondary schools, 120–122
People's Court, 183
Perception, 17, 18, 34–35, 37, 82
 autopoetic, 33
 bracketed, 93
 in nineteenth-century, 59–75
Perry Mason effect, 183
Perspective, first-person, 39
Persuasion, 182–185
Phantasmagoria, 62, 63, 64
Phenomenology, 50–51
Philosophical Investigations (Wittgenstein), 19
Philosophy, 15–16
Phonetic writing systems, 11
Photography, 175
Physiology, 32
Pictorial turn, 14, 15–16, 22, 27, 175–176

Picture criticism, 166
Pictures, political, 78–79
Pillow, Kirk, 100
Plato, 19
Political iconography, 174
Political images, 77–80, 82, 83–89
Political pictures, 78–79
Popular culture, 185–186
Potter, James, 99
Poussin, Nicolas, 19
Powers, Richard, 31
Practico-inert, 74
Pratt Institute, 139
Preception, 32
Prejudice, 144n31
Prigogine, Ilya, 36
Prosaics, 95
Psychoanalysis, 50

Q

Qualisign, 24

R

Race, visuality and, 133–137
Ramachandran, V. S., 37, 38, 53
Rancière, Jacques, 22
Ray, William, 131, 132
Reading, 11–13, 14
Readings, Bill, 135
Reardon, Christopher, 122
Receptive field, 37
Recognition, 17, 94
Reflective judgment, 95–96
Regulus (Turner), 67–70
Religion
 return of, 21, 27
 tele-technology and, 26–27
Representation, 32
Reproductions, 28
Reproductive media, 166
Re-Visioning Project, 113–114, 122
Rhetoric of iconoclasm, 21
Rieegel, Alois, 14

Riegl, Alois, 29
Robertson, Étienne-Gaspard, 63
Robots, 21
Rohrer, Heinrich, 171
Romantics, 39, 40, 42, 45
Röntgen, Wilhelm Conrad, 169
Rorty, Richard, 15, 16
Rumsfeld, Donald, 79

S

Sagan, Drion, 49
Said, Edward, 21
Saramago, Jose, 31
Sartre, 74
Scammell, Margaret, 79
Scanning technology, 27
Scanning tunneling microscope
 (STM), 171–173
Schinkel, Karl-Friedrich, 62
School of seeing, 173
Scientific images, 166–177
Scrims, 62
Scripture, 24
Searle, John, 39, 45
Secondary schools
 in California, 113–115
 in Massachusetts, 116
 in Minnesota, 116–117
 in New Hampshire, 117–118
 in New York, 118–120
 in Ohio, 120
 in Pennsylvania, 120–122
 in Texas, 122–123
 in Vermont, 123
 in Wisconsin, 123
 visual literacy in, 105–124
Second commandment, 24
Seeing, 13, 25–26; *see also* Vision
 movement and, 35
 school of, 173
Self-assembly, 35–36, 40–41, 43, 51
Semiotics, 24
Sensory distribution, 22
Sensory-input independence, 42

Seshadri-Crooks, Kalpana, 133
Sherwin, Richard, 22
Signs, 93
Situational studies, 42–46
Smith, Barbara Herrnstein, 131
Solar after-images, 68–69
Sontag, Susan, 78–79
Spectacle, 66, 72, 74, 75
Spectral, 72, 75
Stafford, Barbara, 13, 91–92
State University of New York, 139
Status quo, 143n21
Steinberg, Saul, 18
Stirner, Max, 67
Sturken, Marita, 92
Subjective vision, 60
Symbolization, 42
Symbols, 24, 38
Synnoetics, 36
Systems theory, 51–52

T

Taung child, 73
Technical Image, The, 165–167
Technology, 45–46, 97–99
 art and, 173–176
 cultural, 165–177
 imaging, 36, 78, 151, 171–173, 175
 visual, 91–92
Television, 26
Ten Commandments, 19, 24
Texas secondary schools, 122–123
Texas Tech, 140
Textual turn, 25
Theoretical pictures, 19
Theory, 16
Thinking Through Art, 116
Thought, 32
Tolerance, 144n31
Translucent imagery, 61
Trew, Alex, 81
Tromp l'oeil, 40
Tufte, Edward, 98

Turner, J. M. W., 67–73
Turrell, James, 40

U

UK Independence Party (UKIP), 85
Universal language of nature, 13
Universities, 87–89, 135–137
University curriculum, 137–141
University of California, 138, 139
University of Chicago, 137–138
University of Michigan, 141
University of Nebraska, 140
University of Wisconsin-Madison, 139

V

Value choices, by individuals, 131–133
Vantage-point, 99
Varela, Francisco, 34
Velázquez, 18
Verbal literacy, 14, 25, 28, 110–111
Verbal metaphors, 15–16
Vermont secondary school, 123
Vico, Giambattista, 42
Videotape, in criminal trials, 179–192
Vision, 33–34
 camera obscura model of, 60–61
 defamiliarizing, 25–26
 as dynamic process, 32
 language of, 13
 medieval attitudes toward, 26
 movement and, 35
 nineteenth-century, 59–75
 role of, in construction of
 experience, 42–46
 subjective, 60
Visual, the, 28, 92–94
Visual aesthetics, power and, 131–133
Visual artifacts, 162
Visual communication, 98
Visual competence, 13
Visual complex, 100–101
Visual culture, 14, 15, 29, 105–106, 109

Visual Culture Questionnaire, 109, 110
Visual images, 77–78
Visuality
 complexity and, 95–96
 in language, 11–13
 race and, 133–137
Visualization of knowledge, 91–92, 94
Visual language, 13
Visual literacy, 11–14, 98–102
 contemporary, 95–96
 crisis in, 96–98
 defined, 32
 geological, 130, 134
 lack of, 87–89
 legal implications, 179–192
 ophthalmological, 106
 in secondary schools, 105–124
Visual media, 15, 92
Visual metaphor, 18
Visual multiculturalism, 129–141
Visual sociology, 174
Visual-spatial world, 13
Visual studies, 28–29, 96–98, 101–102, 129–141
Visual studies programs, 137–141
Visual technologies, 91–92
Visual theory, 102
Visual thinking, 176
Visual Understanding in Education (VUE), 115, 116, 120, 123

W

Warburg, Aby, 14, 29, 174
Warnke, Martin, 174
Whiteness, 136–137
Williams, Raymond, 72
Wisconsin secondary schools, 123
Wittgenstein, Ludwig, 19
Word-image dichotomy, 24
Words
 analogical understanding of, 23–24
 convergence with images, 27–28
Writing, spatial mode of, 16
Writing space, 162

X

X-ray pictures, 169–171

Y

Yates, Andrea, 193n6

Z

Zeki, Semir, 33, 37–38, 53